The Anatomy of Type

The Anatomy of Type

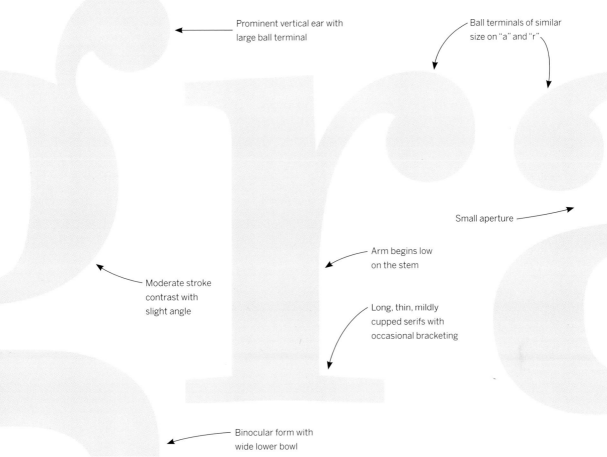

Prominent vertical ear with large ball terminal

Ball terminals of similar size on "a" and "r"

Small aperture

Arm begins low on the stem

Moderate stroke contrast with slight angle

Long, thin, mildly cupped serifs with occasional bracketing

Binocular form with wide lower bowl

A Graphic Guide to 100 Typefaces

Stephen Coles Foreword by Erik Spiekermann

HARPER
DESIGN
An Imprint of HarperCollins Publishers

THE ANATOMY OF TYPE
A GRAPHIC GUIDE TO 100 TYPEFACES

First published in 2012 by
Harper Design
An Imprint of HarperCollins*Publishers*
10 East 53rd Street
New York, NY 10022
Tel: (212) 207-7000
Fax: (212) 207 7654

Library of Congress Cataloging-in-Publication Data is available upon request.

ISBN: 978-0-06-220312-0

Conceived, designed, and produced by
Quid Publishing Ltd.
Level 4 Sheridan House
114 Western Road
Hove BN3 1DD
England

Book design by Tony Seddon
Set in Baskerville Original (Storm) and Benton Sans (Font Bureau)

Printed in China.

First printing, 2012

Contents

Foreword

The bigger a group gets, the lower its intellectual common denominator falls. The average taste of a group is definitely worse than that of any individual member. One can always see this at board presentations, where the propensity to make decisions is affected by the group size. If a group discussion had a color, it would be beige.

If that group had to pick a typeface, it would be Arial—a face whose astonishing prevalence is largely due to its astonishing prevalence. We like best what we see most, which describes a type designer's dilemma: a new typeface has to look like all the others—after all, an "a" has to look like an "a"—but it has to also have something more. Gimmicks don't work, as they wear off quickly, and basing a whole alphabet on one idea also doesn't fly. This is painfully apparent, for example, in a page set in Avant Garde Gothic, whose geometric shapes separate characters from each other rather than combine them into words. The flow of the letters is important: they have to be modest in each other's company so we can read line after line of them. Details that stick out at large sizes may become invisible as the type gets smaller, but they can add warmth, texture, and, yes, character. Type adds the sound to the tunes other people write.

As most users of type are unaware of the fact that type designers even exist, they take it for granted that fonts live on their computers, having got there by some technical intervention or other. For those people, selecting the right typeface is easy: just pull down the menu in your favorite application and click on one of the many popular names that come up. The more familiar these names look, the less likely you are to make a mistake. For those who are a little more interested in what actually makes a typeface useful, even appropriate, advice is easily had from the columns of so-called specialist magazines and websites. But their advice is commonly safe and staid. Security means hiding among the crowd.

If you want to go beyond the beige choices, you need objective criteria that can make finding the right typeface for a project not only likely, but fun. Stephen Coles is one of those people who, like myself, suffers from Typomania—that incurable, but non-lethal, disease which makes you read type specimens instead of popular literature. Stephen also has a typographic memory: he not only remembers what he has seen in those specimens—be they books or websites—but he also recalls the names of thousands of typefaces and can point anybody who asks to the proper reference point. Scary, I know, but useful for those who really want and need to go beyond what that drop-down menu offers at first sight.

If you know the difference between a font and a typeface, you need this book. If you don't, you need it even more.

Erik Spiekermann

Introduction

· ·

This book is all about looking at letters. Not just any letters, but the sets of letters that are designed together, in a systematic and harmonious way, to form a typeface.

What gives a typeface its personality? Why does one font appear bigger or clearer or darker or warmer than another? The answers to these questions can often be found by simply looking more closely at the letters themselves.

The performance of a Text typeface is best judged by viewing it—and using it—at its intended size in a passage of text. But just as typography (the use of type) is all about fussing over the details, the details of the typefaces themselves really do matter. Let's put it another way: a chef doesn't need to grow her own vegetables or raise her own cattle, but she can benefit from knowing how the ingredients were made.

When we enlarge a word or phrase that contains a typeface's most distinctive glyphs, we unearth all sorts of information about what makes that typeface tick. We discover how the space inside and between letters is as important as the strokes of the letters themselves, and how the shape of one letter affects the shape of the others. We learn that seemingly minor attributes can affect the personality of the typeface as a whole, and we can surmise the decisions a type designer made to improve the economy, legibility, or originality of the design.

Once this knowledge is acquired, it becomes a valuable and instantly accessible piece of a type user's skill set. Graphic designers who can scrutinize and describe type's nuances are better equipped to pick the right tool for the job and discuss those choices with colleagues and clients.

In the following pages, you'll find visual and interpretive descriptions of 100 typefaces. The selections were made with an emphasis on versatility and practical use. There are certainly more popular typefaces out there, or those with a more historically significant background, but each of the families represented here is relevant and useful in contemporary design. There is a mix of "classics," based on metal typefaces dating back as far as 500 years, alongside newer releases that are either thoughtful reinterpretations of the classics or completely original designs. A glossary is included on page 9 to help you with some of the most frequently used terms.

While the focus is on Text type, there are also Display faces for setting large and grabbing attention. These were not chosen as mere novelties, but rather for their flexibility of use in a wide variety of settings.

The selections represent a wide range of foundries and designers from around the world, and every typeface was vetted for quality and design integrity. They are organized in a pragmatic way, sorted in groups that borrow some aspects from traditional, history-based classifications but without relying too heavily on dated dogma. Typefaces with similar visual characteristics are placed near each other, making it easy to compare designs and seek alternatives.

How to Use This Book

1. Typeface name

The typeface is the design of a full family of fonts. Variants, such as optical sizes (Display/Text), are noted where necessary below each sample. Digital formats (such as Pro and Std) are omitted because they generally specify a font product's character set, not the design of the typeface.

2. Designer, Foundry, Country of origin, Release year, and Classification

The designer(s) of the typeface are credited as per the publishing foundry. For revivals, the designer of the original typeface is noted in parentheses.

The foundry is listed as per the publisher of the specific typeface shown. There may be versions of the typeface published by other foundries.

The country of origin gives a broad indication of where the typeface was developed.

The date indicates when the typeface was released, or, in some cases, designed. Multiple years indicate the release of variants or extensions. For revivals, the original design's estimated release is displayed in parentheses.

The classification is listed as specified by this book's system. In some cases, a more specific subclass is noted.

3. Character set

An overview of the basic characters (uppercase, lowercase, numerals, and punctuation) in the specified font. Most fonts contain many more characters than are shown here. The specific font style used for the anatomy graphic is noted and distinctive glyphs are highlighted.

4. Anatomy graphic

A few of the typeface's most distinctive glyphs and their distinguishing attributes. Sample words are generally from the language associated with the origins of the typeface.

5. Description

Brief notes about the background and overall character of the typeface, including thoughts about how the attributes highlighted in the anatomy graphic affect the design as a whole. Suggestions for best use are occasionally included.

6. Comparable typefaces

Similar typefaces used in this book are shown with the sample glyphs for easy comparison. Familiar typefaces that are not given a spread in this book are also included, suggesting possible alternatives to overused type.

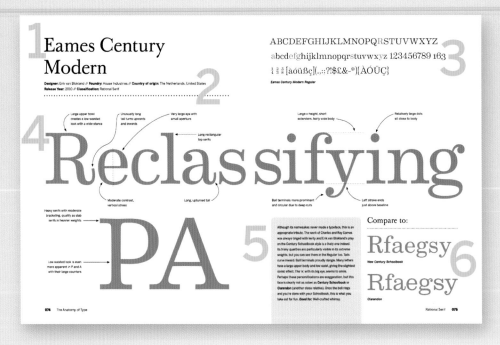

Glossary of Typographic Terminology

This book avoids esoteric lingo whenever possible, but specialized words can be useful for clearly and concisely describing type. Whether you are new to design or a practised professional, this list will be a helpful refresher as you read the following pages.

Aperture: The opening of a counter to the exterior of a glyph (see page 10).

Bracket: A curved or diagonal transition between a serif and main stroke (see page 10).

Character: The basic unit of written language. Can be a letter, a number, a punctuation mark, or other symbol (see *Glyph*).

Counter: Any interior shape of a glyph. It can be completely enclosed by strokes, such as the eye of an "e," or have an opening to the exterior, such as the lower counter of an "e" (see page 10).

Cursive: A style associated with handwriting, typified by slanted stems with curved tails.

Font: A collection of glyphs. The font is the delivery mechanism, represented by a digital file or a set of metal pieces, for a typeface (see *Typeface*).

Foundry: A company that designs, manufactures, and/or distributes fonts.

Glyph: The graphical representation of a character. A font can contain several glyphs for each letter—a lowercase "a" and small cap "A," for example—and can also have alternate forms such as single- and double-story "a"s or an "a" with a swash tail. In this way, a single character can be represented by different glyphs (see *Character*).

Humanist: A method of letter construction tied to handwritten strokes made with a pen or brush (see *Rational*, and also page 14).

Ligature: A single glyph made of multiple characters. The most common examples are functional (Standard), such as "fi," which is designed to resolve excessive spacing or an unpleasant overlap of two letters. There are also ornamental (discretionary) ligatures, such as "st," that are chiefly a stylistic option.

Rational: A method of letter construction using shapes that are drawn as opposed to written (see *Humanist*, and page 15).

Sans serif: A character or typeface without serifs (see page 13).

Serif: A small mark or "foot" at the end of a stroke. Serifs are lighter than their associated strokes (see page 12).

Slab serif: A heavy serif, typically rectangular in shape, with a blunt end. It is also a typeface classification (see page 12).

Stroke: An essential line or structural element of a glyph. The term derives from the stroke of a pen (see page 11).

Stroke contrast: The weight difference between light and heavy strokes (see page 11).

Style: A stylistic member (e.g., bold, italic, condensed) of a typeface family, typically represented by a separate font.

Substrate: The surface material on which type appears. For hundreds of years, type was printed on paper. Now it is increasingly rendered on the digital screens of desktop computers, tablets, and cell phones.

Swash: The extension of a stroke or prominent ornamental addition to a glyph, typically used for decorative purposes.

Typeface: The design of a set of characters. In simple terms, the typeface is what you see and the font is what you use.

Weight: The thickness of a stroke. In type design, the geometry of a line (or shape) is usually described using the terminology of weight.

The Anatomy of Type

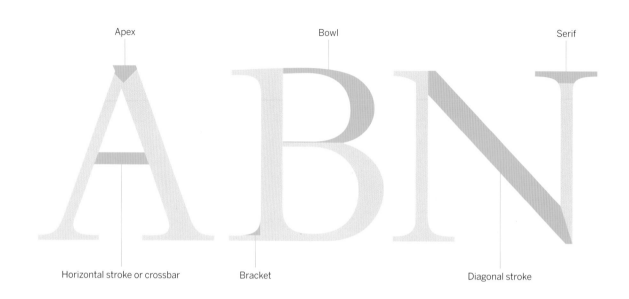

Apex

Bowl

Serif

Horizontal stroke or crossbar

Bracket

Diagonal stroke

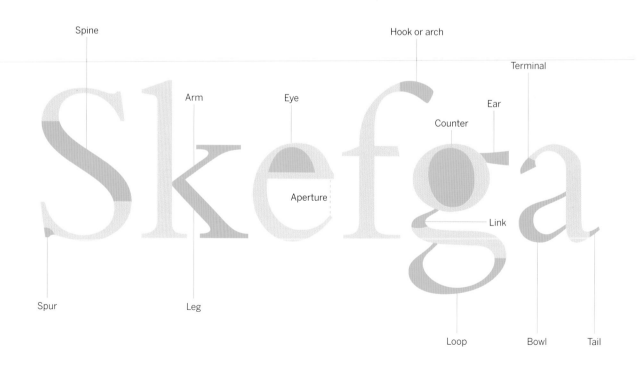

Spine

Hook or arch

Terminal

Arm

Eye

Ear

Counter

Aperture

Link

Spur

Leg

Loop

Bowl

Tail

Just like the human body, the Latin alphabet can take on a surprising range of shapes and proportions. These varieties can come from diverging historical paths, differences in language or culture, or simply the tool used to make the letters—whether it's a pen, a chisel, or a compass.

But there are enough constants in roman (upright) letterforms that a standard vocabulary can label its parts. Using terms that are familiar to everyone who knows basic human anatomy, we can describe and compare typefaces. For example, most roman-based typefaces have an uppercase "R" with a leg. Some legs are perfectly straight, some are bowed, some have an undulating curve, and some end with a "foot" (or serif) on the ground (baseline). Each of these characteristics can contribute to the overall appearance of a typeface—how it changes the look of a word, a paragraph, or a page. And, just as importantly, they can be functional characteristics, telling us what a typeface is capable of.

There are many terms relating to type anatomy that have the same meaning across the typographic community. Chances are, when you say "leg," or "serif," or "baseline" everyone will know exactly what you mean. But there are other terms whose definitions vary, and there are designers and writers who will use different words for the same part of a letter. For this book, we use terms that are as widespread and common as possible, and that help us identify the distinguishing parts of each typeface.

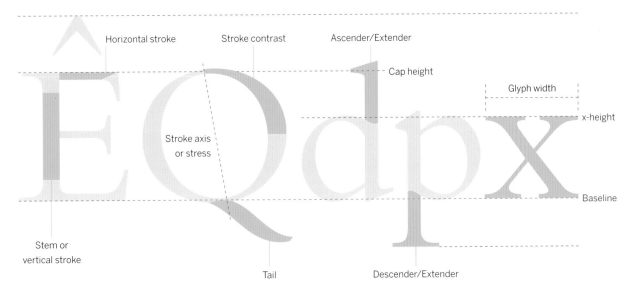

Horizontal stroke
Stroke contrast
Ascender/Extender
Cap height
Glyph width
x-height
Stroke axis or stress
Baseline
Stem or vertical stroke
Tail
Descender/Extender

Type Classification at a Glance

The typefaces in this book are arranged by classification. This makes similar designs easier to compare and introduces a vocabulary that will not only make you sound smart at parties, but will also help you identify, select, and combine typefaces.

But first, a warning: there is no universal classification system. Just like any attempt to apply a set of genres to creative work, be it music, literature, or art, typeface classification is inherently problematic. After all, type is not biology—a typeface doesn't have a genetic code like plants or birds do.

That doesn't mean people haven't tried to create some order from the chaos. Scholars and typographic associations have been inventing new classification systems for nearly 100 years. Still, all of them are fraught with contradictions and controversy. These diverse bundles of letterforms simply have too many subtle variations and too few constants. And once you think you've corralled them into clear, distinguishable groups, a new typeface or style comes along that doesn't fit in any of your bins.

Most classification systems avoid this problem by associating classifications with historical periods. While this is a good way to categorize many of the typefaces from the past, chronological methods become impractical when it comes to contemporary design. Art critics know this problem all too well: what comes after *postmodern*? *Post-postmodern*?

So, while there are the unavoidable links to history, we arranged the typefaces here into groups that are more closely tied to visual appearance. One could argue with any of these labels or sorting decisions—don't be surprised if someone at your party balks when you describe Bodoni as *Rational*, not *Modern*—but hopefully it makes the selections easier to navigate and gives a good sense of the variety of type available. Armed with this knowledge, you can more articulately describe typefaces, draw comparisons, and decide which are the right ones for the job.

Humanist Serif
Very calligraphic, with a consistent stress angle and moderate stroke contrast. Bracketed, often asymmetrical serifs.

Transitional Serif
Slightly calligraphic, with variable stress angle and usually more stroke contrast. Bracketed serifs and bulbous terminals.

Rational Serif
A regularized structure with vertical stress and a moderate to high stroke contrast. Some typefaces have thin, unbracketed serifs. Ball terminals.

Contemporary Serif
Styles vary but most have a large x-height, low stroke contrast, and large chunky serifs. Very open apertures.

Inscribed/Engraved
Derived from chiseled or engraved letters. Low stroke contrast is common. Serifs can be wedge-shaped or similar to those of Humanist. Some have flared terminals.

Grotesque Sans

Similar in structure to Transitional or Rational Serif typefaces. Low stroke contrast and fairly regular proportions. Round shapes are often oval, not circular.

Neo-Grotesque Sans

Like Grotesque, but with more homogenous forms. Minimal stroke contrast. Closed apertures and horizontal terminals. Round shapes are more circular.

Gothic Sans

American variant of the Grotesque style, with simpler, more static forms. Usually with a large x-height, low stroke contrast, and condensed width.

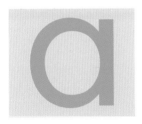

Geometric Sans

Static and clinical. Constructed of shapes that are nearly circular or square. Minimal stroke contrast.

Humanist Sans

Counterpart to Humanist Serif. Calligraphic in structure, often with higher stroke contrast than other sans serifs. Open apertures.

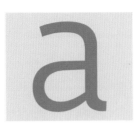

Neo-Humanist Sans

Contemporary evolution of Humanist Sans. Larger x-height. Very open apertures. Usually less stroke contrast.

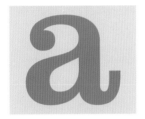

Grotesque Slab

Similar forms to Grotesque sans serifs but with heavy rectangular slab serifs. Closed apertures. Ball terminals are common.

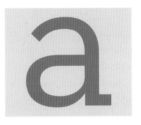

Geometric Slab

Similar forms to Geometric sans serifs but with unbracketed rectangular slab serifs about the same weight as stems.

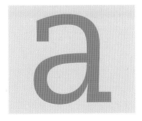

Humanist Slab

Similar forms to Humanist sans serifs but with unbracketed rectangular or wedge-shaped slab serifs.

Script

Any typeface that emulates handwriting, whether connected cursive or informal print.

Key Classification Features

The following examples indicate the key features that inform each typeface classification and will help you to identify which category a newly encountered typeface may belong to.

Humanist Serif

Typeface shown: Garamond Premier

The first roman typefaces following centuries of handwritten forms, Humanist serifs have close ties to calligraphy. An oblique stress, gradually modulating from thick to thin, shows evidence of a pen held at a consistent angle. That angle is often echoed in letters topped with calligraphic terminals and finished with asymmetrical serifs that gently transition from the stem.

Low to moderate contrast, angled stress

Calligraphic terminals

Organic serif with gradual bracket

Humanist letters were initially written with a broad-nib pen held at a consistent angle. The weight of each stroke is determined by the stroke's direction. This is known as "translation."

Transitional Serif

Typeface shown: Baskerville 10

As we move further away from type's calligraphic roots, contrast increases and the stress axis turns more upright and variable within each typeface rather than staying consistent as it does in the Humanist serifs. Letters in these typefaces are more regular in shape and proportion and apertures are slightly smaller. Transitional serifs still have a gradual, bracketed transition from the stem, and terminals are often bulbous.

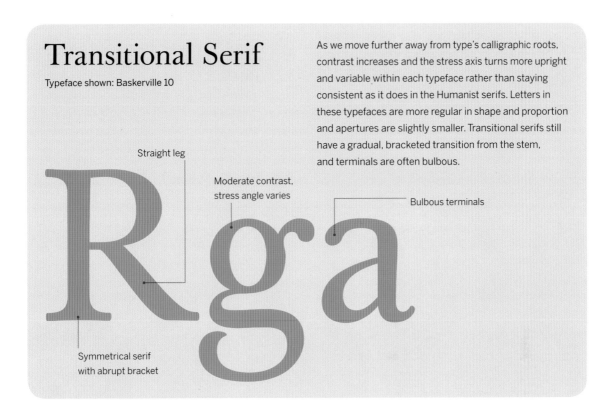

Straight leg

Moderate contrast, stress angle varies

Bulbous terminals

Symmetrical serif with abrupt bracket

Rational Serif

Typeface shown: H&FJ Didot

At the opposite end of the spectrum from the Humanists, Rational serifs have a strong, vertical contrast between thick vertical stems and fine horizontal hairlines. Because these typefaces are not so much written as "constructed," their letterforms are very even in proportion and structure. Serifs are generally symmetrical, and can be bracketed, like Melior and Miller, or thin and abrupt, like the "Didones" (Bodoni and Didot).

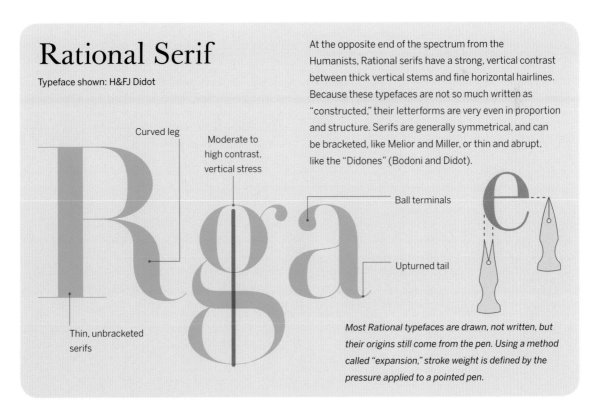

Curved leg

Moderate to high contrast, vertical stress

Ball terminals

Upturned tail

Thin, unbracketed serifs

Most Rational typefaces are drawn, not written, but their origins still come from the pen. Using a method called "expansion," stroke weight is defined by the pressure applied to a pointed pen.

Contemporary Serif

Typeface shown: Neue Swift

In the last 40 years, type designers have borrowed the most pragmatic aspects of the previous styles to develop a new breed of highly functional Text faces, designed to solve the problems of various substrates and reading environments. These designs generally sport a much larger x-height and lower stroke contrast than traditional serif typefaces, but are otherwise not directly related. They range from the spatially economical Swift to the informal and energetic Doko.

Rga

Simplified details

Large apertures
and counters

Heavy wedge serifs

Inscribed/Engraved

Typeface shown: Albertus

Unlike the other serif styles, derived from the stroke of a pen or brush, the typefaces in this category have a closer relationship to letters that are carved or chiseled from stone (also known as "Glyphic"), or engraved on a hard surface like copper or steel. These typefaces can end their "strokes" with long, graceful serifs (Trajan), sharp wedge serifs (Modesto), or no serif at all, but a thickening flare instead (Albertus).

Rga

Shapes
are chiseled

Flared strokes

Grotesque Sans

Typeface shown: Bureau Grot

When sans serif printing type first appeared in the early to mid-1800s, some found the style so strange they called it "grotesque." These typefaces kept the nickname even after they gained popularity and Grotesque (or "Grotesk" in German-speakers) is now associated with any sans serif in this early style. The characteristics of Grotesque typefaces are similar to those of the Transitional and Rational serifs: regular proportions, relatively static forms based on the oval, and fairly closed apertures, with some strokes turning inward.

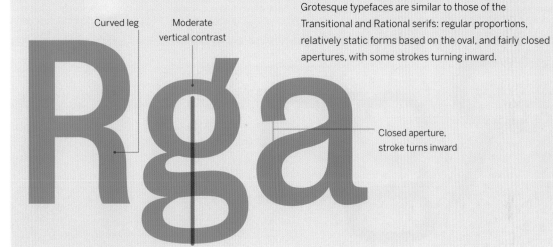

Curved leg

Moderate vertical contrast

Closed aperture, stroke turns inward

Neo-Grotesque Sans

Typeface shown: Neue Helvetica

Neo-Grotesques (*Neo-Grotesk* in German-speaking parts of Europe) are even more rationalized extensions of the Grotesque style. These typefaces, pioneered by Helvetica and Univers, have very little stroke contrast, horizontal terminals, and quite closed apertures. Their homogenized forms are graphically appealing at large sizes, so they often fare better in Display settings.

Very wide "R" is a product of normalized letter widths

Horizontal terminals

Gothic Sans

Typeface shown: News Gothic

Some English and American variants of the Grotesque style are known as Gothics. While the differences are sometimes in name alone, there are a few distinctions that can be drawn (at least from the selections in this book). These include a large x-height, forms that are simpler and more static, very low contrast, and often a condensed width with an upright stance derived from flat-sided rounds. Typefaces like DIN—designed by engineers for industrial use—could be considered Geometric sans serifs but also share many traits with these Gothics.

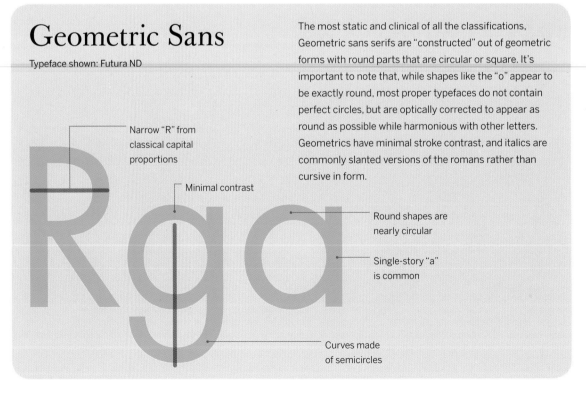

Straight leg

Minimal contrast, vertical stress

Simple double-story "a" with diagonally orientated bowl and no tail

"g" is commonly a binocular form

Geometric Sans

Typeface shown: Futura ND

The most static and clinical of all the classifications, Geometric sans serifs are "constructed" out of geometric forms with round parts that are circular or square. It's important to note that, while shapes like the "o" appear to be exactly round, most proper typefaces do not contain perfect circles, but are optically corrected to appear as round as possible while harmonious with other letters. Geometrics have minimal stroke contrast, and italics are commonly slanted versions of the romans rather than cursive in form.

Narrow "R" from classical capital proportions

Minimal contrast

Round shapes are nearly circular

Single-story "a" is common

Curves made of semicircles

Humanist Sans

Typeface shown: Cronos

Like their serif counterparts, Humanist sans serifs have roots in calligraphy. Their round, dynamic, open forms have higher stroke contrast than the other sans serif classifications (though not as much as most serifs). These typefaces sometimes share the binocular "g" and variable letter widths of their serif sisters. Their italics are "true italics" with cursive forms of "a," "g," "e," and sometimes a descending "f."

Calligraphic strokes and forms

Low to moderate contrast

Open apertures

Rga

Neo-Humanist Sans

Typeface shown: FF Meta

The digital era gave birth to new sans serifs that share characteristics with other classifications but are individual enough to deserve a label of their own. Many of these have a dynamic structure that could be considered an evolution of the Humanist sans, but stroke contrast is reduced and apertures are even more open. The round shapes of typefaces in this category tend to be more square than their predecessors and x-heights are larger on the whole.

Humanist structure

Minimal stroke contrast

Very open apertures

Rga

Grotesque Slab

Typeface shown: Clarendon

If one were to weigh the typical example of each classification, these bulky beasts would tip the scale furthest. They aren't simply Grotesque sans serifs with slab serifs slapped on, but these typefaces do reflect the proportions, structure, and stroke contrast of their serifless counterparts. Ball terminals are common among Grotesque slabs, as are heavy bracketed serifs and closed apertures. The effect of these attention grabbers can be decorative and eye-catching, and usually very bold.

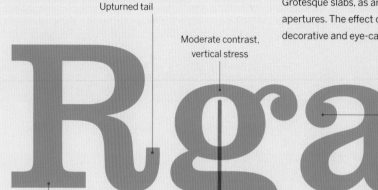

Upturned tail

Moderate contrast, vertical stress

Ball terminals

Bracketed serifs

Geometric Slab

Typeface shown: Neutraface Slab

These slab serifs share the geometrically round or square shapes of their sans counterparts. Rectangular serifs are unbracketed and generally the same weight as the stems. In fact, all strokes are essentially of the same weight, lacking any perceptible contrast. The "R" leg is a straight diagonal and "g" is normally of the monocular form.

Round shapes are circular

Minimal contrast, only visible at junctions

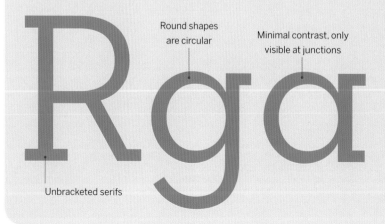

Unbracketed serifs

Humanist Slab

Typeface shown: PMN Caecilia

Put simply, you could take a Humanist sans serif and add unbracketed, rectangular serifs and get pretty close to a Humanist slab. These typefaces often have less stroke contrast than their sans counterparts, and the serifs are sometimes wedge shaped.

Curved leg

Minimal contrast

Rga

Unbracketed serifs

Script

Typeface shown: Tangier

Traditionally, a script typeface emulates handwriting, whether its letters are a graceful, connected cursive or the staccato scribbles of a daily shopping list. Besides formal and informal categories, scripts can also be sorted by the writing tool, such as pen or brush. Script fonts have become increasingly sophisticated in recent years thanks to technical developments like OpenType. Discretionary ligatures and contextual alternatives yield a more convincing emulation of real handwriting and offer a variety of decorative options.

Rga

Most scripts are slanted. Slant can vary throughout the typeface. Formal scripts usually have a consistent angle.

XXXXX

Background typefaces are Cala and Garamond Premiere

Humanist Serif

Adobe Jenson

Designer: (Nicolas Jenson, Ludovico degli Arrighi) Robert Slimbach // **Foundry:** Adobe
Country of origin: (Italy) United States // **Release years:** (1470) 1995–2000 // **Classification:** Venetian Humanist Serif

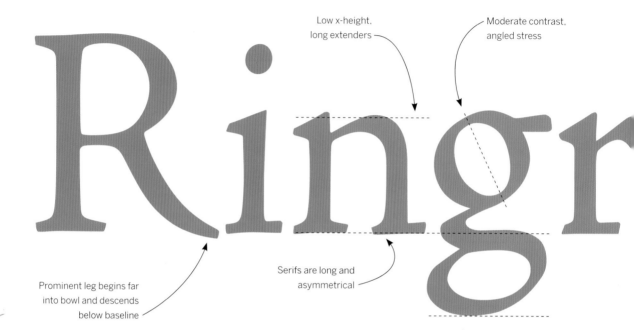

Low x-height, long extenders

Moderate contrast, angled stress

Prominent leg begins far into bowl and descends below baseline

Serifs are long and asymmetrical

Adobe Jenson Caption

Adobe Jenson Display

ABCDEFGHIJKLMNOPQRSTUVWXYZ

abcdefghijklmnopqrstuvwxyz ctſhfiſt 1234567890 369

¼ ⅔ ⅝ [àóüßç](.,:;?!$£&-*){ÀÓÜÇ}

Adobe Jenson Regular

Bar extends beyond round stroke, creating a "beak" or "spur"

aziare

Small counter, large aperture, and long tail

Stems are not purely straight lines, but have a subtle bowing and lean slightly to the right

Bar of "e" has strong angle and fairly small eye

Made in the Renaissance period, Nicolas Jenson's typeface is one of the very first with roman letter-shapes. It is called a Venetian serif, distinguished from other Humanist serifs by its obviously calligraphic construction and its angled, beaked "e." There are many interpretations of Jenson's work, but Adobe's is one of the most visually appealing and functional. It has four complete subfamilies (called "optical sizes") to emulate the size-specific designs of the original metal type. Among these, Caption is dark with sturdy serifs and low stroke contrast for small text, whereas Display is light and delicate, with fine details and long extenders for lovely titles. **Good for:** Any text, short or long, that calls for a rich, flowery perfume.

Compare to:

Rae

Cala

Rae

Centaur

Rae

Bembo Book

Cala

Designer: Dieter Hofrichter // **Foundry:** Hoftype // **Country of origin:** Germany // **Release year:** 2011
Classification: Venetian Humanist Serif

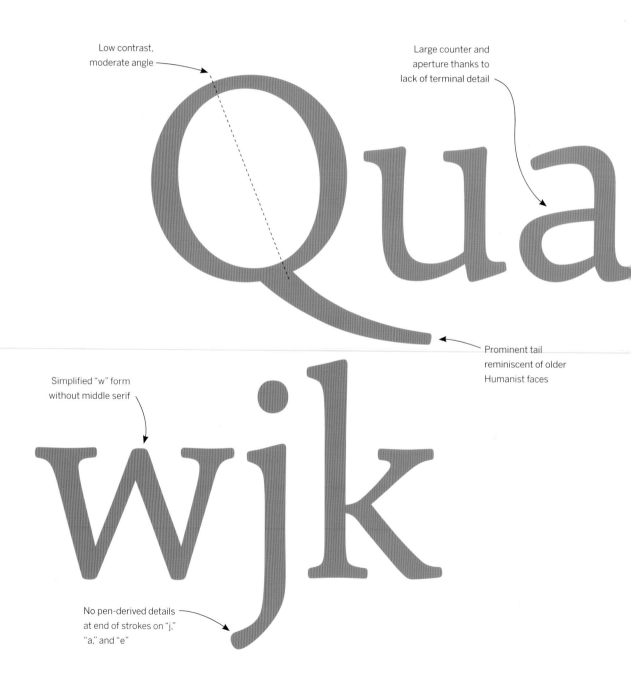

Low contrast, moderate angle

Large counter and aperture thanks to lack of terminal detail

Prominent tail reminiscent of older Humanist faces

Simplified "w" form without middle serif

No pen-derived details at end of strokes on "j," "a," and "e"

ABCDEFGHIJKLMNOPQRSTUVWXYZ

abcdefghijklmnopqrstuvwxyz ctſpſt 1234567890

¼ ⅔ ⅝ [àóüßç](.,:;?!$£&-*){ÀÓÜÇ}

Cala Regular

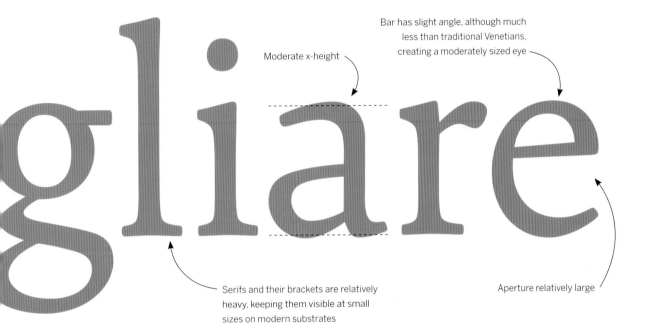

Moderate x-height

Bar has slight angle, although much less than traditional Venetians, creating a moderately sized eye

Serifs and their brackets are relatively heavy, keeping them visible at small sizes on modern substrates

Aperture relatively large

Cala is a contemporary Venetian. Dieter Hofrichter retained the unique characteristics of the Renaissance serif—the tilting "e," the calligraphic strokes with soft ends and blunt serifs—but stripped out the more decorative details. Its proportions are more modern as well, with a slightly larger x-height and cap widths that are more in tune with today's readers (compare to Jenson's "E," "H," and "Z"). While **Adobe Jenson** calls direct attention to its antique roots, Cala just nods to them. *Good for:* Subject matter with one foot in the past and one in the present. Websites with a historical focus.

Compare to:

Qaejkw

Adobe Jenson

Qaejkw

Bembo Book

Bembo Book

Designer: (Aldus Manutius, Francesco Griffo) Monotype staff // **Foundry:** Monotype
Country of origin: (Italy) United Kingdom // **Release year:** (1495) 2005 // **Classification:** Venetian Humanist Serif

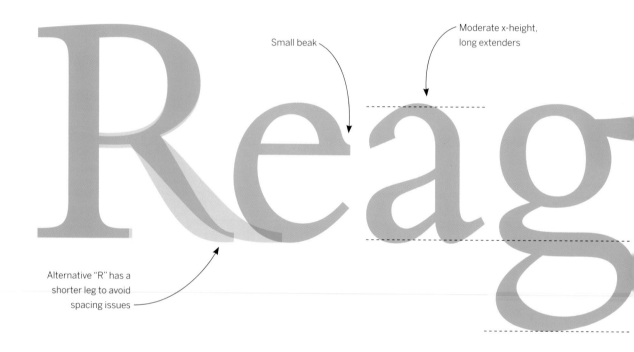

Small beak

Moderate x-height, long extenders

Alternative "R" has a shorter leg to avoid spacing issues

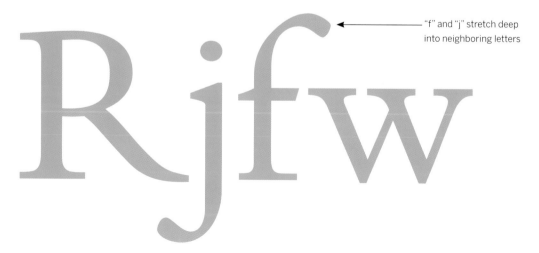

"f" and "j" stretch deep into neighboring letters

ABCDEFGHIJKLMNOPQRSTUVWXYZ

abcdefghijklmnopqrstuvwxyz ctst 1234567890 163

¼ ⅔ ⅝ [àóüßç](.,:;?!$£&-★){ÀÓÜÇ}

Bembo Book MT Regular

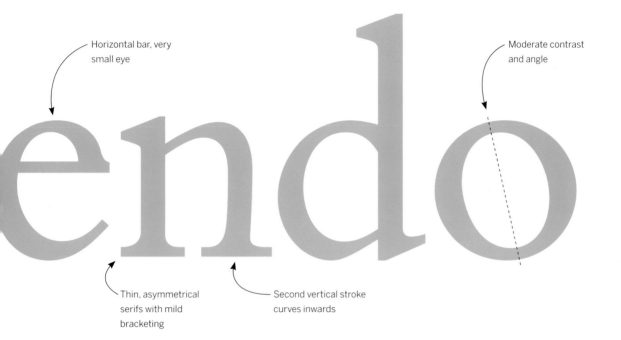

Horizontal bar, very small eye

Moderate contrast and angle

Thin, asymmetrical serifs with mild bracketing

Second vertical stroke curves inwards

Compare to:

Bembo is the most popular of the Renaissance serifs, frequently called upon for setting elegant book text ever since it was cut by Monotype in 1929. The digital version, however, is a feeble shadow of the metal type. Like so many of the revivals that appeared in desktop publishing's early years, Bembo is far too delicate for modern printing, and certainly for the screen. Monotype went back to the digital drawing board for **Bembo Book**, which retains the proper weight of the original. It also offers a very welcome alternative "R" with a leg that doesn't stretch so far, thereby not creating gaps or tripping its neighbors. ***Good for:*** Long text on good, soft paper. Historical novels.

Raejfw

Bembo

Raejfw

Centaur

FF Clifford

Designer: Akira Kobayashi // **Foundry:** FontFont // **Country of origin:** Japan, Germany // **Release year:** 1999
Classification: Humanist Serif, Dutch/English Transitional Serif

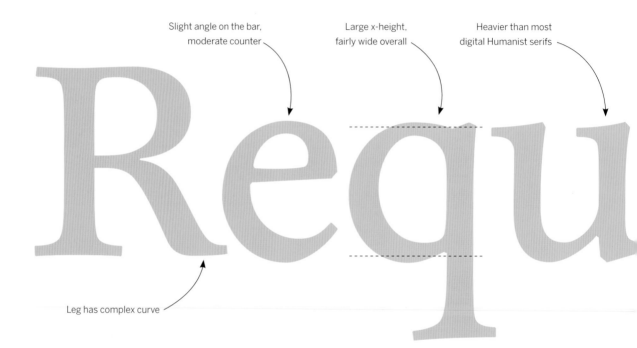

Slight angle on the bar, moderate counter

Large x-height, fairly wide overall

Heavier than most digital Humanist serifs

Leg has complex curve

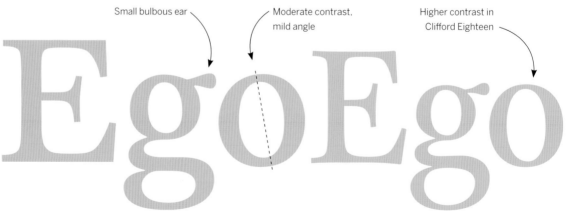

Small bulbous ear

Moderate contrast, mild angle

Higher contrast in Clifford Eighteen

FF Clifford Six Roman

FF Clifford Eighteen Roman

ABCDEFGHIJKLMNOPQRSTUVWXYZ
abcdefghijklmnopqrstuvwxyz ctfjftst 1234567890
[àóüßç](.,:;?!$£&-*){ÀÓÜÇ}

FF Clifford Nine Roman

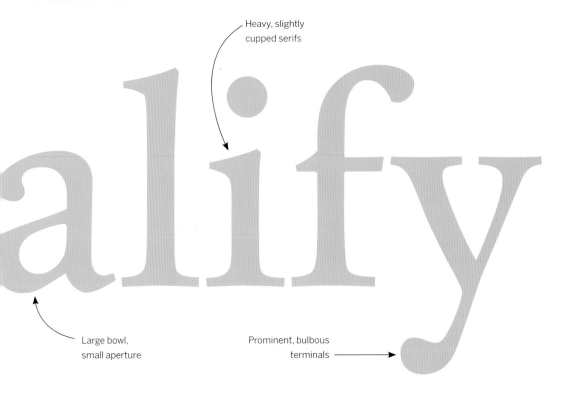

Heavy, slightly cupped serifs

Large bowl, small aperture

Prominent, bulbous terminals

Award-winning Japanese designer Akira Kobayashi was disappointed with the weak digital versions of classic metal typefaces so he sought to make his own. Although his inspiration was an 18th-century typeface by Scottish typefounder Alexander Wilson, **FF Clifford** is entirely his own design. Its dark color, bulbous terminals, and large lowercase make for a very pleasurable reading experience. There is also a distinctive hand-drawn quality to these letters—stems are slightly bowed, serifs are cupped, and there isn't a perfectly straight line to be found. FF Clifford comes in optical sizes (6, 9, and 18) with romans and italics, but no bold, emphasizing the intended purpose. ***Good for:*** Text about the natural world or stuff made by hand.

Compare to:

Ragesify

Original Baskerville 10

Ragesify

MVB Verdigris Text

FF Scala

Designer: Martin Majoor // **Foundry:** FontFont // **Country of origin:** The Netherlands // **Release year:** 1990
Classification: Dutch/French Humanist Serif

Large x-height, moderate extenders, narrow width

Simplified terminal, large counter and aperture

Pointed apex

Sharp points on link and lower bowl where stroke changes direction

Flat-topped bowl

ABCDEFGHIJKLMNOPQRSTUVWXYZ
abcdefghijklmnopqrstuvwxyz 1234567890
¼ ⅔ ⅝ [àóüßç](.,:;?!$£&-*){ÀÓÜÇ}

FF Scala Regular

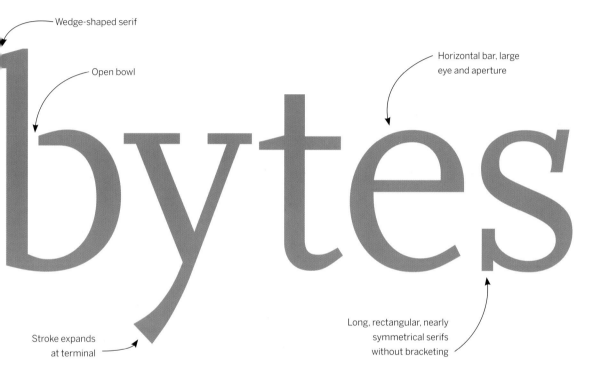

Wedge-shaped serif

Open bowl

Horizontal bar, large
eye and aperture

Stroke expands
at terminal

Long, rectangular, nearly
symmetrical serifs
without bracketing

While serif types like **FF Clifford** are warm and curvaceous, **FF Scala** is hard-edged and constructed. Released in 1990, but designed several years earlier, FF Scala is one of the first typefaces in this style to be designed specifically on and for the computer. Its shapes reflect that fact, with straight lines, rectangular, unbracketed serifs, and sharp points. These aspects are less stark at Text sizes, but the overall effect is a very fresh, modern feeling despite a calligraphic structure that is essentially hundreds of years old. The simplified contours make FF Scala an excellent screen typeface. It truly is an old-style serif for the digital world. ***Good for:*** Modern art exhibition catalogs and websites.

Compare to:

Mabges

Garamond Premier

Mabges

FF Clifford

Lexicon

Designer: Bram de Does // **Foundry:** Enschedé // **Country of origin:** The Netherlands // **Release year:** 1992
Classification: Dutch Humanist/Transitional Serif

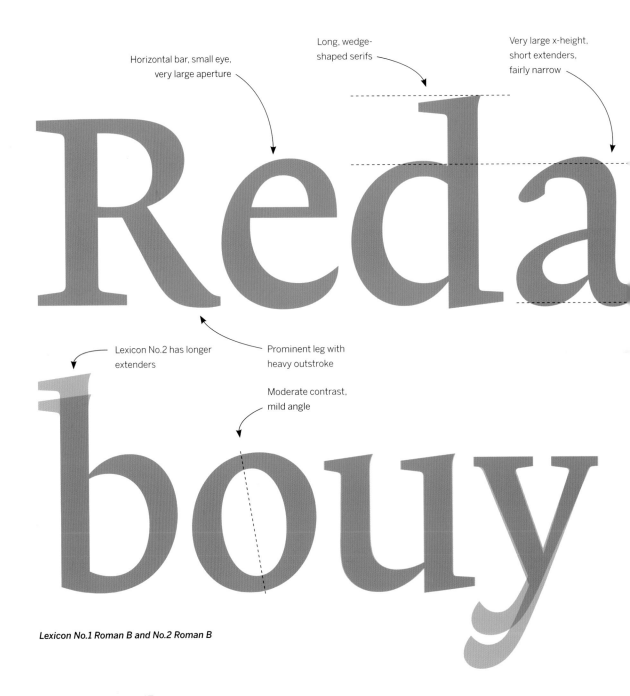

Horizontal bar, small eye,
very large aperture

Long, wedge-
shaped serifs

Very large x-height,
short extenders,
fairly narrow

Lexicon No.2 has longer
extenders

Prominent leg with
heavy outstroke

Moderate contrast,
mild angle

Lexicon No.1 Roman B and No.2 Roman B

ABCDEFGHIJKLMNOPQRSTUVWXYZ

abcdefghijklmnopqrstuvwxyz 1234567890

½ ¼ ¾ [àóüßç](.,:;?!$£&-*){ÀÓÜÇ}

Lexicon No.1 Roman B

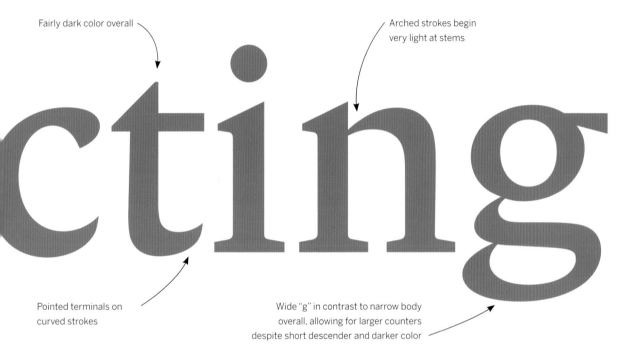

Fairly dark color overall

Arched strokes begin
very light at stems

Pointed terminals on
curved strokes

Wide "g" in contrast to narrow body
overall, allowing for larger counters
despite short descender and darker color

Lexicon was created specifically for dictionaries. As such, it is optimized for maximum readability in a minimum of space. It achieves this using methods that have become identified with Dutch type design: a calligraphic yet efficient construction, narrow width, and very light junctions where curved strokes meet stems, allowing ink to spread without affecting legibility. Despite these functional aspects, Lexicon has a graceful flow that is quite appealing at any size: No.1 has very short extenders, maximizing spatial economy; No.2 offers longer extenders when space isn't at such a premium. The two variants share the same width, so you can switch without text reflow. **Good for:** Dictionaries, Bibles, timetables, newspapers, and other dense text.

Compare to:

AREacegy

Garamond Premier

AREacegy

Le Monde Journal

Minion

Designer: Robert Slimbach // **Foundry:** Adobe // **Country of origin:** United States // **Release year:** 1990
Classification: Venetian/French Humanist Serif

No loud ornamentation,
details are quiet
and subtle

Moderate contrast,
mild angle

Groun

Narrow "g" with
large lower bowl

Modest serifs
with bracketing

jig jig

Minion Caption

Short, unostentatious tail

Minion Display

ABCDEFGHIJKLMNOPQRSTUVWXYZ

abcdefghijklmnopqrstuvwxyz ctsþst 1234567890 163

¼ ⅔ ⅝ [àóüßç](.,:;?!$£&-*){ÀÓÜÇ}

Minion Regular

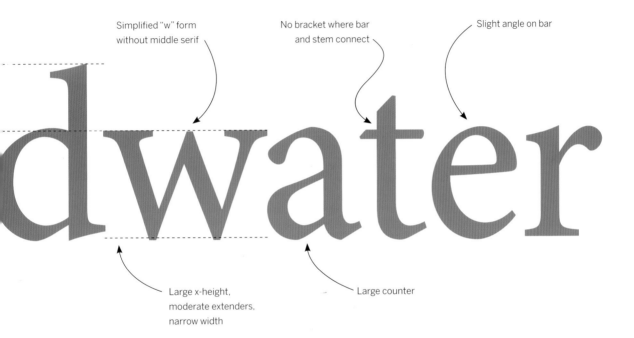

Simplified "w" form without middle serif

No bracket where bar and stem connect

Slight angle on bar

Large x-height, moderate extenders, narrow width

Large counter

Minion is perhaps the most vanilla of serif typefaces. This isn't necessarily a negative—often the goal of a text face is to make as little aesthetic impact as possible. Minion does just that. It can be your everyday hardworking, utilitarian serif. In many ways, Minion is a modernized Garamond or Bembo: the x-height is larger, counters and apertures are more open, serifs are chunkier, and superfluous details are reduced. These effects are maximized in the Caption version, meant for small sizes. For large type, Display is more like its historical models: delicate, with lengthened extenders and sharper serifs. *Good for:* When you really don't want anyone to notice the type.

Compare to:

agsejw

Garamond Premier

agsejw

Adobe Caslon

Garamond Premier

Designer: (Claude Garamond, Robert Granjon) Robert Slimbach // **Foundry:** Adobe
Country of origin: (France) United States // **Release year:** 2005 // **Classification:** French Humanist Serif

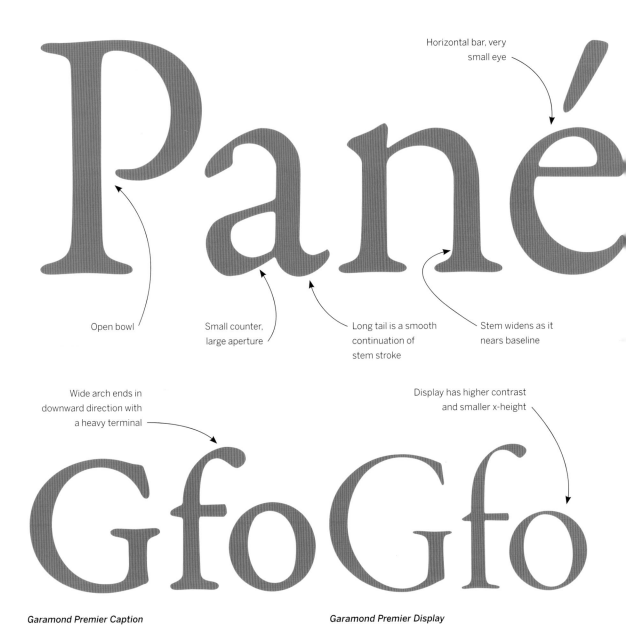

Horizontal bar, very small eye

Open bowl

Small counter, large aperture

Long tail is a smooth continuation of stem stroke

Stem widens as it nears baseline

Wide arch ends in downward direction with a heavy terminal

Display has higher contrast and smaller x-height

Garamond Premier Caption

Garamond Premier Display

ABCDEFGHIJKLMNOPQRSTUVWXYZ

abcdefghijklmnopqrstuvwxyz ctftsþst 1234567890 163

¼ ⅔ ⅝ [àéüßç](.,:;?!$£&-*){ÀÓÜÇ}

Garamond Premier Regular

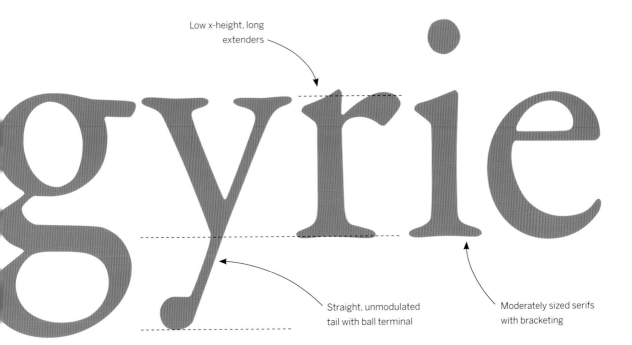

Low x-height, long extenders

Straight, unmodulated tail with ball terminal

Moderately sized serifs with bracketing

Refined and readable, Garamond is probably the most popular of the Humanist serifs. Longtime users of Adobe apps will be familiar with Robert Slimbach's first crack at this classic typeface, Adobe Garamond, but **Garamond Premier** is a major improvement. The most important difference is that Slimbach drew separate subfamilies (optical sizes) corresponding to different sizes of metal type. This lets Garamond's delicate beauty stretch out in headlines but not break apart when small. Despite a subdued character in Caption and Regular (Text) sizes, Garamond is never dull by any means. Use with care: it has a formal personality that might not fit more casual topics. ***Good for:*** Infusing a document with importance, reverence, or poetry.

Compare to:

GfgateP

FF Yoga

GfgateP

Adobe Caslon

MVB Verdigris

Designer: Mark van Bronkhorst // **Foundry:** MVB Fonts // **Country of origin:** United States
Release years: 2003, 2010, 2012 // **Classification:** French Humanist Serif

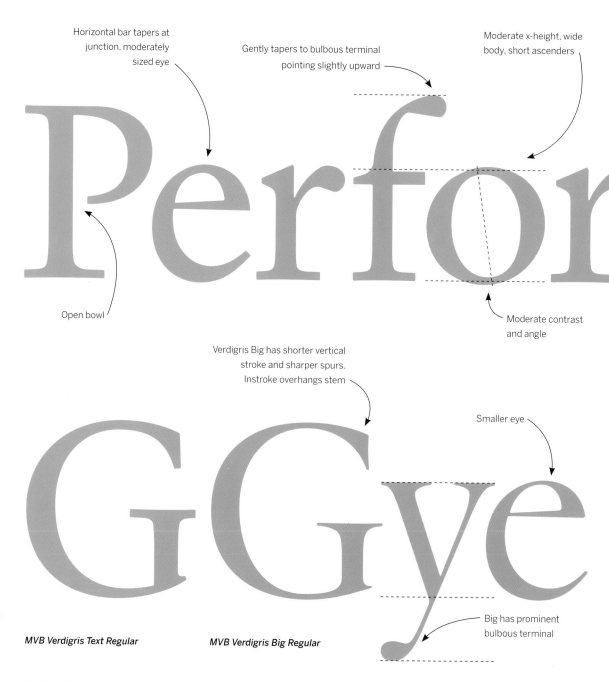

Horizontal bar tapers at junction, moderately sized eye

Gently tapers to bulbous terminal pointing slightly upward

Moderate x-height, wide body, short ascenders

Open bowl

Moderate contrast and angle

Verdigris Big has shorter vertical stroke and sharper spurs. Instroke overhangs stem

Smaller eye

Big has prominent bulbous terminal

MVB Verdigris Text Regular

MVB Verdigris Big Regular

ABCDEFGHIJKLMNOPQRSTUVWXYZ
abcdefghijklmnopqrstuvwxyz 1234567890
¼ ⅔ ⅝ [àóüßç](.,:;?!$£&-*)}ÀÓÜÇ}

MVB Verdigris Text Regular

Distinctive terminal and
lateral stroke angle

ating

Long, straight tail
leads into next letter

Long, nearly
symmetrical serifs
with mild bracketing

When type was metal or wood, every font was a specific size. The scalability of photo and digital type was a productivity boon, but much was lost in the process. Modern interpretations of classic metal typefaces were based on a single size and they often replicated the metal face itself, not the richness and weight of the type's impression on paper. The result was anemic and fragile. **MVB Verdigris** is a direct response to these shortcomings. A distinguished *Garalde* inspired by 16th-century punchcutters, MVB Verdigris comes in a sturdy, functional version for text and a handsome, high-contrast version for titling. Typographic niceties abound, including a set of useful "mid caps" sized between full and small caps. This is truly a text serif for the digital age.

Compare to:

GfgateP

Garamond Premier

GfgateP

Galliard

Background typefaces are Le Monde Journal and Baskerville Original

Transitional Serif

XX

Adobe Caslon

Designer: (William Caslon) Carol Twombly // **Foundry:** Adobe // **Country of origin:** (United Kingdom) United States
Release years: (1725) 1990–1992 // **Classification:** Transitional Serif

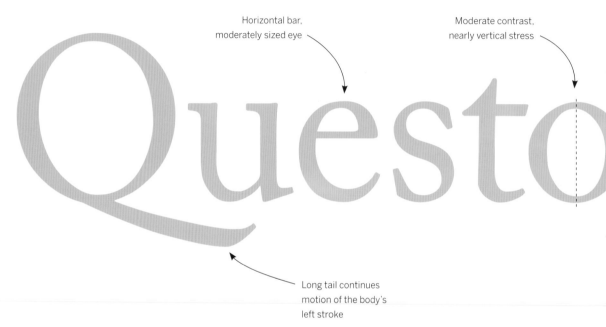

Horizontal bar,
moderately sized eye

Moderate contrast,
nearly vertical stress

Long tail continues
motion of the body's
left stroke

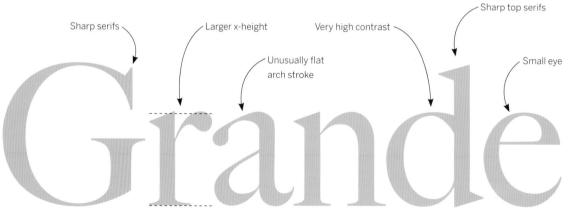

Sharp serifs

Larger x-height

Unusually flat
arch stroke

Very high contrast

Sharp top serifs

Small eye

Big Caslon

ABCDEFGHIJKLMNOPQRSTUVWXYZ
abcdefghijklmnopqrstuvwxyz ᶜᵗſt 1234567890 163
¼ ⅔ ⅝ [àóüßç](.,:;?!$£&-*){ÀÓÜÇ}

Adobe Caslon Regular

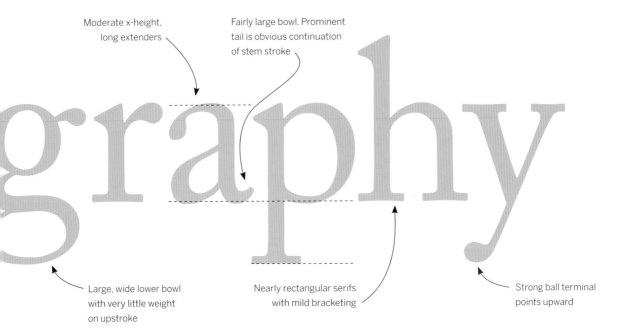

Moderate x-height, long extenders

Fairly large bowl. Prominent tail is obvious continuation of stem stroke

Large, wide lower bowl with very little weight on upstroke

Nearly rectangular serifs with mild bracketing

Strong ball terminal points upward

Ever since its release at the height of the DTP age, **Adobe Caslon** has been the "default" serif for many designers. In fact, the original metal type was also a printer's standby for many years, as evidenced by the expression "when in doubt, use Caslon." The typeface is now so familiar, it simply *feels right* most of the time—though it could seem slightly antique for some settings. Caslon is one of the first typefaces to show hints of a transition from pen-based shapes to constructed letterforms. Adobe's interpretation emphasizes those aspects for a fairly even texture overall, especially in the italic where the slant is very consistent. (Those wanting a darker, hand-cut option might like Font Bureau's Williams Caslon.) *Good for:* Nearly anything, though not intended for large sizes.

Compare to:

Qaeryg

MVB Verdigris

Qaeryg

Garamond Premier

Baskerville Original

Designer: (John Baskerville) František Štorm // **Foundry:** Storm // **Country of origin:** (United Kingdom) Czech Republic
Release year: (1750s–1760s) 2006 // **Classification:** Transitional Serif

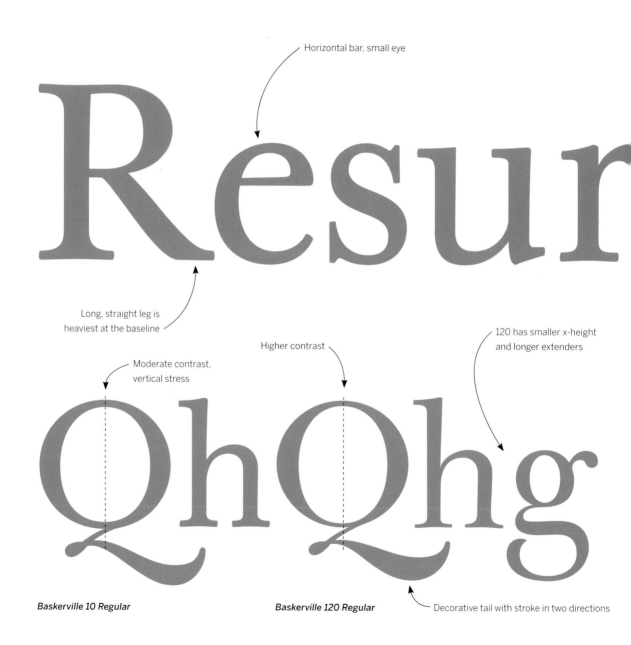

Horizontal bar, small eye

Long, straight leg is
heaviest at the baseline

120 has smaller x-height
and longer extenders

Moderate contrast,
vertical stress

Higher contrast

Decorative tail with stroke in two directions

Baskerville 10 Regular

Baskerville 120 Regular

ABCDEFGHIJKLMNOPQRSTUVWXYZ

abcdefghijklmnopqrstuvwxyz ctfüſpst 123456

7890 163 ¼ ⅔ ⅝ [àóüßç](.,:;?!$£&-*){ÀÓÜÇ}

Baskerville 10 Regular

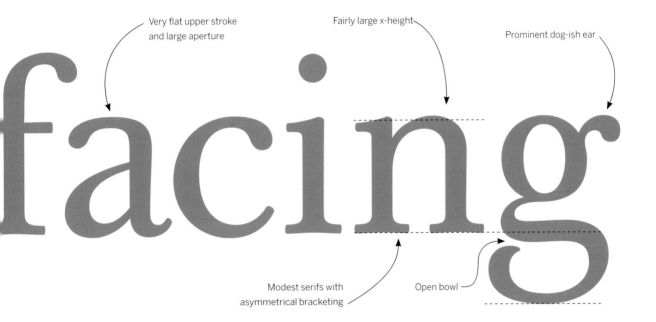

Very flat upper stroke
and large aperture

Fairly large x-height

Prominent dog-ish ear

Modest serifs with
asymmetrical bracketing

Open bowl

Baskerville is the quintessential Transitional serif, positioned neatly between the dynamic calligraphy of the Humanists and the static construction of the Rationalists. Like many of the old-style serifs, there are a few digital versions, but all fall woefully short of the original design by attempting to create a one-size-fits-all typeface from the variety of metal sizes. František Štorm's family is not only more functional, with large and small optical sizes, but also revives Baskerville's handsome, vigorous spirit. These rich curves feel crafted by hand, not computer. Dashing—maybe even exuberant—Baskerville has been known to steal the show, so be sure the content fits it (or doesn't mind playing second fiddle). *Good for:* Debonair swagger.

Compare to:

Rgeawfnc

Mrs Eaves

Rgeawfnc

Baskerville (BT)

Mrs Eaves

Designer: Zuzana Licko // **Foundry:** Emigre // **Country of origin:** United States
Release year: 1996 // **Classification:** Transitional Serif

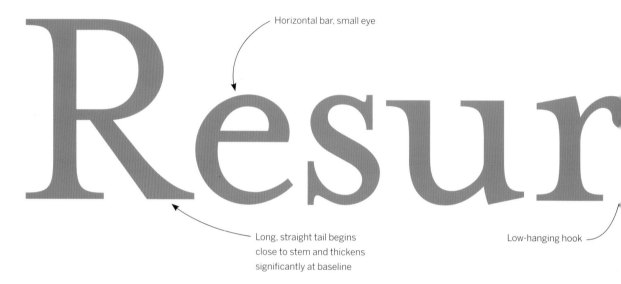

Horizontal bar, small eye

Long, straight tail begins
close to stem and thickens
significantly at baseline

Low-hanging hook

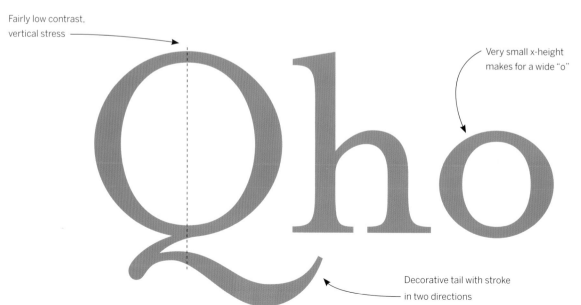

Fairly low contrast,
vertical stress

Very small x-height
makes for a wide "o"

Decorative tail with stroke
in two directions

ABCDEFGHIJKLMNOPQRSTUVWXYZ

abcdefghijklmnopqrstuvwxyz 1234567890

¼ ½ ¾ [àóüßç](.,:;?!$£&-*){ÀÓÜÇ}

Mrs Eaves Roman

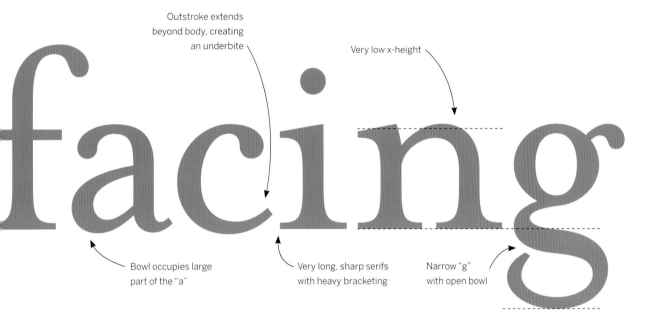

Outstroke extends
beyond body, creating
an underbite

Very low x-height

Bowl occupies large
part of the "a"

Very long, sharp serifs
with heavy bracketing

Narrow "g"
with open bowl

Zuzana Licko's reimagining of Baskerville is named after the housekeeper of John Baskerville who later became his wife. The typeface has a very low x-height and prominent serifs, which makes the lowercase appear quite squat, with a horizontal emphasis. There is also much less sparkling contrast than Baskerville. But otherwise **Mrs Eaves** is quite dainty and ladylike. The long ascenders and sharp details make it less of a daily workhorse and more of the fine china used only when hosting important guests. The place setting gets even more fancy when one incorporates the frilly lace of Mrs Eaves's ligatures, many of which go beyond the functional (a solution for colliding letters) to the flamboyant (pure decoration). *Good for:* Special occasions.

Compare to:

Rgeawfnc

Baskerville 10

Plantin

Designer: (Robert Granjon) Frank Hinman Pierpont // **Foundry:** Monotype // **Country of origin:** (The Netherlands) United Kingdom // **Release year:** (1700) 1914 // **Classification:** Transitional Serif

Slight curve in
diagonal strokes

Top stroke turns in
toward body

Stems have simple,
triangular serifs

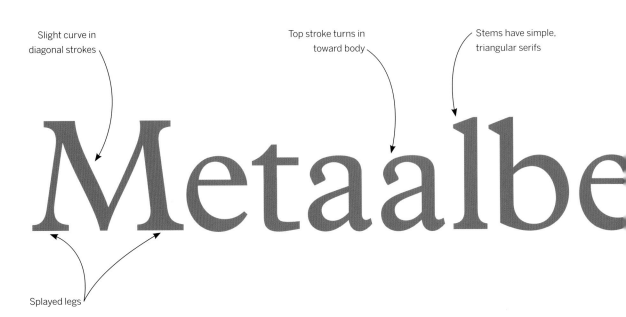

Splayed legs

Fairly low contrast,
vertical stress

Moderate contrast,
strong angle

Ligature

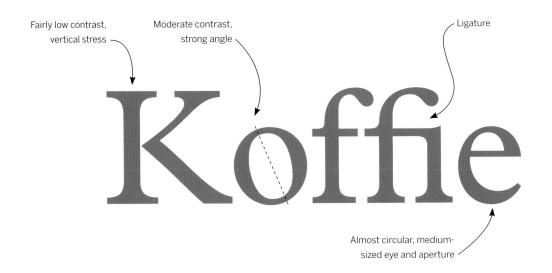

Almost circular, medium-
sized eye and aperture

ABCDEFGHIJKLMNOPQRSTUVWXYZ

abcdefghijklmnopqrstuvwxyz 1234567890

¼ ½ ¾ [àóüßç] (.,:;?!$£&-★) {ÀÓÜÇ}

Plantin Regular

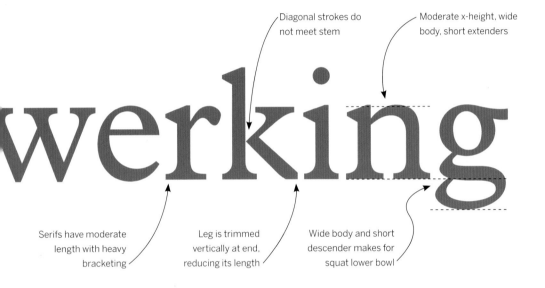

Diagonal strokes do
not meet stem

Moderate x-height, wide
body, short extenders

Serifs have moderate
length with heavy
bracketing

Leg is trimmed
vertically at end,
reducing its length

Wide body and short
descender makes for
squat lower bowl

There are many vestiges of the Humanist pen in **Plantin**, particularly in the terminal of its quaint "a" or the consistently triangular serifs atop stems. But there are elements that don't fit those early types: the stunted extenders, the chunky serifs, and the large counters of the "a" and "e." These contradictions come from a blend of two eras: 16th-century samples from Granjon reshaped to meet the early 20th-century needs of a darker, sturdier face for modern paper. The shortened proportions made Plantin a good newspaper typeface, and a condensed version, News Plantin, was developed for the *Observer* in London. It was also a model for **Times New Roman**. *Good for:* Serious, expedient content, delivered with authority and a bit of charm.

Compare to:

GaetoPg

Times New Roman

GaetoPg

Arnhem

Arnhem

Designer: Fred Smeijers // **Foundry:** OurType // **Country of origin:** The Netherlands
Release year: 2001 // **Classification:** Transitional Serif

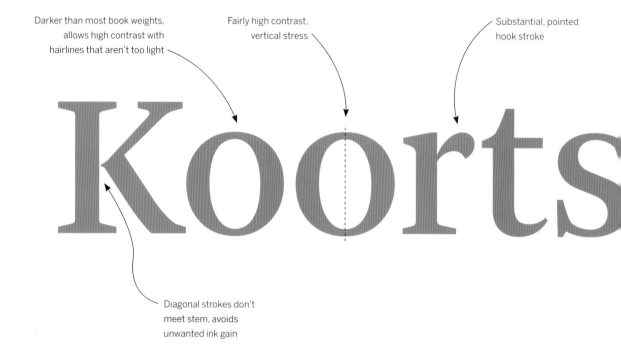

Darker than most book weights, allows high contrast with hairlines that aren't too light

Fairly high contrast, vertical stress

Substantial, pointed hook stroke

Diagonal strokes don't meet stem, avoids unwanted ink gain

Large bowl, low waist

Descending "J" with ball terminal

ABCDEFGHIJKLMNOPQRSTUVWXYZ
abcdefghijklmnopqrstuvwxyz tttf 1234567890 163
¼ ⅔ ⅝ [àóüßç](.,:;?!$£&-*){ÀÓÜÇ}

Arnhem Normal

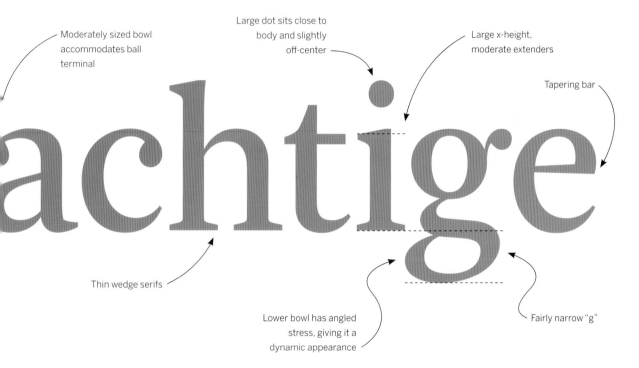

Moderately sized bowl accommodates ball terminal

Large dot sits close to body and slightly off-center

Large x-height, moderate extenders

Tapering bar

Thin wedge serifs

Lower bowl has angled stress, giving it a dynamic appearance

Fairly narrow "g"

Borrowing what Dutch type design has learned from centuries of letterform experimentation, Fred Smeijers has achieved a perfect balance of function and beauty. In fact, it's a great example of how beauty comes from function. **Arnhem** was created for a newspaper, but unlike most news faces it is lively and attractive. This is due mostly to its higher contrast (in all the right places) and its ball terminals and pointed serifs. These "pretty" details all have a purpose: compensating for ink spread on newsprint and giving text a substantial, but not clunky, weight. Arnhem also sports an unusually large x-height for a serif, which enables not only dense text, but also a more harmonious fit with most sans serifs. *Good for:* Magazines. Forward-thinking newspapers.

Compare to:

agecrk

Lexicon

agecrk

Times New Roman

Times New Roman

Designer: Stanley Morison, Victor Lardent, or (disputed) Starling Burgess // **Foundry:** Monotype

Country of origin: United Kingdom // **Release year:** 1932 // **Classification:** Transitional Serif

High contrast, strong angle, especially on "e"

Fairly large x-height and extenders, narrow body

Medium-sized counter, small aperture (nearly closes on itself)

Straight leg extends beyond bowl

Very small aperture

Very wide caps

ABCDEFGHIJKLMNOPQRSTUVWXYZ

abcdefghijklmnopqrstuvwxyz 1234567890

¼ ½ ¾ [àóüßç](.,:;?!$£&-*){ÀÓÜÇ}

Times New Roman

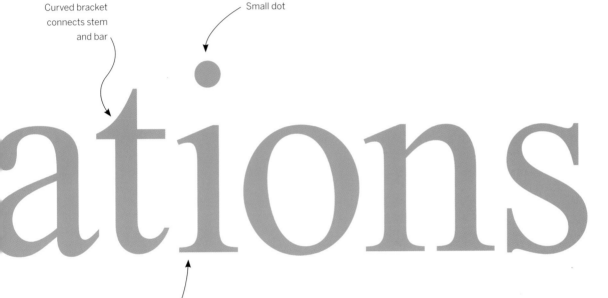

Curved bracket connects stem and bar

Small dot

Long, sharp serifs with curved brackets

Compare to:

Times New Roman is one of today's most familiar and often-used typefaces. It owes its ubiquity to being standard issue in digital publishing systems for many years, but the design's original intended destination was newsprint, not laser paper. Created for *The Times* of London, it is derived from Plantin, but is decidedly more modern, with high contrast and thin serifs. Those details, and peculiarities like its relatively wide and heavy caps, make it less suitable for everyday typesetting—which is ironic, given its status. On modern substrates, Times is actually better in Display settings than Text, where Times Ten fares better. Fresher alternatives are Starling (Font Bureau, 2009) and **Le Monde Journal**. *Good for:* A non-designed, conventional office-document look.

Raego

Le Monde Journal

Raego

Plantin

Raego

Arhnem

Le Monde Journal

Designer: Jean François Porchez // **Foundry:** Porchez Typofonderie // **Country of origin:** France
Release years: 1997–2008 // **Classification:** Transitional Serif

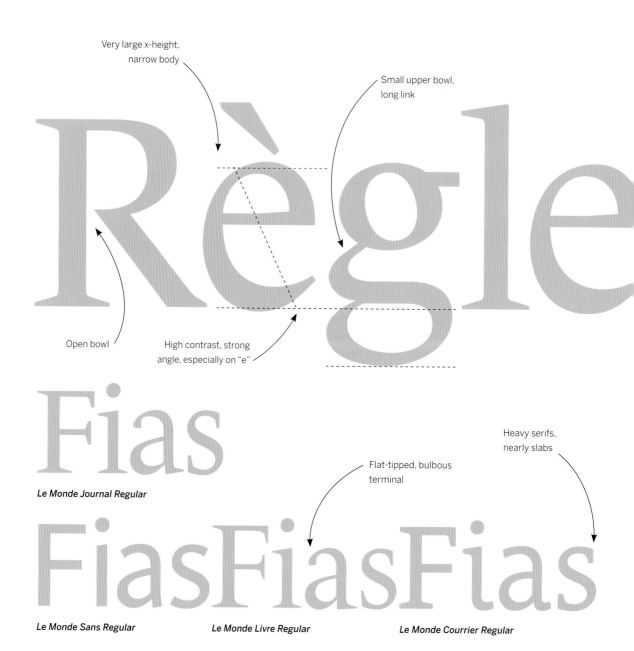

Very large x-height, narrow body

Small upper bowl, long link

Open bowl

High contrast, strong angle, especially on "e"

Le Monde Journal Regular

Heavy serifs, nearly slabs

Flat-tipped, bulbous terminal

Le Monde Sans Regular

Le Monde Livre Regular

Le Monde Courrier Regular

ABCDEFGHIJKLMNOPQRSTUVWXYZ
abcdefghijklmnopqrstuvwxyz Th ct st 1234567890
163 ¼ ½ ¾ [àóüßç](.,:;?!$£&-*){ÀÓÜÇ}

Le Monde Journal Regular

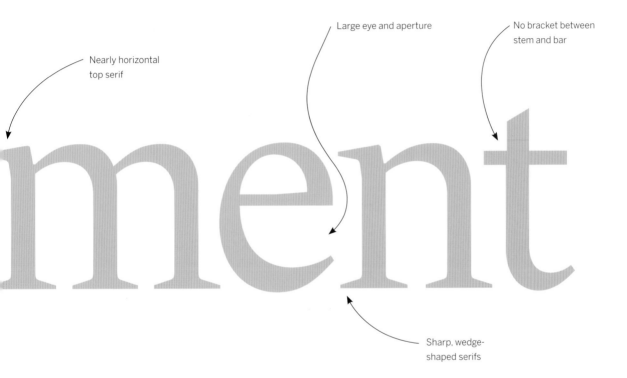

Nearly horizontal top serif

Large eye and aperture

No bracket between stem and bar

Sharp, wedge-shaped serifs

Jean François Porchez's commission for the *Le Monde* newspaper is a perfect example of learning from and improving on historical type. **Le Monde Journal** is a **Times New Roman** for the 21st century. Counters and apertures are much more open ("illuminated from the inside," as Porchez puts it); minimal wedges replace curved brackets; and the x-height is even larger. The overall effect is the color and flavor of a typeface readers are used to seeing in newsprint, but with better readability and a more contemporary feel. There are a broad range of extra weights designed to respond to subtle variations in substrates, plus a superfamily of companions: Sans, Courier (slab), and Livre (larger text and titling). ***Good for:*** Small or space-saving text. Publication design.

Compare to:

Raego

Times New Roman

Raego

Arnhem

Background typefaces are Miller and H&FJ Didot

Rational Serif

XXXXX

Bauer Bodoni

Designer: (Giambattista Bodoni) Heinrich Jost // **Foundry:** Bauer Type Foundry, Neufville, Bitstream
Country of origin: (Italy) Germany // **Release year:** (1790) 1926 // **Classification:** Didone Serif

Large eye, small aperture

Moderate x-height, long extenders, slightly narrow body

Ball terminals of varying size on "a" and "g"

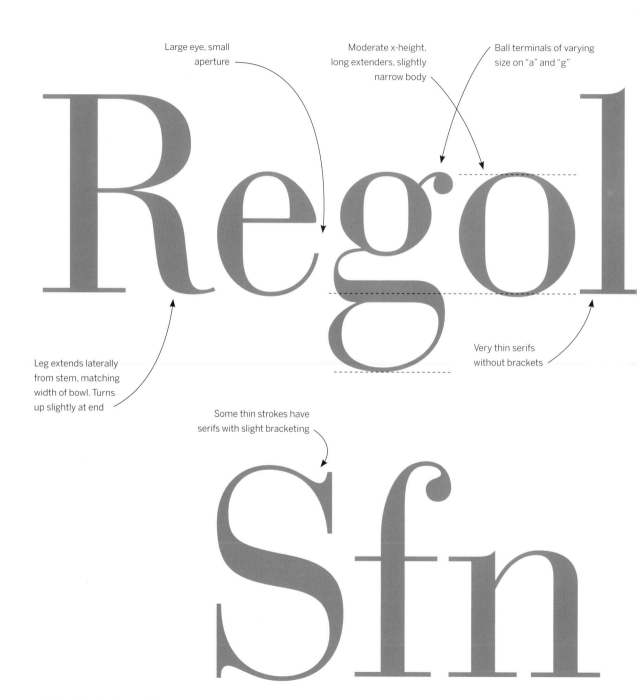

Leg extends laterally from stem, matching width of bowl. Turns up slightly at end

Very thin serifs without brackets

Some thin strokes have serifs with slight bracketing

ABCDEFGHIJKLMNOPQRSTUVWXYZ
abcdefghijklmnopqrstuvwxyz 1234567890
¼ ½ ¾ [àóüßç](.,:;?!$£&-*){ÀÓÜÇ}

Bauer Bodoni Roman

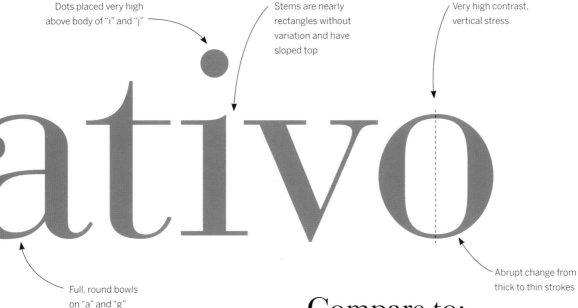

Dots placed very high above body of "i" and "j"

Stems are nearly rectangles without variation and have sloped top

Very high contrast, vertical stress

Abrupt change from thick to thin strokes

Full, round bowls on "a" and "g"

Bodoni is the most typical Rational serif, and **Bauer Bodoni** is perhaps the most typical Bodoni. It has everything we associate with the style: heavy strokes that abruptly reduce to hairlines, long, thin serifs, and distinct ball terminals on the "a," "c," "f," "g," "r," and "y." It appears constructed, rather than written, with only a few letters—such as the leg of the "R" or the tail of the "Q"—directly referencing the stroke of a pen. This font's use is limited, though. It will fall apart if set small or reversed (light type on dark backgrounds). So, this Bodoni is best used simply, letting its delicate details play their part on a large, uncomplicated stage.
Good for: Elegant headlines. Fancy packaging.

Compare to:

Rfaegso
Bodoni ITC Six

Rfaegso
HTF Didot M96

Rfaegso
Filosofia

ITC Bodoni

Designer: (Giambattista Bodoni) Janice Fishman, Holly Goldsmith, Jim Parkinson, Sumner Stone // **Foundry:** ITC
Country of origin: (Italy) United States // **Release year:** (1790) 1994 // **Classification:** Didone Serif

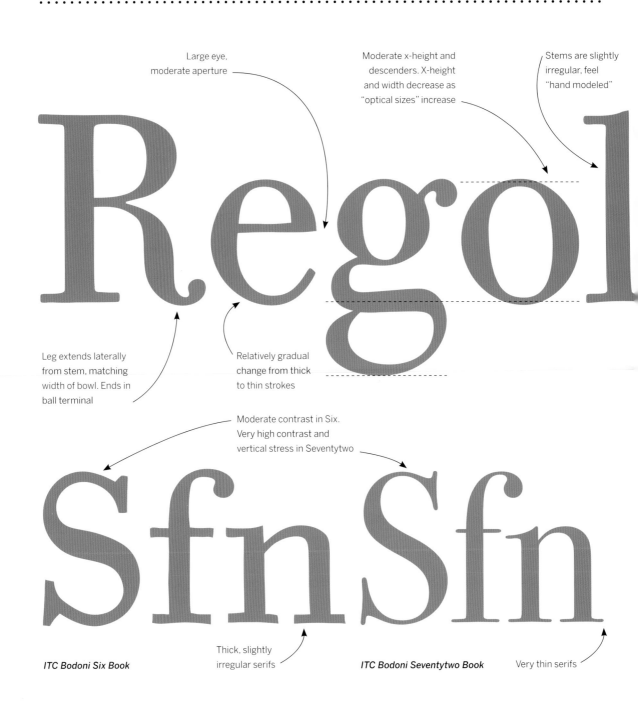

Large eye, moderate aperture

Moderate x-height and descenders. X-height and width decrease as "optical sizes" increase

Stems are slightly irregular, feel "hand modeled"

Leg extends laterally from stem, matching width of bowl. Ends in ball terminal

Relatively gradual change from thick to thin strokes

Moderate contrast in Six. Very high contrast and vertical stress in Seventytwo

ITC Bodoni Six Book

Thick, slightly irregular serifs

ITC Bodoni Seventytwo Book

Very thin serifs

ABCDEFGHIJKLMNOPQRSTUVWXYZ
abcdefghijklmnopqrstuvwxyz 1234567890
¼ ½ ¾ [àóüßç](.,:;?!$£&-*){ÀÓÜÇ}

ITC Bodoni Twelve Book

Ball terminals of "g"and
"a" are similar size

High contrast, very slight
angle

ativo

Slightly cupped serifs
of moderate weight

Compare to:

Rfaegso

Bauer Bodoni

Rfaegso

HTF Didot M96

Rfaegso

Filosofia

Of the many attempts to capture Giambattista Bodoni's classic type, **ITC Bodoni** is the most accurate and versatile. What sets it apart from other digitizations is the close reproduction of three different sizes of metal type. A team of four type designers produced a true revival, reflecting the subtleties of Bodoni—from the rough, hand-cut contours in the Six size (for small text) to the exuberant italic swashes in Seventytwo (for display). With its reduced contrast in the text weights, **ITC Bodoni** is a Bodoni you can set small without fear of disappearing hairlines. It has a warmth and hand-crafted feeling that is absent from most Bodoni interpretations, and is thus a very different face overall. *Good for:* When other Didones would dissolve.

H&FJ Didot

Designer: (Firmin Didot) Jonathan Hoefler // **Foundry:** Hoefler & Frere-Jones // **Country of origin:** (France) United States
Release year: (1784–1811) 1991 as HTF Didot // **Classification:** Didone Serif

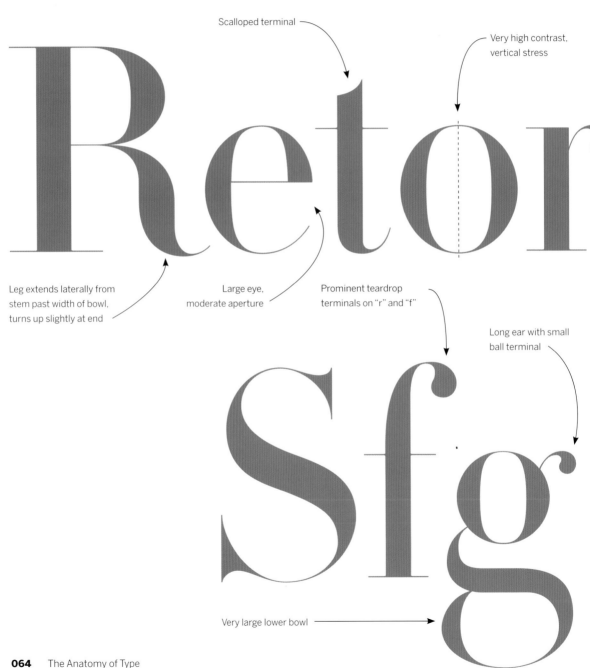

Scalloped terminal

Very high contrast, vertical stress

Leg extends laterally from stem past width of bowl, turns up slightly at end

Large eye, moderate aperture

Prominent teardrop terminals on "r" and "f"

Long ear with small ball terminal

Very large lower bowl

ABCDEFGHIJKLMNOPQRSTUVWXYZ

abcdefghijklmnopqrstuvwxyz 1234567890

|àóüßç|(.,:;?!$£&-*){ÀÓÜÇ}

HTF Didot M96 Medium

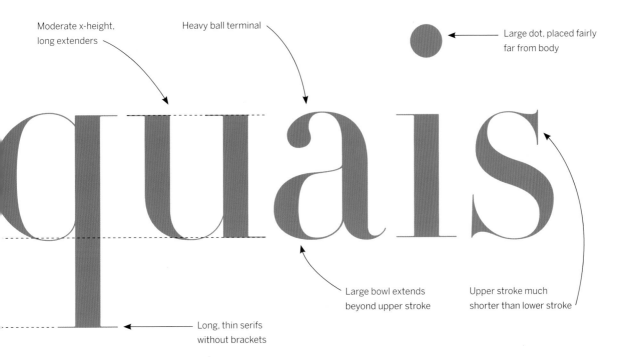

Moderate x-height, long extenders

Heavy ball terminal

Large dot, placed fairly far from body

Large bowl extends beyond upper stroke

Upper stroke much shorter than lower stroke

Long, thin serifs without brackets

Of the two progenitors of the Rationalist approach—Bodoni and Didot—Didot is the more extreme. This is the furthest traditional serif type gets from calligraphic form. While most digital versions of typefaces represent just one optical size, limiting their use, **H&FJ Didot** offers seven. This is the result of a *Harper's Bazaar* commission for a new version of the face that had long been a signature of the magazine. The redesign team asked Hoefler for a family that maintained its hairline serifs over a range of sizes. Hoefler delivered seven optical sizes, each with three weights and corresponding italics. With this arsenal one can set H&FJ Didot at 6 or 96 point and it still looks like Didot. **Good for:** Fashion, wine, the expensive and romantic.

Compare to:

Rfaegso

Bodoni ITC Six

Rfaegso

Bauer Bodoni

Filosofia

Designer: Zuzana Licko // **Foundry:** Emigre // **Country of origin:** United States
Release year: 1996 // **Classification:** Didone Serif

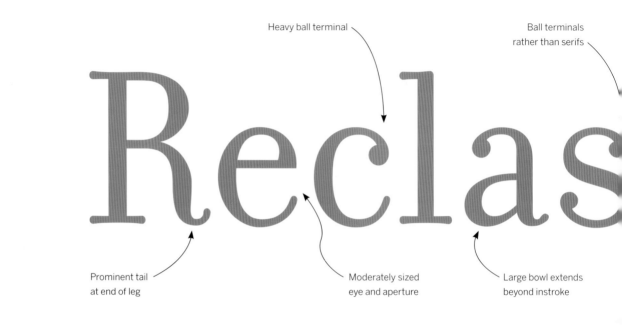

Heavy ball terminal

Ball terminals rather than serifs

Prominent tail at end of leg

Moderately sized eye and aperture

Large bowl extends beyond instroke

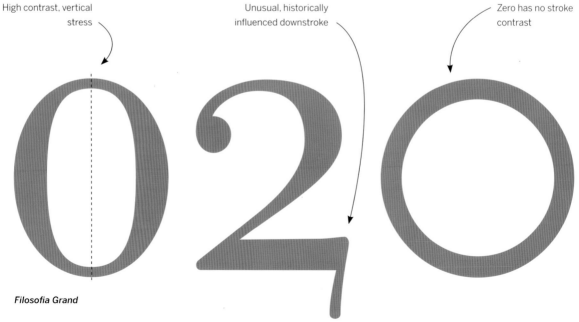

High contrast, vertical stress

Unusual, historically influenced downstroke

Zero has no stroke contrast

Filosofia Grand

ABCDEFGHIJKLMNOPQRSTUVWXYZ

abcdefghijklmnopqrstuvwxyz 1234567890

¼ ½ ¾ [àóüßç] (.,:;?!$£&-*){ÀÓÜÇ}

Filosofia Regular

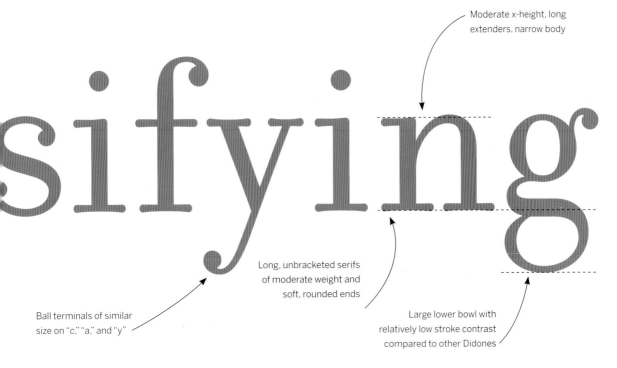

Moderate x-height, long extenders, narrow body

Long, unbracketed serifs of moderate weight and soft, rounded ends

Ball terminals of similar size on "c," "a," and "y"

Large lower bowl with relatively low stroke contrast compared to other Didones

While **Filosofia** is clearly inspired by Bodoni, it departs in many ways. Zuzana Licko's invention has less contrast than most digital Bodonis, and the modulation from thick to thin is more gradual. Strokes have soft, round ends, in contrast to the abruptness of other Didones. Also, unlike Bodoni and Didot, the "s" has ball terminals—and this single distinguishing glyph has a major effect on the typeface as a whole, giving it a more ornamented, yet informal flair. All this adds up to a casual, affable attitude, relative to others in this class. Bodoni and Didot are rarified city dwellers, top-hatted patrons of the high arts. Filosofia is pretty and polite, but comes from the country. ***Good for:*** Artisanal baked goods. Fine jams and preserves.

Compare to:

Rfaegso

ITC Bodoni Six

Rfaegso

Bauer Bodoni

Farnham

Designer: (Johann Fleischman) Christian Schwartz // **Foundry:** Font Bureau // **Country of origin:** (The Netherlands) United States // **Release year:** (mid-to-late 1700s) 2004 // **Classification:** Transitional/Rational Serif

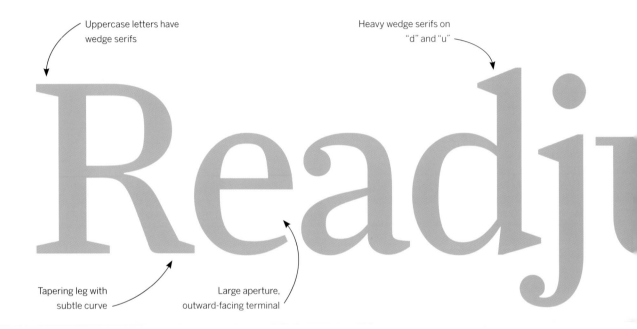

Uppercase letters have wedge serifs

Heavy wedge serifs on "d" and "u"

Tapering leg with subtle curve

Large aperture, outward-facing terminal

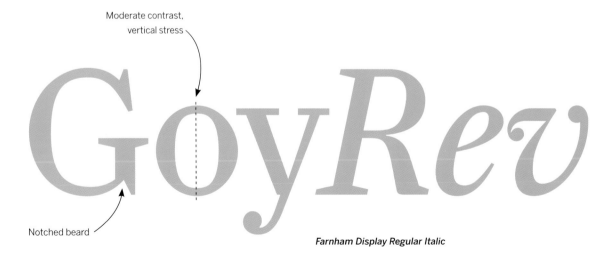

Moderate contrast, vertical stress

Notched beard

Farnham Display Regular Italic

ABCDEFGHIJKLMNOPQRSTUVWXYZ
abcdefghijklmnopqrstuvwxyz 1234567890 163
¼ ½ ¾ [àóüßç](.,:;?!$£&-*){ÀÓÜÇ}

Farnham Text Regular

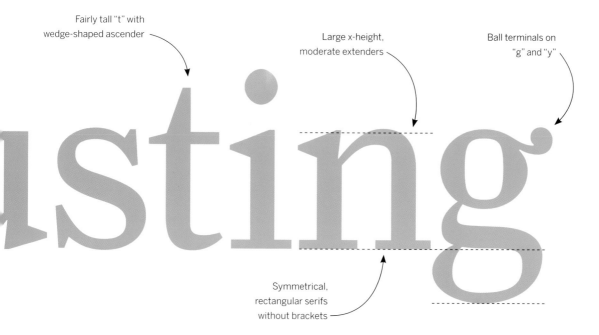

Fairly tall "t" with
wedge-shaped ascender

Large x-height,
moderate extenders

Ball terminals on
"g" and "y"

Symmetrical,
rectangular serifs
without brackets

Farnham is full of energy and tension. So many ideas are tossed into a single design: angled and vertical contrast, wedges, rectangles, and balls. Though some of these concepts seem to contradict each other, they all add up to a vibrant typeface that sparkles on the page without overwhelming the text. This usability comes from Christian Schwartz's pragmatic approach. Inspired by the eccentric work of 18th-century designer Johann Fleischman, Schwartz harmonized widths and shapes, opened apertures, and toned things down throughout. He let loose in the Display italic swashes. Farnham isn't a neutral workhorse by any means, but it is surprisingly versatile, with separate Text and Display versions and lots of weights. *Good for:* Making the boring interesting.

Compare to:

Gagdecfy

New Century Schoolbook

Gagdecfy

Ingeborg

New Century Schoolbook

Designer: (Morris Fuller Benton) Linotype staff // **Foundry:** Linotype // **Country of origin:** United States
Release year: (1917–1923) 1980 // **Classification:** Rational Serif

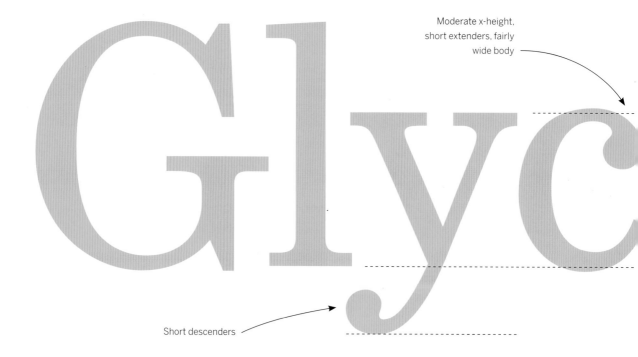

Moderate x-height, short extenders, fairly wide body

Short descenders

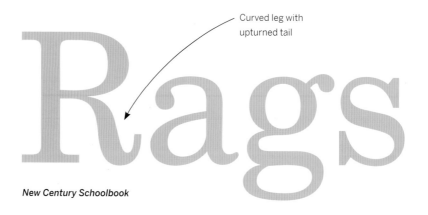

Curved leg with upturned tail

New Century Schoolbook

ABCDEFGHIJKLMNOPQRSTUVWXYZ

abcdefghijklmnopqrstuvwxyz 1234567890

¼ ½ ¾ [àóüßç](.,:;?!$£&-*){ÀÓÜÇ}

New Century Schoolbook Roman

Ball terminals of similar
size on "c," "y," and "r"

Moderate contrast,
vertical stress

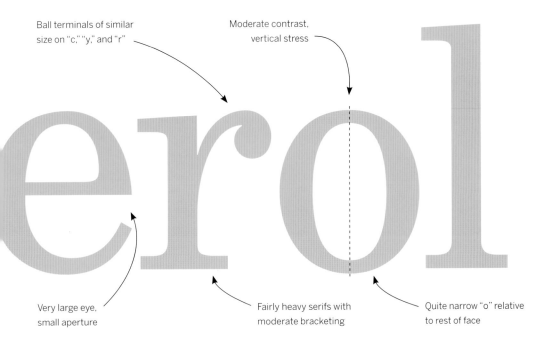

Very large eye,
small aperture

Fairly heavy serifs with
moderate bracketing

Quite narrow "o" relative
to rest of face

For millions of Americans (and many others), **New Century Schoolbook** inspires memories of childhood days. The variation on Century was designed for educational texts and it quickly became the standard for any book intended for the youth demographic. So, the friendly, comfortable feeling of the typeface could come from a nostalgic familiarity more than any visual characteristic. Still, these letters are comfortable ones. The construction is Rational in its contrast and regularity, but no characteristic is too extreme. The large counters and ball terminals also lend a geniality, and shapes are quite round, emphasized by closed apertures. *Good for:* Reminiscing. Gentle instruction. Putting readers at ease.

Compare to:

Rfaegsy

Miller Text

Rfaegsy

Eames Century Modern

Miller

Designer: Matthew Carter, Tobias Frere-Jones, Cyrus Highsmith // **Foundry:** Font Bureau
Country of origin: United States // **Release years:** 1997–2000 // **Classification:** Rational Serif

Moderate contrast, vertical stress

Upturned tail

Repa

Leg bows, ends with long serif

Outstroke ends slightly beyond body, creating a fuller, circular shape on "e" and "c"

Alternative "R" has upturned tail more typical of Scotch/ Century Schoolbook

SoftR

Miller Text Italic

Miller Display Roman

ABCDEFGHIJKLMNOPQRSTUVWXYZ
abcdefghijklmnopqrstuvwxyz 1234567890
¼ ½ ¾ [àóüßç](.,:;?!$£&-*){ÀÓÜÇ}

Miller Text Roman

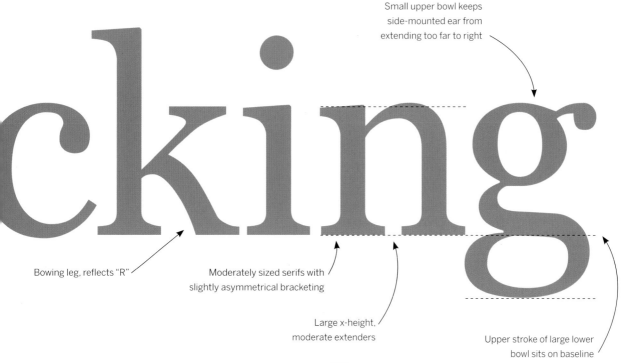

Small upper bowl keeps side-mounted ear from extending too far to right

Bowing leg, reflects "R"

Moderately sized serifs with slightly asymmetrical bracketing

Large x-height, moderate extenders

Upper stroke of large lower bowl sits on baseline

Miller comes from a style of Scottish type that is now frequently called *Scotch Roman*. Like other Rational serifs, there is moderate vertical stroke contrast and regular construction, but the serifs are particularly robust. It's relatively narrow, too, although that isn't obvious at first glance, making Miller popular among publication designers who appreciate sturdiness and spatial economy. There are various details—like the "a" tail or "k" leg—that give the face a historical touch, lending a sense of authority. Since its release in 1997 Font Bureau has expanded Miller to include versions for various headline sizes, giving magazines and newspapers even more reasons to build their designs around the family. *Good for:* News and other weighty content.

Compare to:

Raekg

New Century Schoolbook

Raekg

Ingeborg

Eames Century Modern

Designer: Erik van Blokland // **Foundry:** House Industries // **Country of origin:** The Netherlands, United States
Release year: 2010 // **Classification:** Rational Serif

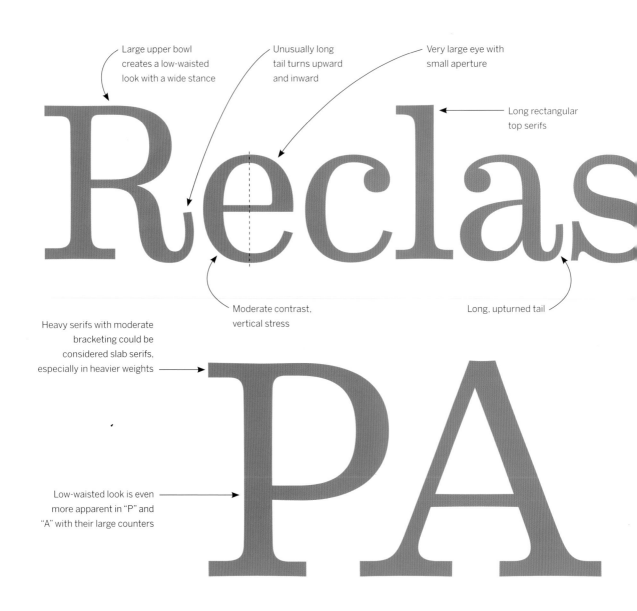

Large upper bowl creates a low-waisted look with a wide stance

Unusually long tail turns upward and inward

Very large eye with small aperture

Long rectangular top serifs

Moderate contrast, vertical stress

Long, upturned tail

Heavy serifs with moderate bracketing could be considered slab serifs, especially in heavier weights

Low-waisted look is even more apparent in "P" and "A" with their large counters

ABCDEFGHIJKLMNOPQRSTUVWXYZ

abcdefghijklmnopqrstuvwxyz 123456789 163

¼ ⅔ ⅝ [àóüßç](.,:;?!$£&-*){ÀÓÜÇ}

Eames Century Modern Regular

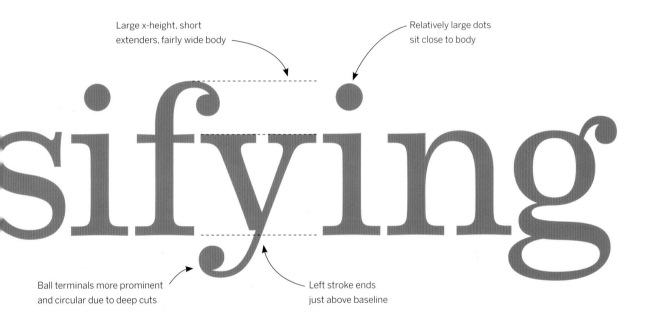

Large x-height, short extenders, fairly wide body

Relatively large dots sit close to body

Ball terminals more prominent and circular due to deep cuts

Left stroke ends just above baseline

Although its namesakes never made a typeface, this is an appropriate tribute. The work of Charles and Ray Eames was always tinged with levity, and Erik van Blokland's play on the **New Century Schoolbook** style is a lively one indeed. Its frisky qualities are particularly visible in its extreme weights, but you can see them in the Regular too. Tails curve inward. Ball terminals proudly dangle. Many letters have a large upper body and low waist, giving the slightest comic effect. The "e," with its big eye, seems to smile. Perhaps these personifications are exaggerations, but this face is not as sober as Century Schoolbook or **Clarendon** (another close relative). Once the bell rings and you're done with your Schoolbook, this is what you take out for fun. *Good for:* Well-crafted whimsy.

Compare to:

Rfaegsy

New Century Schoolbook

Rfaegsy

Clarendon

Ingeborg

Designer: Michael Hochleitner // **Foundry:** Typejockeys // **Country of origin:** Austria
Release year: 2009 // **Classification:** Rational Serif

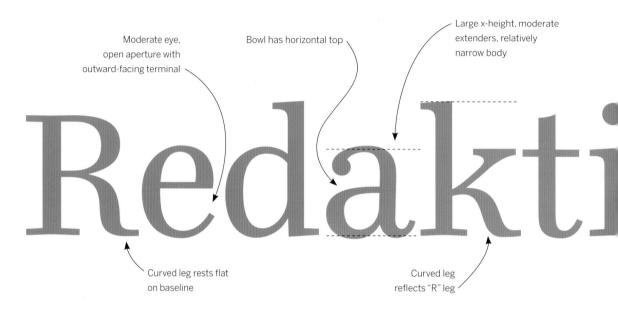

Moderate eye, open aperture with outward-facing terminal

Bowl has horizontal top

Large x-height, moderate extenders, relatively narrow body

Curved leg rests flat on baseline

Curved leg reflects "R" leg

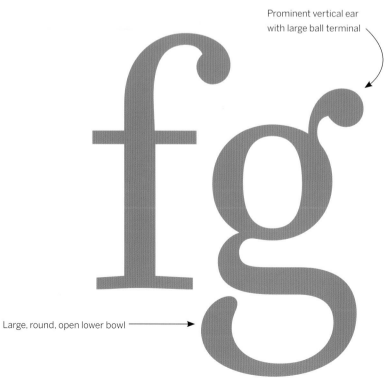

Prominent vertical ear with large ball terminal

Large, round, open lower bowl

ABCDEFGHIJKLMNOPQRSTUVWXYZ
abcdefghijklmnopqrstuvwxyz 1234567890 163
¼ ½ ¾ [àóüßç](.,:;?!$£&-*){ÀÓÜÇ}

Ingeborg Regular

Moderate contrast, slight angle

Ball terminals of similar size on "a," "r," and "f"

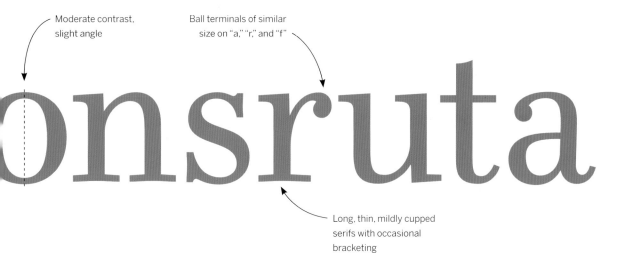

onsruta

Long, thin, mildly cupped serifs with occasional bracketing

Most people will likely encounter **Ingeborg**'s showy Display variants: the decorative fill and shadow of Block, and the buxom swashes of Fat Italic. These are indeed finely crafted crowd-pleasers, but the typeface's more important contribution to typography is in the text weights. Michael Hochleitner managed to comfortably combine the neoclassical glamour of Didones, the readability of other Rational typefaces like the Scotch Romans, and the sturdiness of a slab serif. The result is a very original design that is both beautiful and practical. ***Good for:*** Books. Magazines. Substance and style.

Compare to:

QRgkaef

Miller Text

QRgkaef

Eames Century Modern

Melior

Designer: Hermann Zapf // **Foundry:** D. Stempel AG, Linotype // **Country of origin:** Germany
Release year: 1952 // **Classification:** Rational Serif

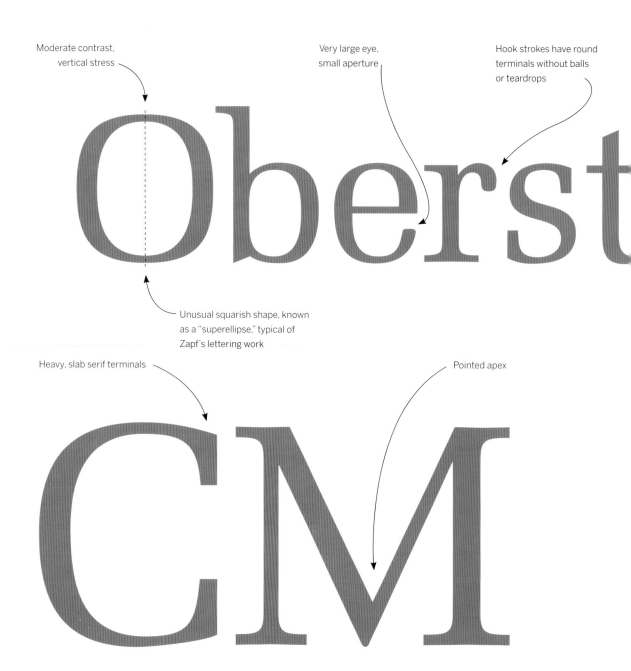

Moderate contrast, vertical stress

Very large eye, small aperture

Hook strokes have round terminals without balls or teardrops

Unusual squarish shape, known as a "superellipse," typical of Zapf's lettering work

Heavy, slab serif terminals

Pointed apex

ABCDEFGHIJKLMNOPQRSTUVWXYZ
abcdefghijklmnopqrstuvwxyz 1234567890
¼ ½ ¾ [àóäßç](.,:;?!$£&-*){ÀÓÜÇ}

Melior

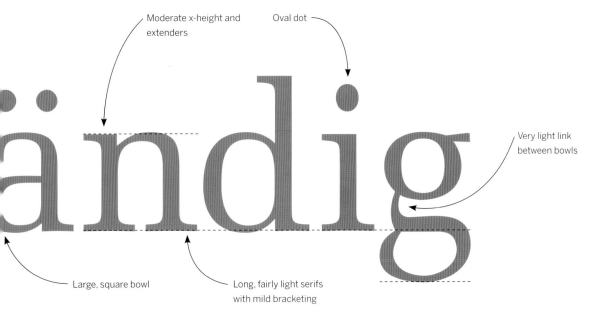

Moderate x-height and extenders

Oval dot

Very light link between bowls

Large, square bowl

Long, fairly light serifs with mild bracketing

Melior is one of the few serif typefaces with round forms based on the *superellipse*, an oval with nearly flat sides. This squarish shape is much more common in sans serifs, particularly Grotesques and square Geometrics, making Melior an unusually harmonious serif companion for typefaces like **Univers** and Eurostile. The superellipse—also common in Hermann Zapf's lettering for book covers—can feel dated, perhaps because it brings to mind the shape of a vintage TV screen. Melior's rounded terminals ("a," "e," "r") are also typical of the soft, unfocused type of the phototype era. Still, Melior remains a unique typeface, a milestone of its time with ideas that are still rare in new designs. ***Good for:*** Sober, readable text. Referencing the 1960s–80s.

Compare to:

Oargey

Univers 55

Oargey

Forza

xxXXx

Background typefaces are Doko and Neue Swift

Contemporary Serif

Neue Swift

Designer: Gerard Unger // **Foundry:** Linotype // **Country of origin:** The Netherlands
Release years: 1985 (Swift), 1995 (Swift 2.0), 2009 // **Classification:** Contemporary Serif

Blunt, wedge-shaped ends are prominent on terminating horizontal strokes

Arch strokes are quite flat with pronounced tapering

Moderate bowl and large aperture

Long, sharp, wedge-shaped serifs

Angled bar tapers at left, increasing size of eye

ABCDEFGHIJKLMNOPQRSTUVWXYZ
abcdefghijklmnopqrstuvwxyz 1234567890 163
¼ ⅔ ⅝ [àóüßç](.,:;?!$£&-*){ÀÓÜÇ}

Neue Swift Regular

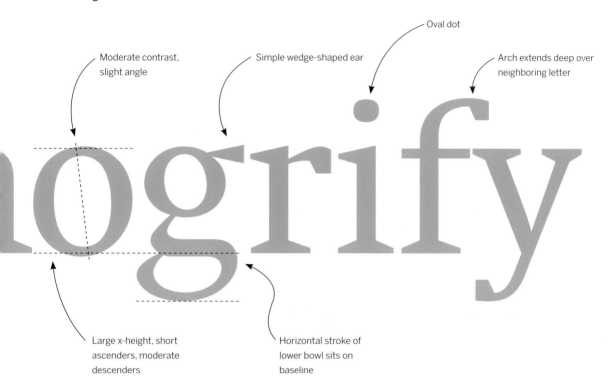

Oval dot

Moderate contrast, slight angle

Simple wedge-shaped ear

Arch extends deep over neighboring letter

Large x-height, short ascenders, moderate descenders

Horizontal stroke of lower bowl sits on baseline

Wedge-shaped serifs (like the wings of the bird that give **Neue Swift** its name), along with the large x-height and open apertures, were remedies for the poor quality of newspaper printing in the 1980s. They also produce a strong horizontal flow, appropriate for quick, easy reading. These functional aspects gave the typeface a very distinctive look and were soon seen as aesthetic advantages for branding and magazines, where they added a fresh crispness to text. Gerard Unger and others have improved and expanded the typeface over the years, and the current version has more weights than the original. See also Matthew Carter's Charter, which was developed around the same time and features similar design ideas.

Compare to:

rsafgmnocj

Times New Roman

rsafgmnocj

Lexicon No.1

Skolar

Designer: David Březina // **Foundry:** TypeTogether // **Country of origin:** Czech Republic
Release year: 2009 // **Classification:** Contemporary Serif

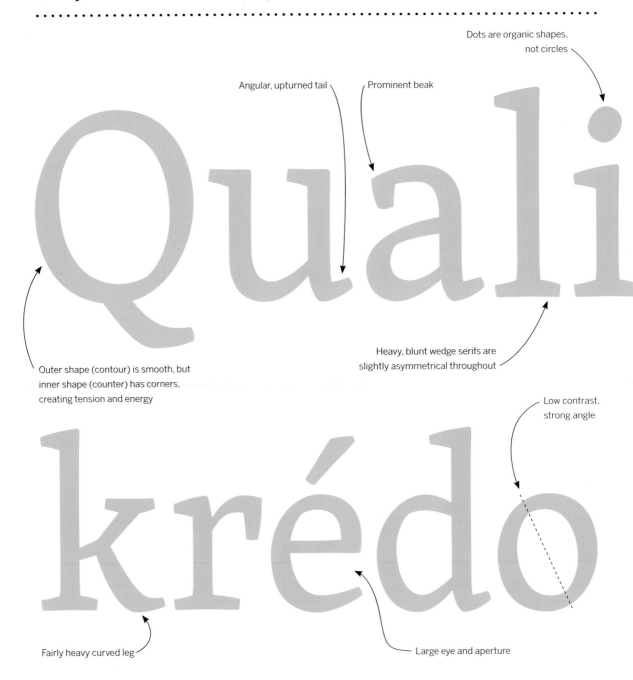

Dots are organic shapes, not circles

Angular, upturned tail

Prominent beak

Outer shape (contour) is smooth, but inner shape (counter) has corners, creating tension and energy

Heavy, blunt wedge serifs are slightly asymmetrical throughout

Low contrast, strong angle

Fairly heavy curved leg

Large eye and aperture

ABCDEFGHIJKLMNOPQRSTUVWXYZ

abcdefghijklmnopqrstuvwxyz ćtčhśt

1234567890 163 ¼⅔⅝ [àóüßç](.,:;?!$£&-*){ÀÓÜÇ}

Skolar Regular

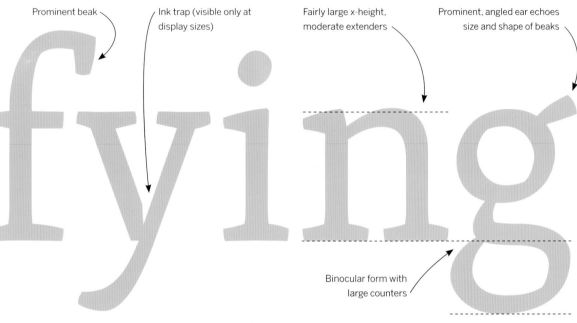

Prominent beak

Ink trap (visible only at display sizes)

Fairly large x-height, moderate extenders

Prominent, angled ear echoes size and shape of beaks

Binocular form with large counters

Compare to:

Gafgrksy

Fedra Serif A

Gafgrksy

Doko

Gafgrksy

Rumba Small

While **Skolar** has conventional bones—a standard Humanist skeleton with short caps—its muscles make it new. The very low contrast and hefty serifs follow a contemporary trend that began with typefaces like **Fedra Serif**. But unlike Fedra, Skolar goes easy on the eccentricity. Its main calling card is the prominent beak serifs found on the "a" and "s." Though these reduce apertures, they successfully add to the dark color of the type without hindering legibility. Another key trait is the angularity of the counters in many glyphs, which contradict their smooth outlines and create a vigorous tension. This technique has become a signature of the MA Typeface Design program at the UK's Reading University, where David Březina created Skolar.

Fedra Serif

Designer: Peter Bilak // **Foundry:** Typotheque // **Country of origin:** The Netherlands
Release years: 2003–2009 // **Classification:** Humanist Serif

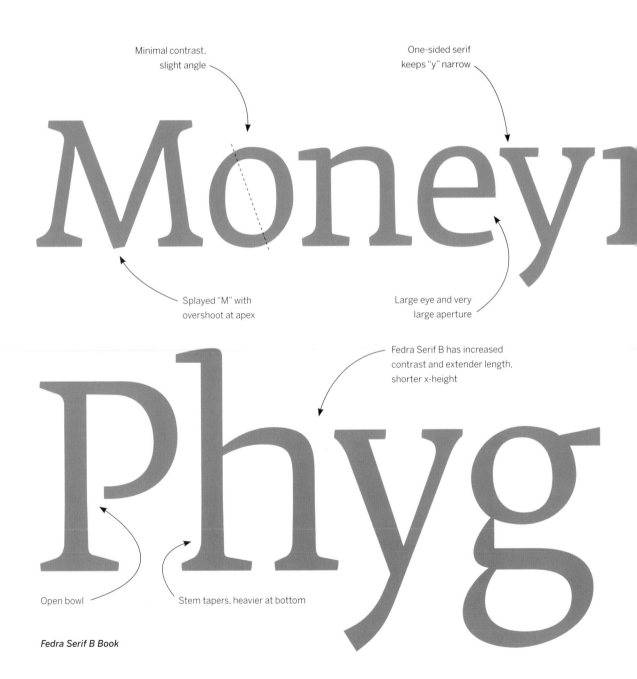

Minimal contrast, slight angle

One-sided serif keeps "y" narrow

Splayed "M" with overshoot at apex

Large eye and very large aperture

Fedra Serif B has increased contrast and extender length, shorter x-height

Open bowl

Stem tapers, heavier at bottom

Fedra Serif B Book

ABCDEFGHIJKLMNOPQRSTUVWXYZ

abcdefghijklmnopqrstuvwxyz 1234567890

163 ¼ ⅔ ⅝ [àóüßç](.,:;?!$£&-*){ÀÓÜÇ}

Fedra Serif A Book

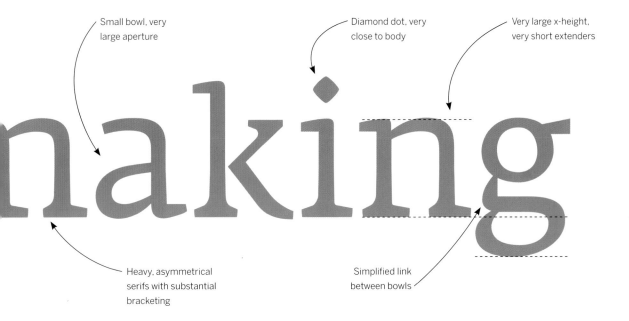

Small bowl, very large aperture

Diamond dot, very close to body

Very large x-height, very short extenders

Heavy, asymmetrical serifs with substantial bracketing

Simplified link between bowls

Matching the proportions of its highly original sans companion, **Fedra Serif** broke ground as a text face with an unusually high x-height, low contrast, and large counters and apertures. These attributes were a response to coarse rendering systems and a reflection of modern tastes. Yet the typeface resists cold austerity thanks to its Humanist structure. This combination of ideas was part of a movement that began in the early 21st century and continues today, represented by many of the faces in this book's "Contemporary Serif" class. Fedra Serif is a unique member of this clan, with distinctive details (open bowls, diamond dots) but also a width-matching family (Fedra Serif B) with more traditional proportions and contrast. *Good for:* Dense but dynamic text. Very small type.

Compare to:

Maegyk P

Doko

Maegyk P

Freight Micro

FF Meta Serif

Designer: Erik Spiekermann, Christian Schwartz, Kris Sowersby // **Foundry:** FontFont
Country of origin: Germany // **Release year:** 2007 // **Classification:** Contemporary Serif

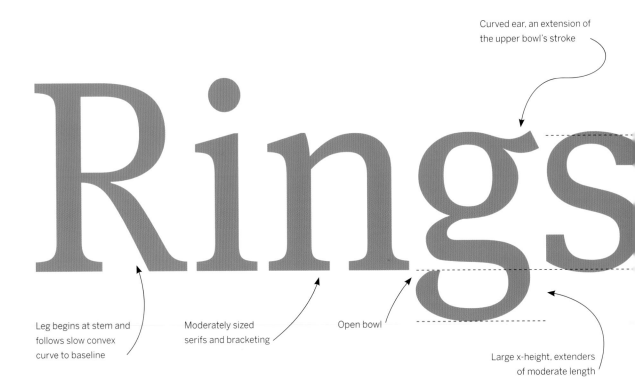

Curved ear, an extension of
the upper bowl's stroke

Leg begins at stem and
follows slow convex
curve to baseline

Moderately sized
serifs and bracketing

Open bowl

Large x-height, extenders
of moderate length

FF Meta

FF Unit

FF Unit Slab

ABCDEFGHIJKLMNOPQRSTUVWXYZ

abcdefghijklmnopqrstuvwxyz 1234567890 163

¼ ⅔ ⅝ [àóüßç](.,:;?!$£&-*){ÀÓÜÇ}

FF Meta Serif Book

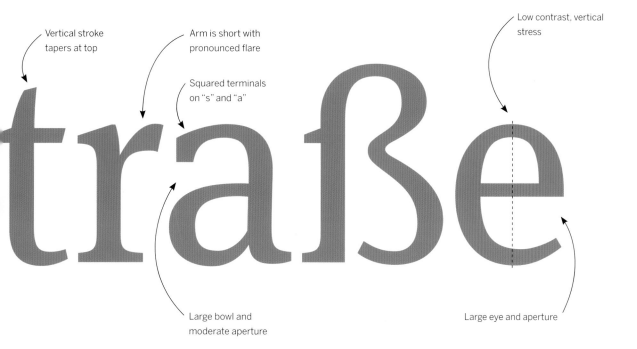

Vertical stroke tapers at top

Arm is short with pronounced flare

Squared terminals on "s" and "a"

Low contrast, vertical stress

Large bowl and moderate aperture

Large eye and aperture

Erik Spiekermann's response to demand for a serif version of his most popular typeface is this collaboration with Christian Schwartz and Kris Sowersby. **FF Meta Serif** is much more than **FF Meta** with serifs. The typeface retains some of FF Meta's charm, but is slightly more restrained, a capable workhorse in nearly any context. Despite this moderate approach, FF Meta Serif sports some distinctive features: squared terminals on "a" and "s," robust serifs, contemporary proportions, and of course the trademark open-bowled "g." Not only do the FF Meta companions play well together, but they were also designed to work with FF Unit and **FF Unit Slab**, forming a multifaceted palette for complex hierarchies.

Compare to:

Rrgaes

Fedra Serif A

Rrgaes

Skolar

Doko

Designer: Ondrej Jób // **Foundry:** Urdt // **Country of origin:** Slovakia, The Netherlands
Release year: 2011 // **Classification:** Contemporary Serif

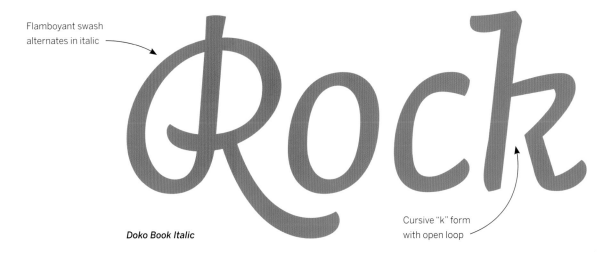

Curves thin slightly when they meet stems, but weight compensation is also handled by a notch into the stem

Moderate extenders

Curve-to-corner terminals influenced by brush on "a" and "e"

Flamboyant swash alternates in italic

Cursive "k" form with open loop

Doko Book Italic

ABCDEFGHIJKLMNOPQRSTUVWXYZ

abcdefghijklmnopqrstuvwxyz 1234567890 163

¼ ½ ¾ [àóüßç](.,:;?!$£&-*){ÀÓÜÇ}

Doko Book

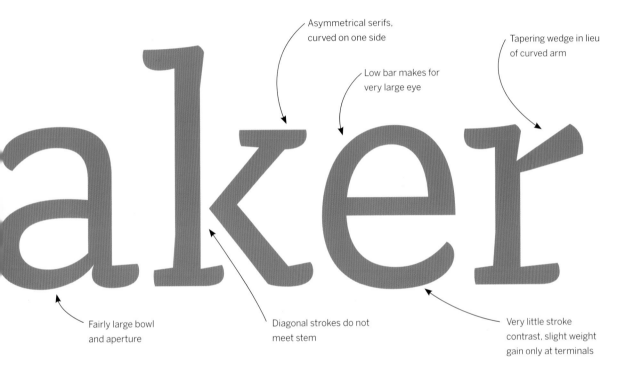

Asymmetrical serifs, curved on one side

Tapering wedge in lieu of curved arm

Low bar makes for very large eye

Fairly large bowl and aperture

Diagonal strokes do not meet stem

Very little stroke contrast, slight weight gain only at terminals

Doko takes the Contemporary Humanist serif to playful extremes. Inspired by the hand-lettering of cartoons and informal illustration, it dances on the line between expressiveness and functionality, Display type and Text type. As Ondrej Jób's project originated at the Royal Academy of Art (KABK) in The Hague, one can see evidence of Dutch pioneers in Doko—such as the pointed brushlike terminals of **Lexicon** or the minimal contrast and proportions of **Fedra Serif**. But Doko's top-heavy body and animated swash italic adds a chipper, lighthearted vibe to the bloodline. Despite all the frivolity, Doko is built like a standard text family: regular and bold with italics and multiple figure styles. *Good for:* Making something fun, light-hearted, or approachable.

Compare to:

Srasek

Auto 1

Srasek

Auto 3 Italic

XXxX

Background typefaces are Luxury Diamond and Modesto

Inscribed/Engraved

Luxury Diamond

Designer: Christian Schwartz, Dino Sanchez // **Foundry:** House Industries // **Country of origin:** United States
Release years: 2002–2006 // **Classification:** Engraved

High contrast, vertical stress

Very wide body, small caps only slightly shorter than caps

Top serif references decorative engravers, lettering and marks of luxury brands

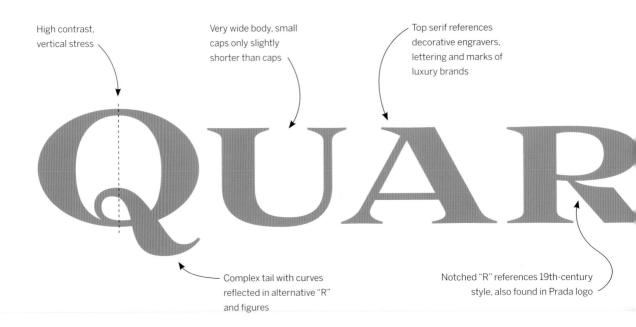

Complex tail with curves reflected in alternative "R" and figures

Notched "R" references 19th-century style, also found in Prada logo

Extra exuberance is reserved for Didone-style figures

ABCDEFGHIJKLMNOPQRST
UVWXYZ ABCDEFGHIJKLMNOP
QRSTUVWXYZ 1234567890
¼ ⅛ ⅔ ⅝ [ÀÓÜÇ](.,:;?!$£&-*){ÀÓÜÇ}

Luxury Diamond

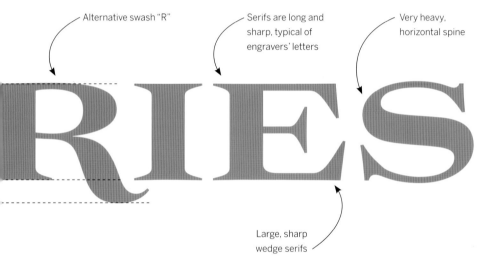

Alternative swash "R"

Serifs are long and sharp, typical of engravers' letters

Very heavy, horizontal spine

Large, sharp wedge serifs

When Luxury first launched it had a price tag of $1,500 for three fonts. Of course, it was a tongue-in-cheek conceptual stunt, a comment on the exclusivity of brands like Prada, Chanel, and Gucci. The fonts were later reissued by House Industries with conventional pricing. Publicity gimmicks aside, the designs are a brilliant celebration (or mockery) of common trends in luxury branding. The most recognizable of the three typefaces is **Luxury Diamond**, an encapsulation metal engraving style, with its long triangular serifs, wide stance, and decorative details like the notched "R" and curvaceous figures. There is also a Text family with a full lowercase character set. *Good for:* Raising a product's perceived value. Filling horizontal space.

Compare to:

QUARES425

Trajan

QUARES425

Bauer Bodoni

Albertus

Designer: Berthold Wolpe // **Foundry:** Monotype // **Country of origin:** United Kingdom
Release year: 1940 // **Classification:** Inscribed

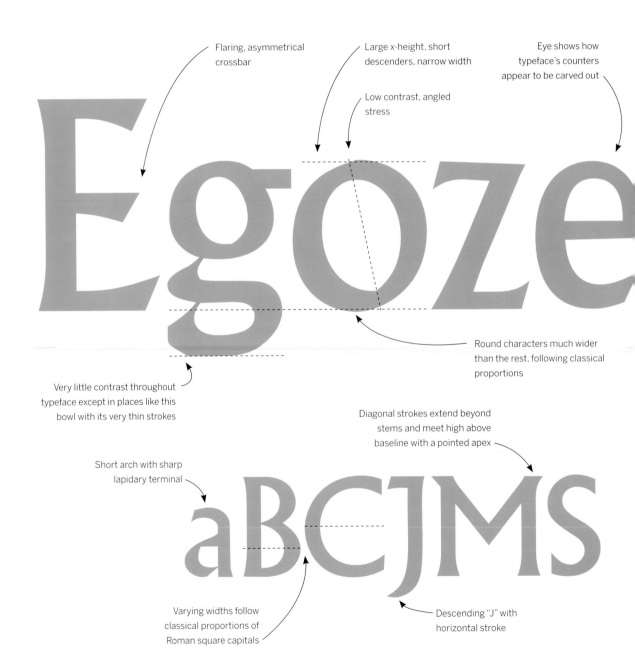

Flaring, asymmetrical crossbar

Large x-height, short descenders, narrow width

Eye shows how typeface's counters appear to be carved out

Low contrast, angled stress

Round characters much wider than the rest, following classical proportions

Very little contrast throughout typeface except in places like this bowl with its very thin strokes

Diagonal strokes extend beyond stems and meet high above baseline with a pointed apex

Short arch with sharp lapidary terminal

Varying widths follow classical proportions of Roman square capitals

Descending "J" with horizontal stroke

ABCDEFGHIJKLMNOPQRSTUVWXYZ

abcdefghijklmnopqrstuvwxyz 1234567890

¼ ½ ¾ [àóüßç](.,:;?!$£&-*){ÀÓÚÇ}

Albertus Regular

Very large dot
sits close to body

Only indication of
a serif is a subtle
flaring at terminals

In 1932, Monotype's Stanley Morison asked Berthold Wolpe to create a typeface based on his inscriptional lettering. The result is **Albertus**, a design that shows clear signs of its carved origins. The model letters were raised from the surface of bronze tablets, not debossed, which may explain the unusual angular shape of the counters, which were carved out of the lettershapes rather than the other way around. Flared terminals—in lieu of conventional serifs—were also a result of this technique. Albertus has become one of the trademarks of London, used for many of its street signs and official placards. *Good for:* An official or ceremonial aura, without the pomposity of **Trajan**. Emulating wood- or stone-carved letters.

Compare to:

ACEGJMORS

Optima Bold

ACEGJMORS

Trajan Bold

Modesto

Designer: Jim Parkinson // **Foundry:** Parkinson // **Country of origin:** United States
Release years: 2000–2003 // **Classification:** Glyphic

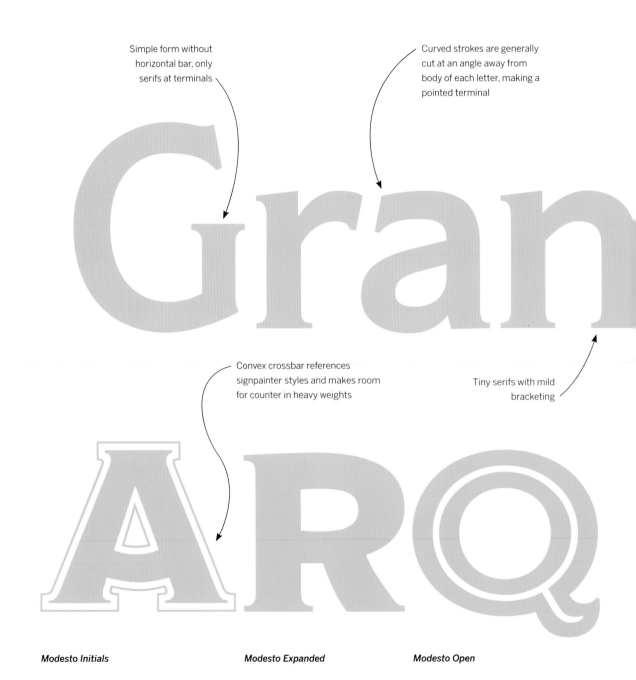

Simple form without horizontal bar, only serifs at terminals

Curved strokes are generally cut at an angle away from body of each letter, making a pointed terminal

Convex crossbar references signpainter styles and makes room for counter in heavy weights

Tiny serifs with mild bracketing

Modesto Initials

Modesto Expanded

Modesto Open

ABCDEFGHIJKLMNOPQRSTUVWXYZ

abcdefghijklmnopqrstuvwxyz 1234567890

¼ ½ ¾ [àóüßç](.,:;?!$£&-*){ÀÓÜÇ}

Modesto Text Medium

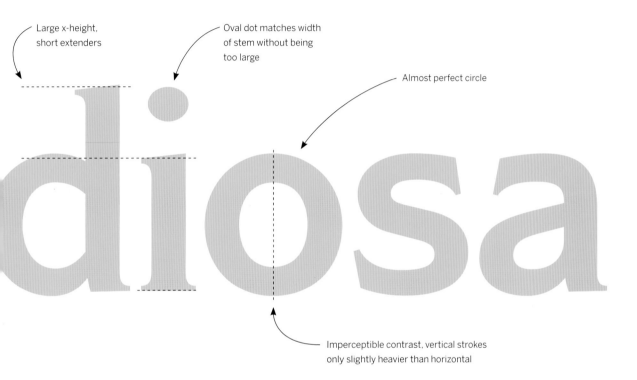

Large x-height,
short extenders

Oval dot matches width
of stem without being
too large

Almost perfect circle

Imperceptible contrast, vertical strokes
only slightly heavier than horizontal

Jim Parkinson has made a habit of translating the styles of hand-letterers and sign-painters—particularly those of America—to typefaces. **Modesto** incorporates various elements of early 20th-century lettering, with its simplified, monolinear Gothic construction, short descenders, bowed "A," and tiny serifs. The family features a carnival of options, from narrow to wide, and inlined to outlined. And despite Modesto's natural proclivity for Display settings, there are Text weights. These happen to be an interesting option for anyone who seeks a lowercase in the style of Copperplate Gothic, the popular turn-of-the-century typeface with a similar structure and serifs. *Good for:* An antique, handmade feel. Wholesome, vintage Americana.

Compare to:

GANDIOS

Copperplate Gothic 31 AB

Gandios

Gotham

Trajan

Designer: Carol Twombly // **Foundry:** Adobe // **Country of origin:** United States
Release year: 1989 // **Classification:** Inscribed

Small caps nearly the height of caps

Exuberant "Q" with long tail

Long, thin serifs with subtle curve

Open bowl

No serifs where diagonals connect

ABCDEFGHIJKLMNOPQRSTUVWXYZ

ABCDEFGHIJKLMNOPQRSTUVWXYZ 12345

67890 163 ¼ ½ ¾ [ÀÓÜÇ](.,:;?!$£&-*){ÀÓÜÇ}

Trajan Bold

Subtle modeling on serifs
shows evidence of brush
strokes in original source

Moderate contrast,
strong angle

Classical proportions: rounds much
wider than other characters

Trajan is synonymous with drama. This association is partly a result of Trajan's overuse in movie posters—it has become the subject of internet parodies and design conference lectures. But these letters are pretty dramatic on their own—from the classical *capitalis monumentalis* proportions to the long, sweeping strokes and serifs. Carol Twombly's source was Trajan's Column, an early 2nd-century monument in Rome. While the letters were inscribed into stone with a chisel, recent research suggests that they were first painted with a brush, which explains their graceful serifs. There are many other interpretations of this style, including Goudy, Pietra, Waters Titling, and Penumbra. ***Good for:*** Drama, of course. Majesty. Momentous events.

Compare to:

QUAEROS

Optima

XxX

Background typefaces are Bureau Grot and FF Bau

Grotesque Sans

Bureau Grot

Designer: David Berlow, Jill Pichotta, Christian Schwartz, Richard Lipton // **Foundry:** Font Bureau
Country of origin: United States // **Release years:** 1989–1993 (Bureau Grotesque) 2006 // **Classification:** Grotesque Sans

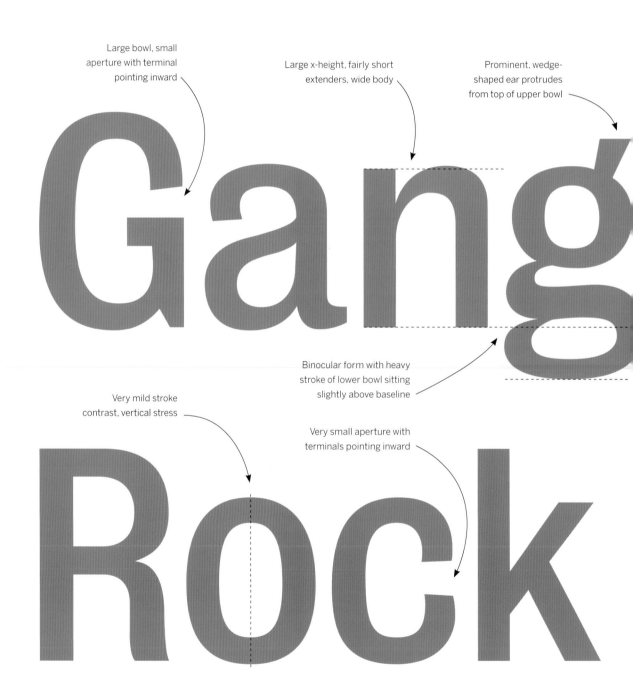

Large bowl, small aperture with terminal pointing inward

Large x-height, fairly short extenders, wide body

Prominent, wedge-shaped ear protrudes from top of upper bowl

Binocular form with heavy stroke of lower bowl sitting slightly above baseline

Very mild stroke contrast, vertical stress

Very small aperture with terminals pointing inward

ABCDEF**G**HIJKLMNOPQ**R**STUVWXYZ
abcd**e**f**g**hijkl**m**nop**q**r**s**tuvwxyz 1234567890
¼ ½ ¾ [àóüßç](.,:;?!$£&-*){ÀÓÜÇ}

Bureau Grot Book

Very closed aperture with the terminals pointing inward

Round shapes are generally squared off, only slightly convex on sides, top, and bottom

Many letters have bottom-heavy, irregular quality

Long hook stroke points inward

The English Grotesques that inspired **Bureau Grot** come from the 19th century, when sans serifs had a warmth and life that was slowly drained from them as modernism took hold. Shapes are irregular and organic, modulating strokes curve in toward the body and terminate at varying angles. All of this gives David Berlow's typeface a dynamic, energetic feeling. Ever since its release as Bureau Grotesque in 1989, the multi-weight, multi-width family has been popular with newspapers and magazines who have enjoyed having a style to fit any space. It was expanded even further in 2006, and the fonts were revised and given more conventional names. **Good for:** Lively headlines of nearly any dimension.

Compare to:

GRarsteg

Knockout 31 Junior Middleweight

GRarsteg

FF Bau

Knockout

Designer: Jonathan Hoefler // **Foundry:** Hoefler & Frere-Jones // **Country of origin:** United States
Release year: 1994 // **Classification:** Grotesque Sans

Notched "1" is a historical form, uncommon today

Curved terminal

Round forms have "pill" shape with flat sides, and round top and bottom

Alternative "1" has more conventional form

Stroke of bowl, slightly lighter than others, extends perpendicular to stem

Short tail is subtle continuation of stem with vertical terminal

In lieu of horizontal stroke, "t" curves slightly before hitting baseline

Standard "R" with curved leg

Alternative "R" with straight leg

Knockout 27 Junior Bantamweight

ABCDEFGHIJKLMNOPQRSTUVWXYZ

abcdefghijklmnopqrstuvwxyz 1234567890

[àóüßç] (.,:;?!$£&-*) {ÀÓÜÇ}

Knockout 31 Junior Middleweight

Very mild contrast, only visible in some strokes and crossbars

Moderate x-height, fairly short extenders

Ear curves upward with horizontal terminal

Large eye thanks to thin bar, small aperture

Most strokes terminate at 90° angles

Knockout was, like **Bureau Grot**, influenced by sans serifs of the 1800s and early 1900s, many of which were wood types, each designed separately for a specific weight and width, and not necessarily in the same family. Jonathan Hoefler brought these varying designs into one unifying family yet retained their individualism where appropriate. So, any single style we show above will be slightly unlike the others, whether it's the flat terminals of the narrow fonts that give them a compact, upright stature, or the dramatically increased contrast in the bold fonts that lets them appear even heavier. This wide range of personalities and dimensions can make Knockout even more versatile than a larger, more homogenous family. *Good for:* Just about any design but the most modern.

Compare to:

Rtage 1

Bureau Grot

Rtage 1

Neue Helvetica

FF Bau

Designer: (Unknown) Christian Schwartz // **Foundry:** (Schelter & Giesecke) FontFont // **Country of origin:** (Germany) USA
Release year: (late 1800s to early 1900s) 2002 // **Classification:** Grotesque Sans

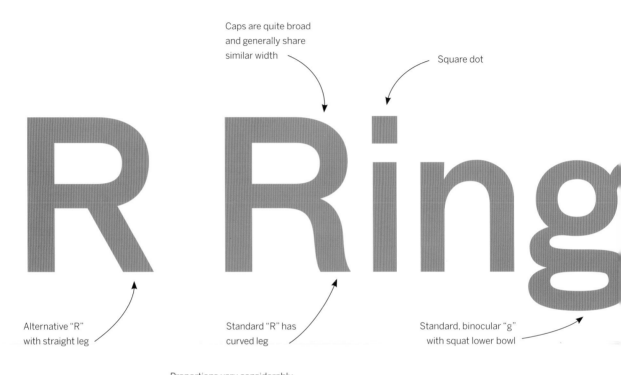

Caps are quite broad and generally share similar width

Square dot

Alternative "R" with straight leg

Standard "R" has curved leg

Standard, binocular "g" with squat lower bowl

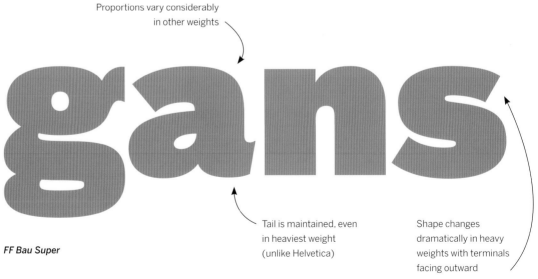

Proportions vary considerably in other weights

FF Bau Super

Tail is maintained, even in heaviest weight (unlike Helvetica)

Shape changes dramatically in heavy weights with terminals facing outward

ABCDEFGHIJKLMNOPQRSTUVWXYZ
abcdefghijklmnopqrstuvwxyz
1234567890 163 ¼ ⅔ ⅝
[àóüßç](.,:;?!$£&-*){ÀÓÜÇ}

FF Bau Medium

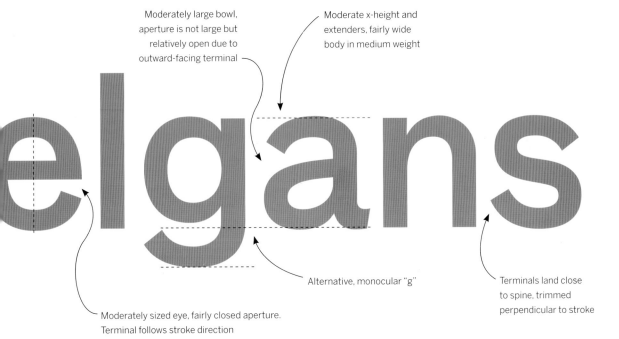

Moderately large bowl, aperture is not large but relatively open due to outward-facing terminal

Moderate x-height and extenders, fairly wide body in medium weight

Alternative, monocular "g"

Terminals land close to spine, trimmed perpendicular to stroke

Moderately sized eye, fairly closed aperture. Terminal follows stroke direction

The roots of Helvetica—such as Schelter & Giesecke's late 19th-century "Grotesk"—are much warmer and more irregular than the calculated modernist icon that would follow. **FF Bau** is a revival of that early Grot, a mainstay of the celebrated Bauhaus in Dessau. Christian Schwartz closely followed the three original weights and added a "Super" heavy weight, which required some changes in form, but retains the tailed "a," unlike Helvetica's bolds. This, along with the other angled, outward-facing terminals, can make FF Bau more handmade and dynamic—and maybe more antique, depending on the context and use. *Good for:* When Helvetica is too cold or perfect.

Compare to:

Rgatse
Neue Helvetica 55

Rgatse
Akzidenz-Grotesk

xXXxX

Background typefaces are Akkurat and National

Neo-Grotesque Sans

Univers

Designer: Adrian Frutiger // **Foundry:** Deberny & Peignot, Linotype // **Country of origin:** France, Germany
Release year: 1957 // **Classification:** Neo-Grotesque Sans

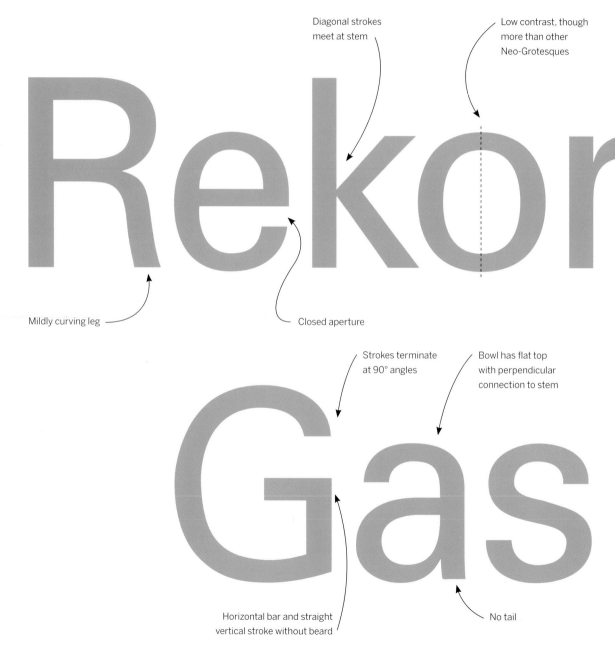

Diagonal strokes meet at stem

Low contrast, though more than other Neo-Grotesques

Mildly curving leg

Closed aperture

Strokes terminate at 90° angles

Bowl has flat top with perpendicular connection to stem

Horizontal bar and straight vertical stroke without beard

No tail

ABCDEFGHIJKLMNOPQRSTUVWXYZ
abcdefghijklmnopqrstuvwxyz 1234567890
¼ ½ ¾ [àóüßç](.,:;?!$£&-*){ÀÓÜÇ}

Univers 55 Roman

Moderate x-height and descenders, fairly narrow body

Monocular "g"

Released in the same year as Helvetica, Adrian Frutiger's masterpiece is the first multi-width, multi-weight superfamily designed as a consistent system from the beginning. The release was promoted by a multicolored grid diagram that is still well-known and imitated today. To achieve the pioneering uniformity throughout the family, Frutiger created a core design that is quite spare, allowing for the extensive variations in weight and width. **Univers** is therefore a very neutral typeface, delivering readable text while drawing very little attention to itself. Univers Next is a modern reworking of the family that was initially optimized for photo, not digital typesetting. ***Good for:*** A clear, neutral vessel for unfettered communication.

Compare to:

Gaekys

Helvetica Neue 55

Gaekys

National

Neue Helvetica

Designer: (Max Miedinger, Eduard Hoffmann) Linotype staff // **Foundry:** (Haas) Linotype
Country of origin: (Switzerland) Germany // **Release year:** (1957) 1983 // **Classification:** Neo-Grotesque Sans

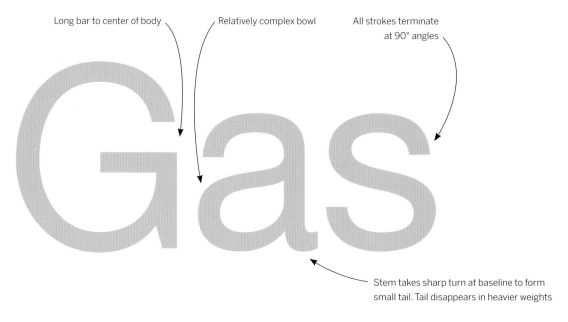

Bowl occupies upper half of body

Very low contrast

Mildly curving leg extends from far right side of bowl

Closed aperture

Rounded shapes are nearly circular

Long bar to center of body

Relatively complex bowl

All strokes terminate at 90° angles

Stem takes sharp turn at baseline to form small tail. Tail disappears in heavier weights

ABCDEFGHIJKLMNOPQRSTUVWXYZ

abcdefghijklmnopqrstuvwxyz 1234567890

¼ ½ ¾ [àóüßç](.,:;?!$£&-*){ÀÓÜÇ}

Neue Helvetica 55

Moderate x-height and descenders, fairly wide body

Monocular "g" with fairly flat lower stroke

Compare to:

Rgaslor

FF Bau

Rgaslor

National

Rgaslor

Akkurat

More than 50 years since its release, Helvetica is the world's most widely known typeface. Its popularity is due in part to its attempt at idealized construction: contrast is minimal; strokes terminate at 90° angles; letter shapes and widths are unusually uniform, bucking conventional forms; and the overall texture is atypically even, almost homogenous. The result is useful for logos and graphic display type, where consistency is desired, but not as effective for long passages of text, where dynamic rhythm and unique lettershapes are vital. **Neue Helvetica** is a 1980s effort to harmonize the previously incompatible styles. **Neue Haas Grotesk** refers to the original drawings for an even more holistic family, unconstrained by various technological compromises.

Akkurat

Designer: Laurenz Brunner // **Foundry:** Lineto // **Country of origin:** Switzerland
Release year: 2004 // **Classification:** Neo-Grotesque Sans

Bowl occupies
half of body

Virtually no
stroke contrast

Rekor

Straight leg connects
to bowl unusually far
from stem

Large eye, closed
aperture

Rounded shapes are
more oval than circular

Relatively simple bowl
with horizontal top

All strokes terminate
at 90° angles

Gas

Upper and lower counters
nearly identical, horizontal
spine, symmetrical form

Horizontal bar and straight
vertical stroke with beard

Stem takes sharp turn at
baseline to form small tail

ABCDEFGHIJKLMNOPQRSTUVWXYZ

abcdefghijklmnopqrstuvwxyz 1234567890

¼ ½ ¾ [àóüßç](.,:;?!$£&-*){ÀÓÜÇ}

Akkurat Regular

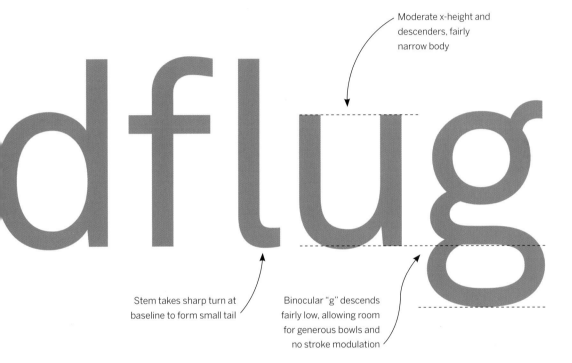

Moderate x-height and descenders, fairly narrow body

Stem takes sharp turn at baseline to form small tail

Binocular "g" descends fairly low, allowing room for generous bowls and no stroke modulation

Compare to:

As uniform and static as Helvetica is, **Akkurat** attempts to take it a step further—and succeeds. This typeface, by Laurenz Brunner, is rooted in the Swiss tradition of pragmatic, rational design. Letters like the "a" and "s" have middle strokes that are more horizontal, and thus more aligned. Stroke contrast is reduced. Forms are stiffer. In fact, Akkurat could be considered a Geometric sans serif, and would fit in that section if it didn't make sense to show it next to Helvetica given their similarities. A few characteristics give Akkurat its own place in the Neo-Grotesque category: a binocular "g," tailed "I," and a narrow overall width, resulting in oval-shaped rounds. *Good for:* Reflecting grid-based design concepts while remaining readable.

Rgaslor

Neue Helvetica

Rgaslor

FF DIN

National

Designer: Kris Sowersby // **Foundry:** Klim // **Country of origin:** New Zealand
Release years: 2004–2009 // **Classification:** Neo-Grotesque Sans

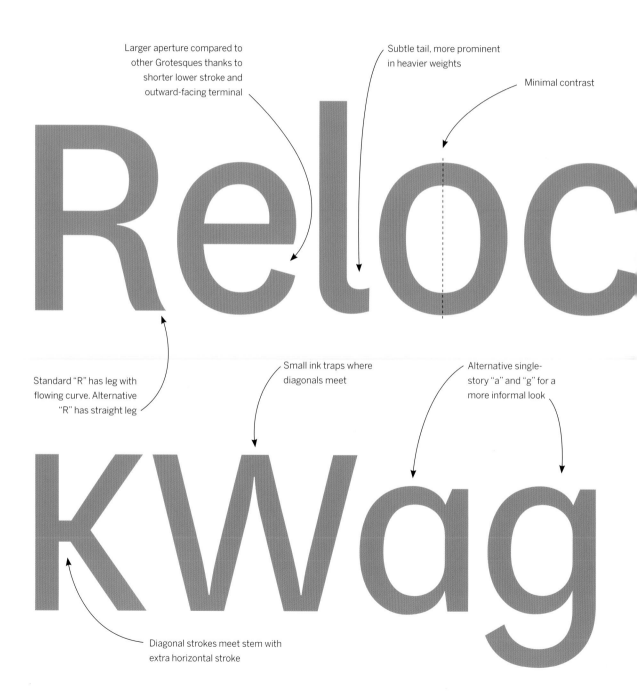

Larger aperture compared to other Grotesques thanks to shorter lower stroke and outward-facing terminal

Subtle tail, more prominent in heavier weights

Minimal contrast

Standard "R" has leg with flowing curve. Alternative "R" has straight leg

Small ink traps where diagonals meet

Alternative single-story "a" and "g" for a more informal look

Diagonal strokes meet stem with extra horizontal stroke

ABCDEFGHIJKLMNOPQRSTUVWXYZ

abcdefghijklmnopqrstuvwxyz 1234567890 163

¼ ⅔ ⅝ [àóüßç](.,:;?!$£&-*){ÀÓÜÇ}

National Regular

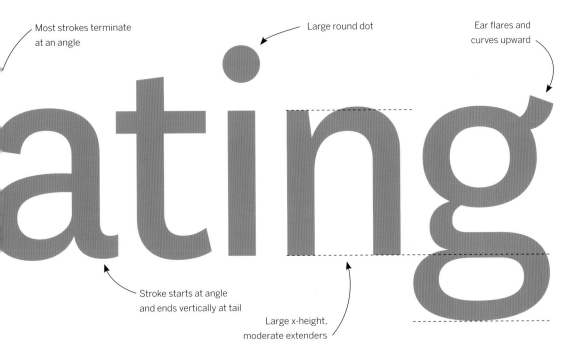

Most strokes terminate
at an angle

Large round dot

Ear flares and
curves upward

Stroke starts at angle
and ends vertically at tail

Large x-height,
moderate extenders

National is a Grotesque with Humanist qualities. While there is very little contrast, the strokes are somewhat calligraphic in structure, with angled terminals and very little uniformity. The overall affect is a warmer, contemporary Grot—more casual than **Univers** or **Neue Helvetica**, but more modern than **Bureau Grot** or **Knockout**. Like all of Kris Sowersby's work, National is fully equipped for professional typesetting, with all the language support, figure sets, and even small caps to tackle a wide variety of text. *Good for:* Straightforward text with a subtle informality. Annual reports that don't put readers to sleep.

Compare to:

Ragtleij
Neue Helvetica

Ragtleij
FF Bau

Antique Olive

Designer: Roger Excoffon // **Foundry:** (Fonderie Olive) Linotype // **Country of origin:** France
Release years: 1962–1966 // **Classification:** Neo-Grotesque/Geometric Sans

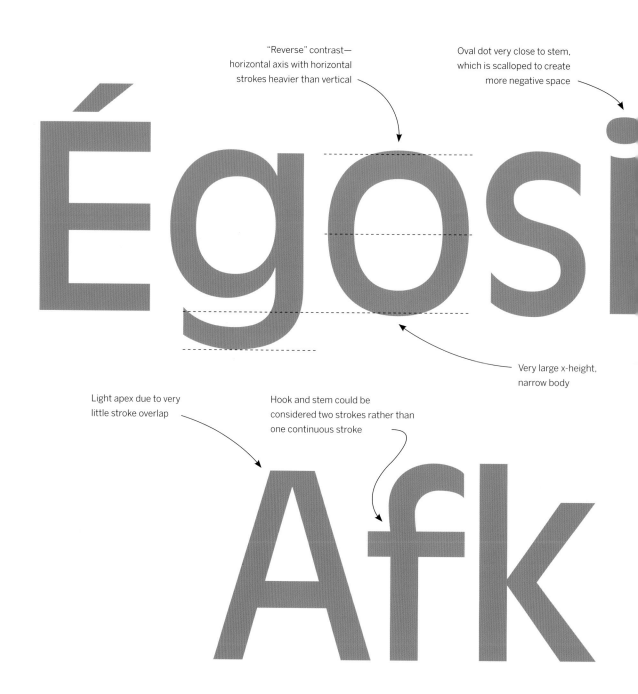

"Reverse" contrast—horizontal axis with horizontal strokes heavier than vertical

Oval dot very close to stem, which is scalloped to create more negative space

Very large x-height, narrow body

Light apex due to very little stroke overlap

Hook and stem could be considered two strokes rather than one continuous stroke

ABCDEFGHIJKLMNOPQRSTUVWXYZ

abcdefghijklmnopqrstuvwxyz

1234567890 ¼ ½ ¾ [âóÜßç](.,:;?!$£&-*){ÉÓÜÇ}

Antique Olive Roman

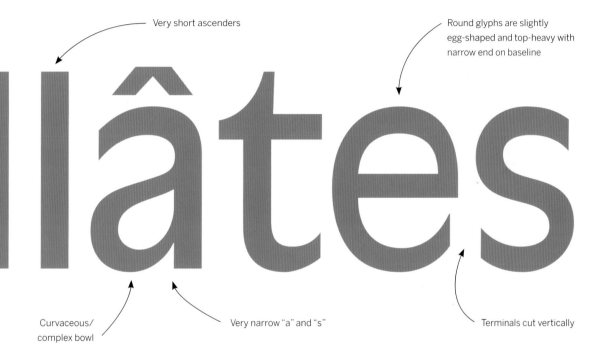

Very short ascenders

Round glyphs are slightly egg-shaped and top-heavy with narrow end on baseline

Curvaceous/ complex bowl

Very narrow "a" and "s"

Terminals cut vertically

Erik Spiekermann quips that German/Swiss type is like a pre-1990s Mercedes, Teutonic and utilitarian; and French type is like a Citroën 2CV, with sensual curves that value form over function. At first glance, **Antique Olive** certainly fits that analogy. Roger Excoffon's unusual creation defies categorization. Its main peculiarity is in its horizontal axis—heavy top and bottom, light in the middle. Add the uniformly sheared terminals, the very large x-height, and the oval rounds, and you get an odd but charming duck. Though the round shapes do look like olives, that's not how this face got its name. It was made for Fonderie Olive. "Antique" was the French term for sans serif, not "old." Still, Antique Olive can feel dated. For a more contemporary option see **FF Balance**.

Compare to:

GRgoseat

FF Balance

Background typefaces are Bell Centennial and Benton Sans

Gothic Sans

Bell Centennial

Designer: Matthew Carter // **Foundry:** Linotype, Adobe, Bitstream // **Country of origin:** United States
Release year: 1978 // **Classification:** Gothic Sans

Apex is heaviest part of glyph, requiring a large ink trap

Ink traps follow path of diagonal strokes

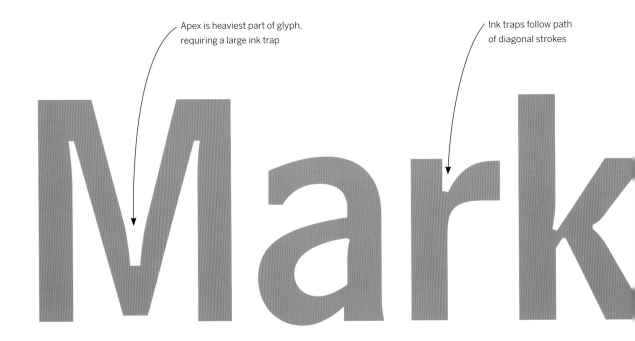

Multiple ink traps in close proximity give strokes an unusual bowing effect

Squared terminals

Minimal contrast

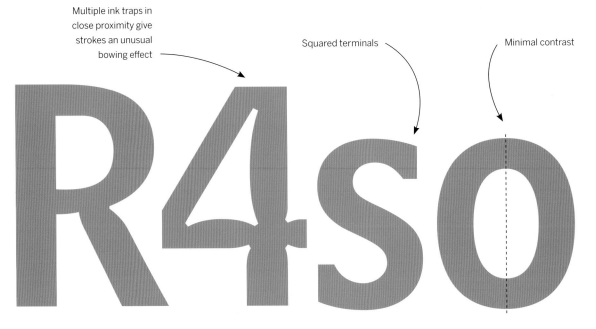

ABCDEFGHIJKLMNOPQRSTUVWXYZ
abcdefghijklmnopqrstuvwxyz 1234567890
1_4 1_2 3_4 [àóüßç](.,:;?!$£&-*){ÀÓÜÇ}

Bell Centennial Name & Number

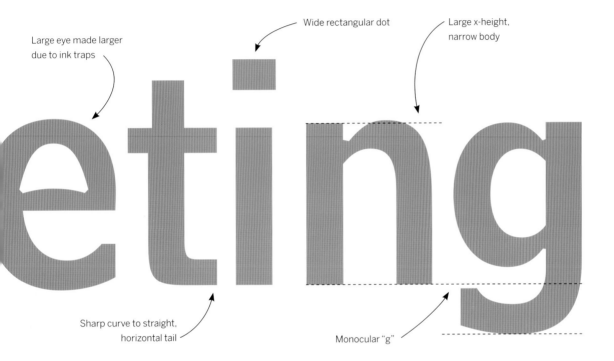

Large eye made larger
due to ink traps

Wide rectangular dot

Large x-height,
narrow body

Sharp curve to straight,
horizontal tail

Monocular "g"

Bell Centennial's bizarre "4" and "M" are a perfect lesson in type made specifically for its intended medium. In this case, the platform was telephone books. In 1974, AT&T asked Matthew Carter to replace their previous typeface, Bell Gothic, with something that could save costs by fitting more lines per page. To keep the type legible at tiny sizes on cheap paper, Carter made extensive use of a compensation technique called "ink trapping." This reduces the amount of ink-spread that distorts letters by filling junctions and counters. So, what looks strange, even ugly, at large sizes, actually takes its proper form on the pulpy pages of a directory. Many capitalize on Bell Centennial's curiosity to set eye-catching headlines.

Compare to:

NVAsgakei

Amplitude

NVAsgakei

News Gothic

News Gothic

Designer: (Morris Fuller Benton) Bitstream staff // **Foundry:** (American Type Founders) Bitstream
Country of origin: United States // **Release year:** (1908) 1958 // **Classification:** Gothic Sans

Bowl curves downward
from stem

Rounds are oval, almost
egg-shaped, with
pointed end on top

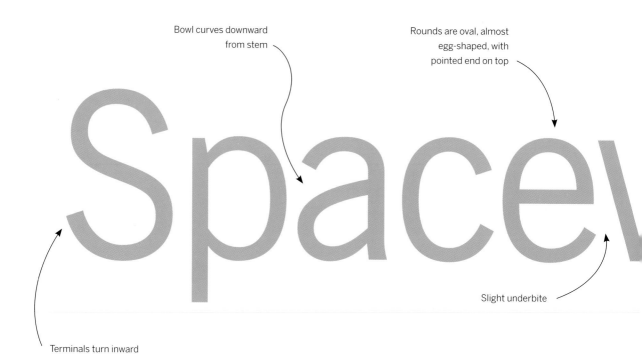

Slight underbite

Terminals turn inward

Minimal contrast

Very narrow "r"

Tail crosses
rounded stroke

ABCDEFGHIJKLMNOPQRSTUVWXYZ
abcdefghijklmnopqrstuvwxyz 1234567890
¼ ½ ¾ [àóüßç](.,:;?!$£&-*){ÀÓÜÇ}

News Gothic BT Roman

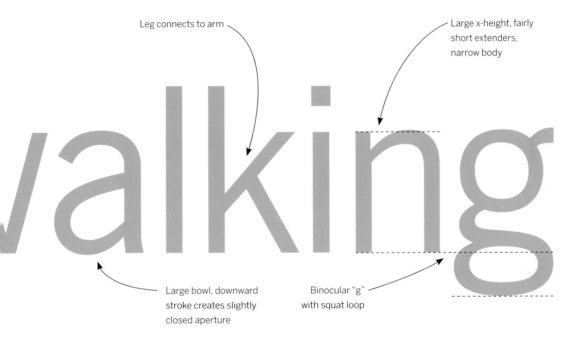

Leg connects to arm

Large x-height, fairly
short extenders,
narrow body

Large bowl, downward
stroke creates slightly
closed aperture

Binocular "g"
with squat loop

In many ways, this is the archetypal American sans serif. Designed by the prolific Morris Fuller Benton in 1908, **News Gothic** (and its Linotype follower, Trade Gothic) became the most popular sans in the States for several decades. Designers growing tired of traditional type were drawn to its clean, sensible demeanor and the versatility of its compact, monolinear structure. Benton only designed a few weights for News Gothic; other compatible styles were added later, some with different typeface names. The digital version shown here is Bitstream's, which modernizes some of the characters and gathers all the disparate styles into a more consistent family. Benton Sans performs a similar service with an even wider range. ***Good for:*** A perennial no-nonsense workhorse.

Compare to:

agekyjs

Benton Sans

agekyjs

Whitney

Benton Sans

Designer: (Morris Fuller Benton) Tobias Frere-Jones, Cyrus Highsmith // **Foundry:** (American Type Founders) Font Bureau
Country of origin: United States // **Release years:** (1908) 1995–2008 // **Classification:** Gothic Sans

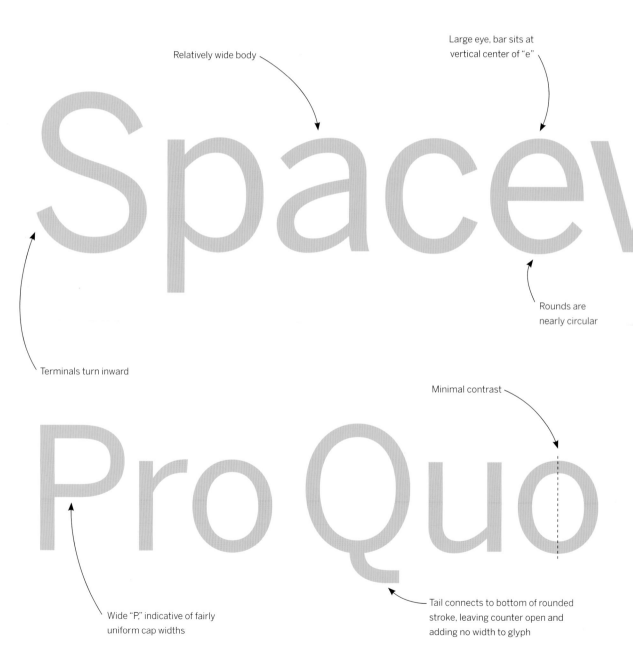

Relatively wide body

Large eye, bar sits at vertical center of "e"

Rounds are nearly circular

Terminals turn inward

Minimal contrast

Wide "P," indicative of fairly uniform cap widths

Tail connects to bottom of rounded stroke, leaving counter open and adding no width to glyph

ABCDEFGHIJKLMNOPQRSTUVWXYZ
abcdefghijklmnopqrstuvwxyz 1234567890
¼ ½ ¾ [àóüßç](.,:;?!$£&-*){ÀÓÜÇ}

Benton Sans Regular

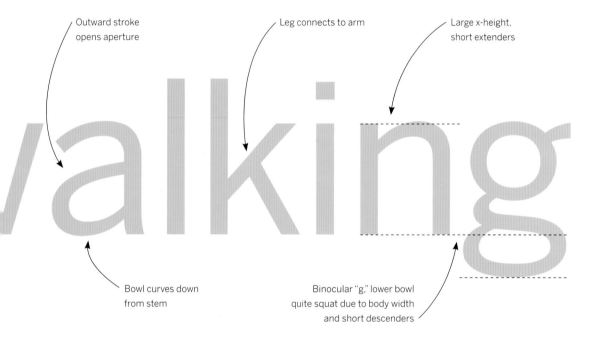

Outward stroke
opens aperture

Leg connects to arm

Large x-height,
short extenders

Bowl curves down
from stem

Binocular "g," lower bowl
quite squat due to body width
and short descenders

Benton Sans is a welcome update to Morris Fuller
Benton's News Gothic. At first glance it's clear that
the new face owes a lot to its forefather, but there are
some major advancements that bring Benton's classic
into the 21st century. The regular width is slightly wider,
allowing it to set paragraphs of text at a smaller size.
Terminals point outward, opening apertures and further
improving readability. But the most important
enhancement is the breadth of the family: eight weights
in each of four widths. This large set of options is typical
of Font Bureau's offerings—megafamilies made for the
demands of publication design. *Good for:* Sturdy, plain
type for complex typographic hierarchies.

Compare to:

agekyjs

News Gothic BT

agekyjs

Whitney

Whitney

Designer: H&FJ staff // **Foundry:** Hoefler & Frere-Jones // **Country of origin:** United States
Release year: 2004 // **Classification:** Gothic Sans

Outward-facing terminals
and open aperture, leads
into neighboring letters

Spacev

Terminals point outward

Angled terminal on
ascending and
descending stems

Bowl curves down
from stem

Minimal contrast

Ugos

Alternative "U" with spur

Alternative monocular "g"

ABCDEFGHIJKLMNOPQRSTUVWXYZ
abcdefghijklmnopqrstuvwxyz 12334567890
¼ ½ ¾ [àóüßç](.,:;?!$£&-*){ÀÓÜÇ}

Whitney Medium

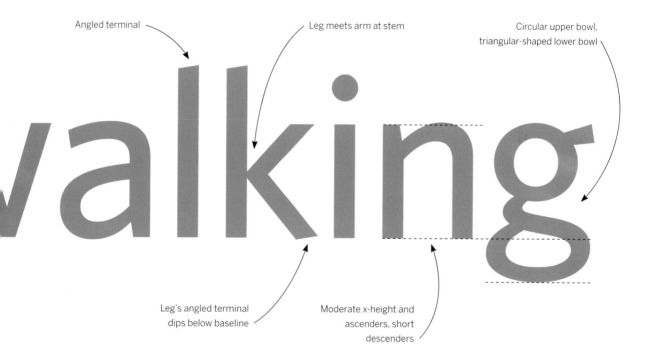

Angled terminal

Leg meets arm at stem

Circular upper bowl, triangular-shaped lower bowl

Leg's angled terminal dips below baseline

Moderate x-height and ascenders, short descenders

As a base, **Whitney** is a Gothic—doing much of what **Benton Sans** does for **News Gothic**—only it takes the style a big step further into Humanist territory, evolving into a more expressive sans serif that combines the best of the two categories. The apertures are very open and stems have a diagonal cut at their ends, adding to the contemporary feel. A bevy of alternative forms lend even more versatility, allowing the user to tone down the personality by swapping out the angled terminals. Whitney is not only a great Text face, it's also tuned for wayfinding systems, with a compact design that is still clear from a distance. There is also a very complete set of figures as well as circled and squared "index" numbers to aid in infographics.

Compare to:

rstikfg

News Gothic BT

rstikfg

Benton Sans

Background typefaces are ITC Avant Garde Gothic and MVB Solano Gothic

Geometric Sans

xXxXX

Futura ND

Designer: (Paul Renner) Marie-Therésè Koreman // **Foundry:** (Bauer Type Foundry) Neufville //
Country of origin: (Germany) Spain // **Release years:** (1927) 1999–2012 // **Classification:** Geometric Sans

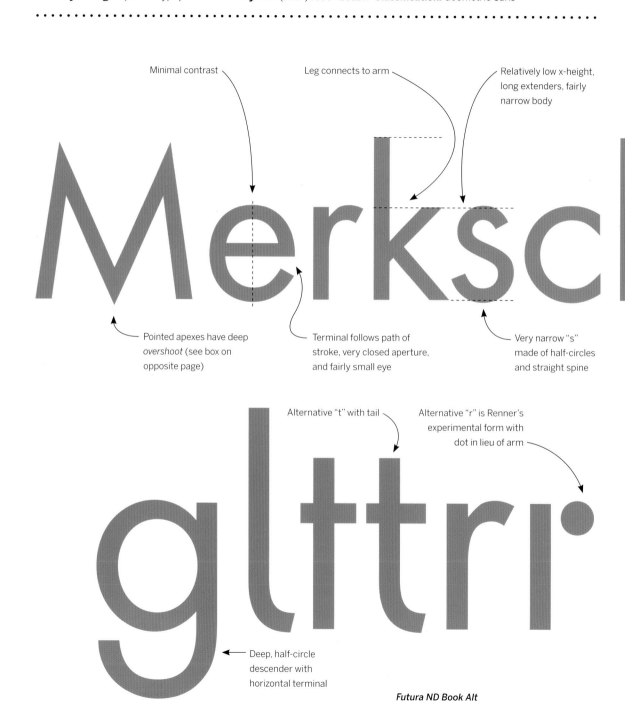

Minimal contrast

Leg connects to arm

Relatively low x-height, long extenders, fairly narrow body

Pointed apexes have deep *overshoot* (see box on opposite page)

Terminal follows path of stroke, very closed aperture, and fairly small eye

Very narrow "s" made of half-circles and straight spine

Alternative "t" with tail

Alternative "r" is Renner's experimental form with dot in lieu of arm

Deep, half-circle descender with horizontal terminal

Futura ND Book Alt

ABCDEFGHIJKLMNOPQRSTUVWXYZ
abcdefghijklmnopqrstuvwxyz 1234567890 163
¼ ⅔ ⅝ [äóüßç](.,:;¿!$£&-*){ÀÓÜÇ}

Futura ND Book

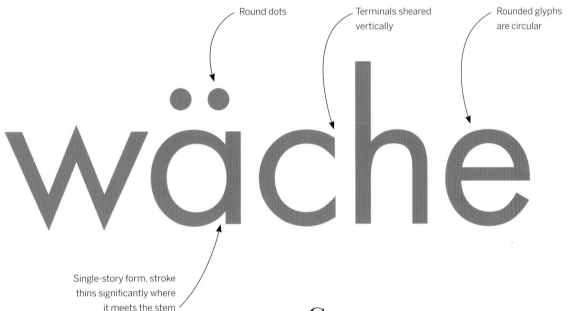

Round dots

Terminals sheared vertically

Rounded glyphs are circular

Single-story form, stroke thins significantly where it meets the stem

Compare to:

Rtaeopsy

Avenir 55

Rtaeopsy

Gotham

Rtaeopsy

Verlag

Futura has become widely known as the prototypical Geometric typeface. Bauhaus experiments in geometric form led Paul Renner to develop a typeface that was initially made entirely of straight lines and circular shapes. This was eventually tamed into more conventional letterforms, but they remained mostly Geometric. Futura's capitals are based on classical proportions, explaining their variable widths. There are countless digital versions, but **Futura ND** comes directly from original sources, and the latest release includes alternatives previously unavailable. Caution: the protrusion of pointed apexes ("M," "N," "w") is called "overshoot," an optical compensation for type intended for Text sizes, but potentially distracting when large.

Avenir

Designer: Adrian Frutiger // **Foundry:** Linotype, Germany // **Country of origin:** France, Germany
Release year: 1988 // **Classification:** Geometric Sans

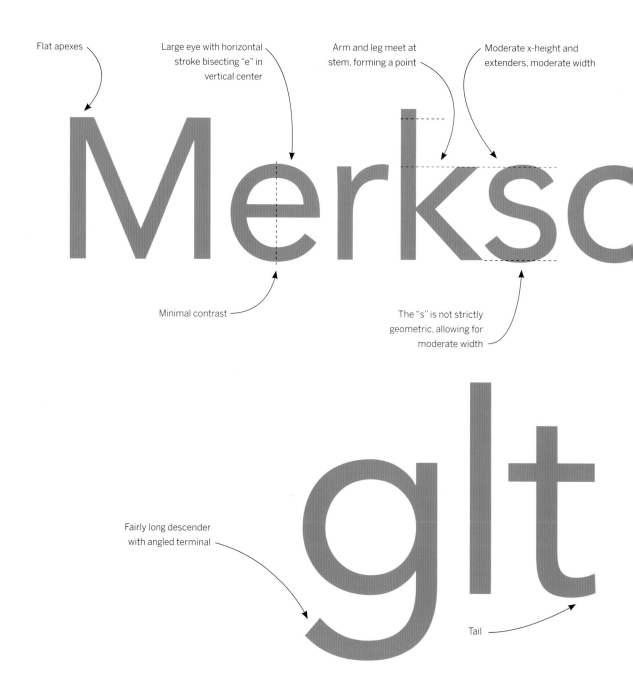

Flat apexes

Large eye with horizontal stroke bisecting "e" in vertical center

Arm and leg meet at stem, forming a point

Moderate x-height and extenders, moderate width

Minimal contrast

The "s" is not strictly geometric, allowing for moderate width

Fairly long descender with angled terminal

Tail

ABCDEFGHIJKLMNOPQRSTUVWXYZ

abcdefghijklmnopqrstuvwxyz 1234567890

¼ ½ ¾ [äóüßç](.,:;?!$£&-*){ÀÓÜÇ}

Avenir 55 Roman

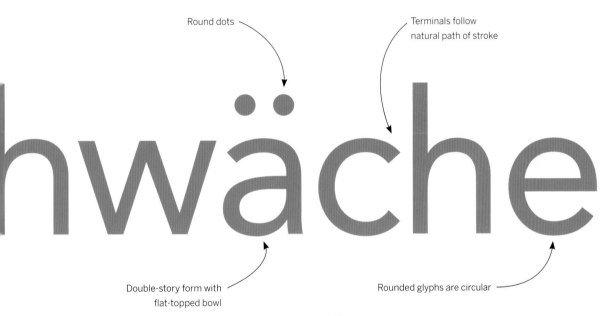

Round dots

Terminals follow
natural path of stroke

Double-story form with
flat-topped bowl

Rounded glyphs are circular

Compare to:

Rtaeopsy

Futura ND

Rtaeopsy

Gotham

Rtaeopsy

Verlag

"Right from the beginning, I was convinced that **Avenir** is the better Futura," said a confident Adrian Frutiger in a recent interview looking back at his 1988 creation. In some respects, his declaration was more than mere boasting—coming 60 years after Futura, Avenir remedied many of the compromises that Renner made in his quest for geometry. Frutiger abandoned pure circles and strictly even stroke weight for "corrected" curves and a bit of contrast. Letter widths are more regular, the x-height is larger, and a double-story "a" replaces the less legible single-story one. Avenir retains the simplicity and clarity of a Geometric sans serif; it just does it more gracefully, sacrificing graphical purity for readability. ***Good for:*** Comfortable geometric type.

Gotham

Designer: Tobias Frere-Jones // **Foundry:** Hoefler & Frere-Jones // **Country of origin:** United States
Release year: 2000 // **Classification:** Geometric Sans

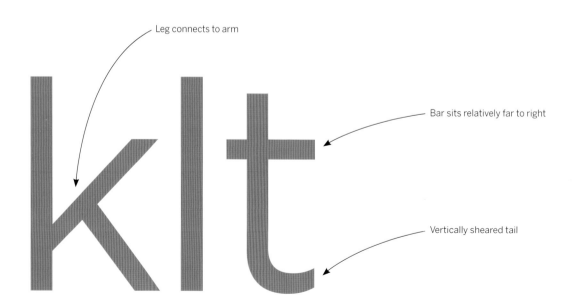

Large bowl and aperture

Rounded glyphs
are nearly circular

Flat apexes, pointed middle
apex. Diagonals meet far
above the baseline

Standard "a" has double-
story form with oval bowl

Minimal contrast

Leg connects to arm

Bar sits relatively far to right

Vertically sheared tail

ABCDEFGHIJKLMNOPQRSTUVWXYZ
abcdefghijklmnopqrstuvwxyz 1234567890
¼ ⅔ ⅝ [àóüßç](.,:;?!$£&-*){ÀÓÜÇ}

Gotham Book

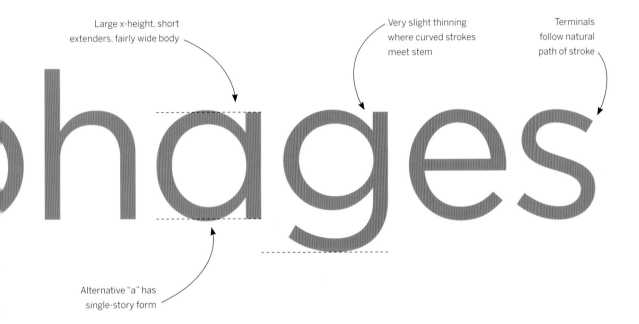

Large x-height, short
extenders, fairly wide body

Very slight thinning
where curved strokes
meet stem

Terminals
follow natural
path of stroke

Alternative "a" has
single-story form

One can't really describe this Hoefler & Frere-Jones
creation better than H&FJ themselves: "**Gotham**.
What letters look like." The typeface is simply self-
evident. Each character just feels "normal" and "right."
Inspired by mid-century architectural lettering of New
York City, Gotham celebrates the alphabet's most basic
form. These qualities made Gotham the most popular
release of recent years. It's used everywhere, in logos,
in magazines, in the very things that inspired it: signs.
Gotham's simplicity is not merely geometric—like
Avenir, it feels more natural than mechanical. In fact,
its lowercase shares a lot with Avenir's, despite being
much larger. But Gotham's essence is in the caps:
broad, sturdy "block" letters of very consistent width.

Compare to:

Matoeg

Avenir 55

Matoeg

ITC Avant Garde Gothic

ITC Avant Garde Gothic

Designer: Herb Lubalin, Tom Carnase // **Foundry:** ITC // **Country of origin:** United States
Release year: 1970 // **Classification:** Geometric Sans

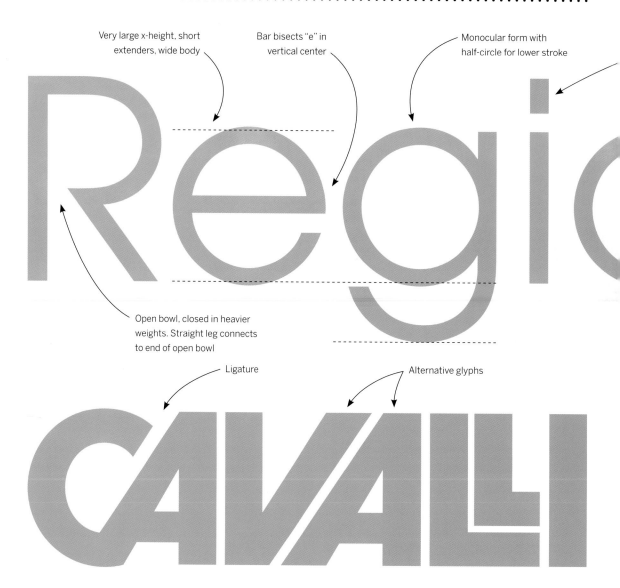

Very large x-height, short extenders, wide body

Bar bisects "e" in vertical center

Monocular form with half-circle for lower stroke

Open bowl, closed in heavier weights. Straight leg connects to end of open bowl

Ligature

Alternative glyphs

ITC Avant Garde Gothic Bold

AABCCⱭDEFFⱭGHIJKLLⱢMⱮNOPⱣⱤQ RⱤⱭSTŦUU
VⱯWWXYZ abcdefghijklmnopqrstuvwxyz
1234567890 ¼ ⅔ ⅝ (àóüßç)(.,:;?!$£&-*){ÀÓÜÇ}

ITC Avant Garde Gothic Book

Rectangular dot meets height of caps and ascenders

Rounded glyphs are perfect circles with a slight thinning at connection to stem

Horizontal terminals

onals

No stroke contrast, absolute geometry

Very narrow "s" made of half-circles

ITC Avant Garde Gothic was a response to popular demand for the type in the logo of *Avant Garde*, a groundbreaking magazine of the 1960s. The logo, designed by Herb Lubalin, was lettered by Tom Carnase. From it the two created a typeface for use in the magazine only. Later it became ITC's first offering. Key traits are a large x-height, strict geometry, and the infamous leaning letters and ligatures that allow extra tight fitting words. These glyphs are often abused, leading Ed Benguiat to famously declare, "The only place Avant Garde looks good is in the words 'Avant Garde.'" There are a few digital versions of the typeface. The ITC Pro fonts have many of the alts and ligs, but with merely slanted obliques instead of corrected ones offered by Elsner+Flake.

Compare to:

Rsotae

Gotham

Rsotae

Futura ND

Calibre/Metric

Designer: Kris Sowersby // **Foundry:** Klim // **Country of origin:** New Zealand
Release year: 2011 // **Classification:** Geometric Sans

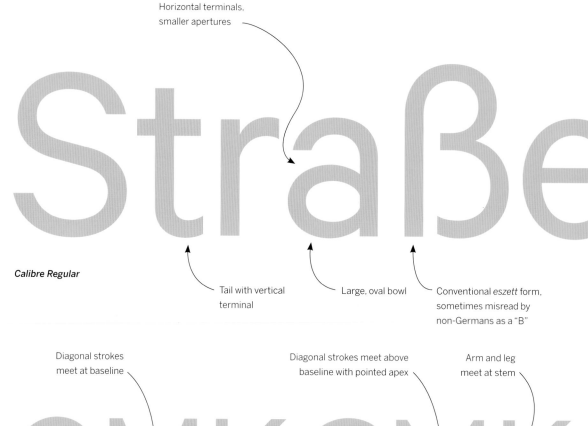

Horizontal terminals,
smaller apertures

Calibre Regular

Tail with vertical
terminal

Large, oval bowl

Conventional *eszett* form,
sometimes misread by
non-Germans as a "B"

Diagonal strokes
meet at baseline

Diagonal strokes meet above
baseline with pointed apex

Arm and leg
meet at stem

Calibre Regular

Metric Regular

Leg connects to arm

Flat sided "G"

ABCDEFGHIJKLMNOPQRSTUVWXYZ

abcdefghijklmnopqrstuvwxyz 1234567890

¼ ⅔ ⅝ [àóüʃç](.,:;?!$£&-*){ÀÓÜÇ}

Metric Regular

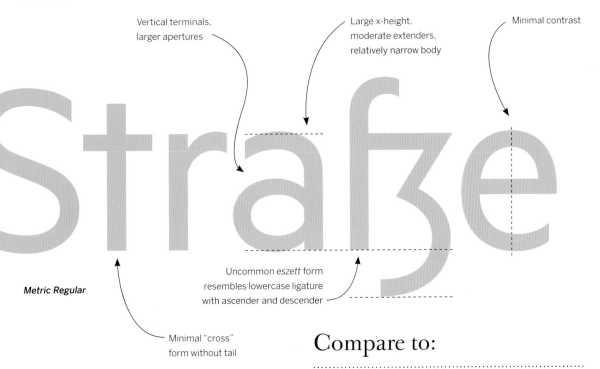

Vertical terminals, larger apertures

Large x-height, moderate extenders, relatively narrow body

Minimal contrast

Metric Regular

Uncommon *eszett* form resembles lowercase ligature with ascender and descender

Minimal "cross" form without tail

Compare to:

GMKalgies

Interstate

GMKalgies

FF DIN

GMKalgies

Verlag

Metric is a loose interpretation of the West Berlin street signs that impressed designer Kris Sowersby on a visit in 2010. It tempers the strict geometry of the original alphabets but retains the charm of letters designed by engineers. Most terminals are vertical, the "t" is a simple cross, and the "a" has an oval belly. **Calibre** retains the basic structure of Metric but extends many of the strokes so that they curve around to terminate horizontally, parallel with the baseline. This puts Calibre closer to Neo-Grotesque territory. Though published separately, the fonts can be used interchangeably. *Good for:* A fresh, yet still Rational, alternative to **Futura** or Helvetica.

FF DIN

Designer: Albert-Jan Pool // **Foundry:** FontFont // **Country of origin:** Germany
Release year: 1995 // **Classification:** Geometric Sans

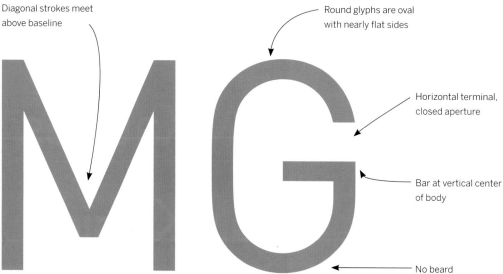

Alternative "G" with angled terminal

Leg connects to arm

Fairly wide "s" with nearly horizontal spine

Tail

Diagonal strokes meet above baseline

Round glyphs are oval with nearly flat sides

Horizontal terminal, closed aperture

Bar at vertical center of body

No beard

ABCDEFGHIJKLMNOPQRSTUVWXYZ

abcdefghijklmnopqrstuvwxyz ÆæŒœ 12345

67890 163 ¼ ½ ¾ [äóüßç](.,:;?!$£&-*]{ÀÓÜÇ}

FF DIN Regular

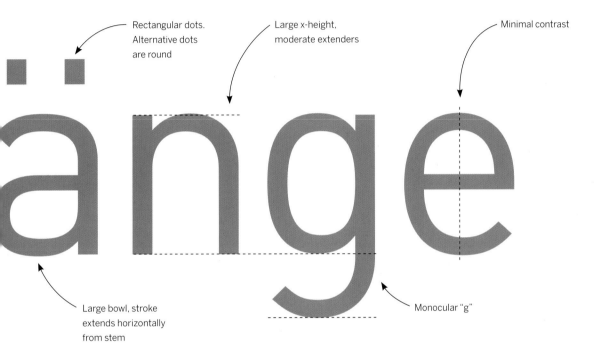

Rectangular dots. Alternative dots are round

Large x-height, moderate extenders

Minimal contrast

Large bowl, stroke extends horizontally from stem

Monocular "g"

DIN is essentially the national typeface of Germany. Developed over many years by the German Institute for Standardization (Deutsches Institut für Normung) for traffic signs and other official applications, DIN is an unusually successful design by committee. Its spare, geometric construction effectively communicates without artifice or distraction. But the institute's DIN 1451 was essentially drawn by engineers and lacked the subtleties of a type designer's expertise. For **FF DIN** Albert-Jan Pool took the challenge, easing some of the typeface's harsh geometry and expanding the simple two-width family into many more weights with all the requirements for professional digital typesetting.
Good for: Mechanical simplicity with a Teutonic touch.

Compare to:

Isagek GM

Heron Sans

Isagek GM

Akkurat

Interstate

Designer: Tobias Frere-Jones // **Foundry:** Font Bureau // **Country of origin:** United States
Release year: 1993 // **Classification:** Geometric Sans

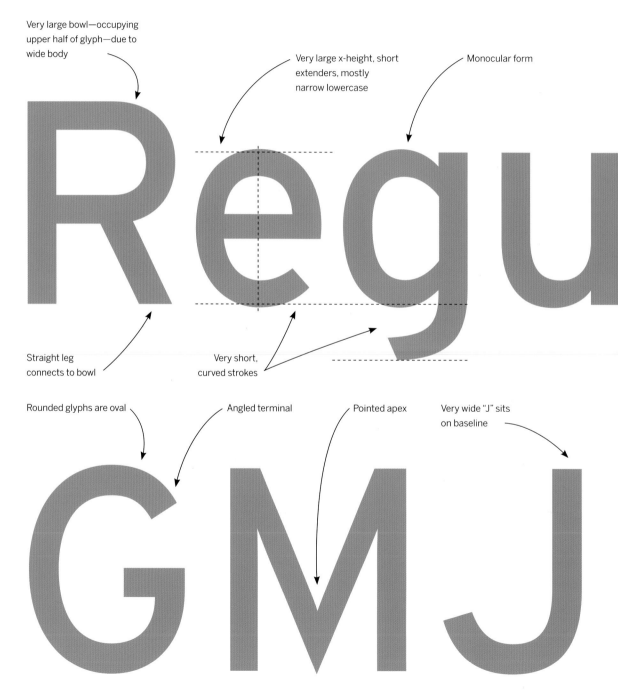

Very large bowl—occupying upper half of glyph—due to wide body

Very large x-height, short extenders, mostly narrow lowercase

Monocular form

Straight leg connects to bowl

Very short, curved strokes

Rounded glyphs are oval

Angled terminal

Pointed apex

Very wide "J" sits on baseline

ABCDEFGHIJKLMNOPQRSTUVWXYZ

abcdefghijklmnopqrstuvwxyz 1234567890

[àóüßç](.,:;?!$£&-*){ÀÓÜÇ}

Interstate Regular

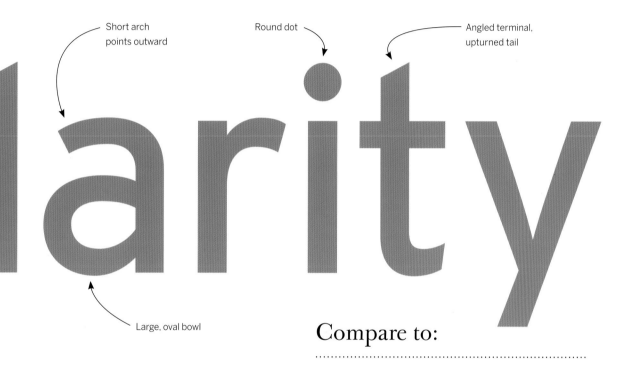

Short arch
points outward

Round dot

Angled terminal,
upturned tail

Large, oval bowl

Just as **FF DIN** does for Germany's official type, **Interstate** is a typographic adaptation of American road signs. The alphabets of the U.S. Federal Highway Administration are spare concoctions of straight lines and semicircles. Still, the simplicity and wide open forms of the FHWA Series suit it well for quick reading at a distance. Plus, over 50 years of exposure to the typefaces on mile markers and street signs has made them quite familiar and comfortable to American readers. Signs are gradually being replaced with those using a new typeface (Clearview Hwy), but we can continue to experience the old design in Tobias Frere-Jones's interpretation, a large and useful family of 40 fonts.

Compare to:

gilaeytsRGMJ

FF DIN

gilaeytsRGMJ

Metric

gilaeytsRGMJ

Calibre

Verlag

Designer: H&FJ staff // **Foundry:** Hoefler & Frere-Jones // **Country of origin:** United States
Release year: 2006 // **Classification:** Geometric Sans

. .

Large eye with relatively light
horizontal stroke bisecting
"e" at vertical center

Splayed "M," diagonals
meet just above baseline

Arm and leg meet at stem

Full convex bowl extends
beyond x-height

Pointed apexes

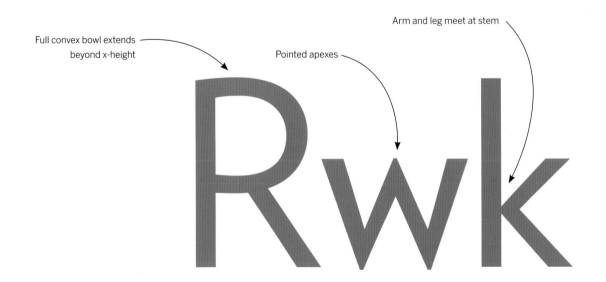

ABCDEFGHIJKLMNOPQRSTUVWXYZ
abcdefghijklmnopqrstuvwxyz 1234567890 163
[äóüßç](.,:;?!$£&-*){ÀÓÜÇ}

Verlag Book

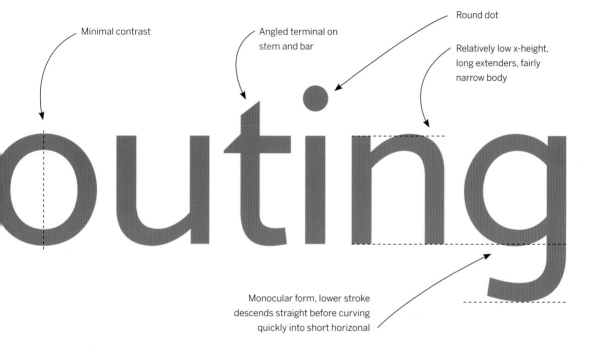

Minimal contrast

Angled terminal on
stem and bar

Round dot

Relatively low x-height,
long extenders, fairly
narrow body

Monocular form, lower stroke
descends straight before curving
quickly into short horizonal

Verlag is a successful adaptation of pre-war modernist sans serifs to a typographically sensitive family for 21st-century design. It combines the crispness of 1920s-era geometric pioneers Futura and Erbar with the gentler, more readable qualities of 1930s-era Metro, Tempo, and Vogue. The lower x-height, pointed (but not pin-sharp) apexes, open apertures, and full rounds make Verlag a very warm and elegant option among Geometrics. It was originally created for the Guggenheim Museum and later released publicly as an extremely useful 30-font family with typographic niceties like short lining figures to harmonize with the small lowercase in running text. *Good for:* Situations where Futura doesn't have enough flexibility or grace.

Compare to:

Motagw

Neutraface 2 Text

Motagw

Futura ND

Klavika

Designer: Eric Olson // **Foundry:** Process // **Country of origin:** United States
Release year: 2004 // **Classification:** Geometric Sans

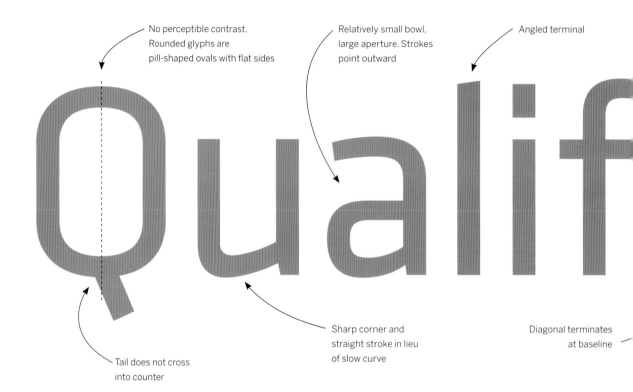

No perceptible contrast.
Rounded glyphs are
pill-shaped ovals with flat sides

Relatively small bowl,
large aperture. Strokes
point outward

Angled terminal

Sharp corner and
straight stroke in lieu
of slow curve

Diagonal terminates
at baseline

Tail does not cross
into counter

Minimal "r" with
short, straight arm

Arm and leg join without
touching stem

Squared curves,
straight spine

ABCDEFGHIJKLMNOPQRSTUVWXYZ

abcdefghijklmnopqrstuvwxyz 1234567890 163

¼ ½ ¾ [àóüßç](.,:;?!$£&-*){ÀÓÜÇ}

Klavika Regular

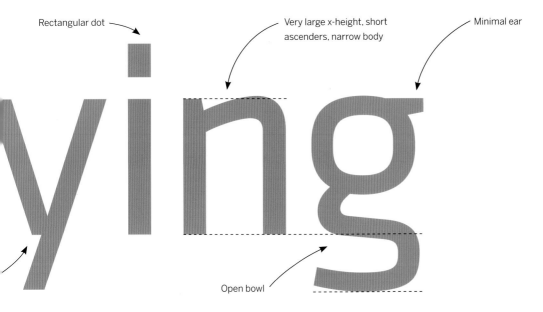

Rectangular dot

Very large x-height, short ascenders, narrow body

Minimal ear

Open bowl

Compare to:

RMGK ayig

Forza Book

RMGK ayig

MVB Solano Gothic

RMGK ayig

FF Unit

Released at the height of the "Web 2.0" era, **Klavika** has become a prototypical sans serif of the information age. This is reinforced by the fact that it is the basis for the Facebook logo, but it's been widely used in many other markets as well, including the automobile, sports, and publication industries. The foundation of the typeface is the pill shape. Lettershapes that are conventionally curved ("c," "e," "o," "s") are instead flat-sided with a slightly concave top and bottom. Rectangular Geometrics existed before, in 19th-century Display faces, and in the 1960s with Eurostile, but Klavika's freshness comes from its open apertures—terminals (even on the distinctive, open-bowled "g") point outward, allowing letters to breathe and relieving rigidity.

MVB Solano Gothic

Designer: Mark van Bronkhorst // **Foundry:** MVB Fonts // **Country of origin:** United States
Release years: 2007–2010 // **Classification:** Geometric Sans

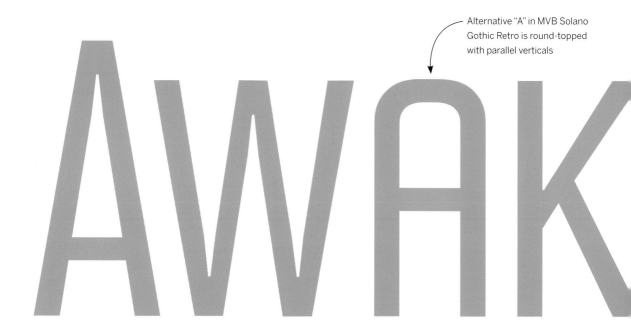

Alternative "A" in MVB Solano Gothic Retro is round-topped with parallel verticals

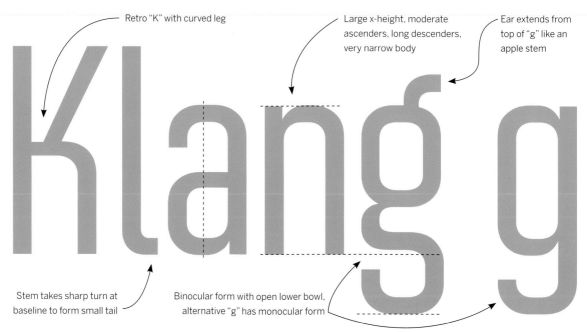

Retro "K" with curved leg

Large x-height, moderate ascenders, long descenders, very narrow body

Ear extends from top of "g" like an apple stem

Stem takes sharp turn at baseline to form small tail

Binocular form with open lower bowl, alternative "g" has monocular form

ABCDEFGHIJKLMNOPQRSTUVWXYZ

abcdefghijklmnopqrstuvwxyz 1234567890

¼ ⅔ ⅝ [àóüßç](„,:;?!$£&-*){ÀÓÜÇ}

MVB Solano Gothic Medium

Retro, two-stroke "N"

Rounded glyphs are rectangular, with flat top, bottom, and sides

ENInG

Compare to:

Klang

Forza Book

Klang

Heroic Condensed Regular

Klang

Klavika

MVB Solano Gothic Bold was originally designed as a Display face for the city of Albany (near San Francisco). Named for the city's main street, the typeface needed to work on signage surrounded by early 20th-century architecture, yet in current settings. Following a common sign-painting and architectural lettering style of the era, the design is based on a rounded rectangle and simple monolinear strokes. Alternative "Retro" fonts offer more decorative forms, such as a curved-leg "K," round-topped "A," and lowercase-style cap "N." *Good for:* Compact headlines and infographics. References to vintage workmanship.

Forza

Designer: H&FJ staff // **Foundry:** Hoefler & Frere-Jones // **Country of origin:** United States
Release year: 2010 // **Classification:** Geometric Sans

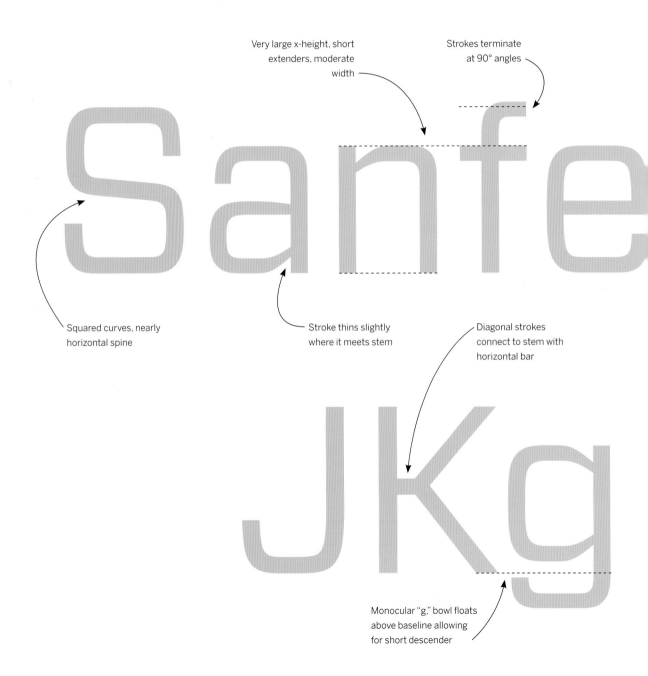

Very large x-height, short extenders, moderate width

Strokes terminate at 90° angles

Squared curves, nearly horizontal spine

Stroke thins slightly where it meets stem

Diagonal strokes connect to stem with horizontal bar

Monocular "g," bowl floats above baseline allowing for short descender

ABCDEFGHIJKLMNOPQRSTUVWXYZ
abcdefghijklmnopqrstuvwxyz 1234567890
[àóüßç](.,:;?!$£&-*){ÀÓÜÇ}

Forza Book

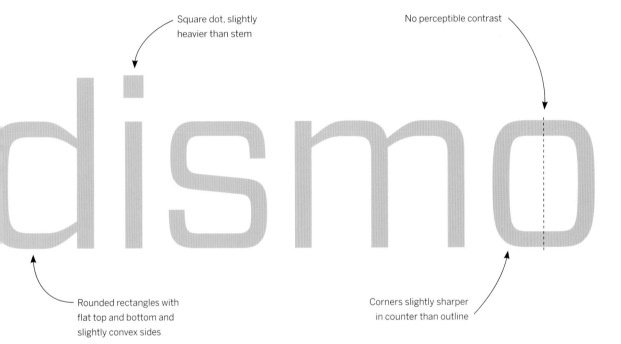

Square dot, slightly
heavier than stem

No perceptible contrast

Rounded rectangles with
flat top and bottom and
slightly convex sides

Corners slightly sharper
in counter than outline

When people think square sans, Bank Gothic or
Eurostile usually come to mind. But these designs
have become quite dated, each a particular relic of their
time. **Forza** closely follows Eurostile's path, but forges
its own way where it makes good sense: rounded shapes
are concave only on their sides, curved strokes meet
stems with a thinner, angled stroke or horizontal. These
refinements move the appearance away from the
blobby vintage TV shape associated with Eurostile,
particularly in its counters. Forza is actually the
de-seriffed version of Vitesse, which was designed
earlier. Both are strong, masculine typefaces that
command attention. ***Good for:*** Athletics. Automobiles.
Communicating toughness and authority.

Compare to:

SJKaefsod

Eurostile

SJKaefsod

MVB Solano Gothic

xxxxXx

Background typefaces are FF Yoga Sans and Auto 1

Humanist Sans

xxxxx

Gill Sans

Designer: Eric Gill // **Foundry:** Monotype // **Country of origin:** United Kingdom
Release years: 1928–1932 // **Classification:** Humanist/Geometric Sans

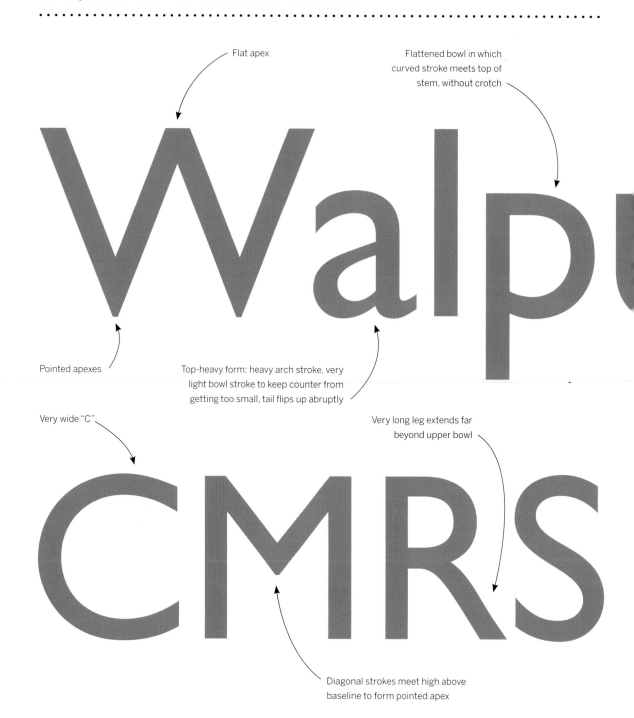

Flat apex

Flattened bowl in which curved stroke meets top of stem, without crotch

Pointed apexes

Top-heavy form: heavy arch stroke, very light bowl stroke to keep counter from getting too small, tail flips up abruptly

Very wide "C"

Very long leg extends far beyond upper bowl

Diagonal strokes meet high above baseline to form pointed apex

ABCDEFGHIJKLMNOPQRSTUVWXYZ
abcdefghijklmnopqrstuvwxyz 1234567890
¼ ½ ¾ [àóüßç](.,:;?!$£&-*){ÀÓÜÇ}

Gill Sans Regular

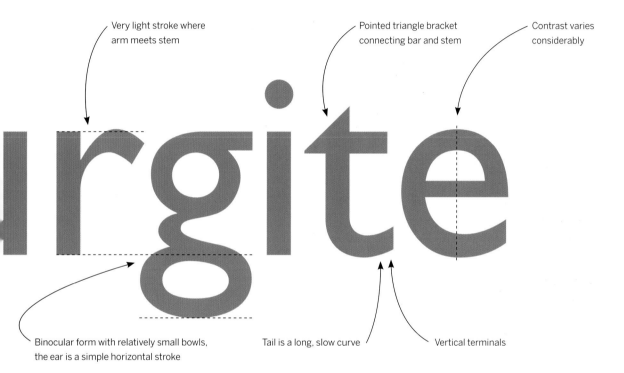

Very light stroke where
arm meets stem

Pointed triangle bracket
connecting bar and stem

Contrast varies
considerably

Binocular form with relatively small bowls,
the ear is a simple horizontal stroke

Tail is a long, slow curve

Vertical terminals

Long a standard part of the Mac's pre-installed font bundle, **Gill Sans** has become known to modern-day users as an elegant sans option when compared to the others they find on their computer. But in many ways, Eric Gill's typeface, a follower of Edward Johnston's type for the London Underground, is an awkward mix of Geometric and Humanist ideas—from its circular "o" to its dynamic, calligraphic "a." Uppercase widths vary wildly. The long-legged "R" causes spacing issues, especially in the lighter weights. And the "g" is an odd concoction that even Gill himself fittingly called a "pair of spectacles." Still, there is lasting charm in this face, and it has become synonymous with British culture ever since it debuted.

Compare to:

RMagype

FF Yoga Sans

FF Yoga Sans

Designer: Xavier Dupré // **Foundry:** FontFont // **Origin:** Cambodia, Germany
Release year: 2009 // **Classification:** Humanist Sans

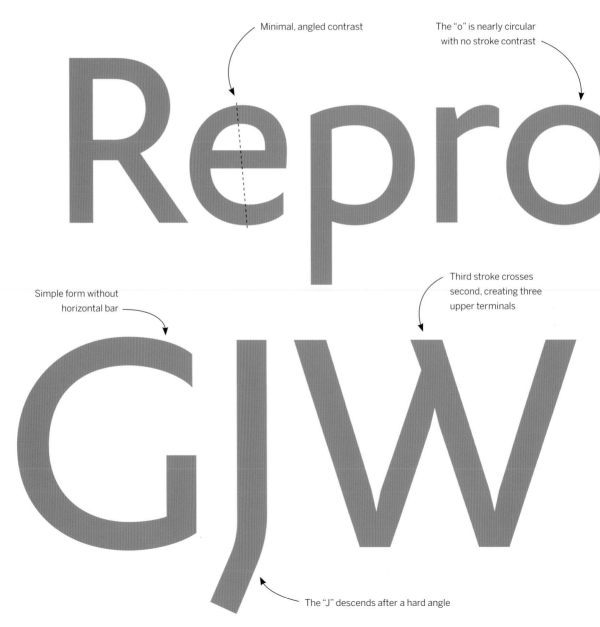

Minimal, angled contrast

The "o" is nearly circular with no stroke contrast

Simple form without horizontal bar

Third stroke crosses second, creating three upper terminals

The "J" descends after a hard angle

ABCDEFGHIJKLMNOPQRSTUVWXYZ

abcdefghijklmnopqrstuvwxyz 1234567890 163

¼ ⅔ ⅝ [àóüßç](.,:;?!$£&-*){ÀÓÜÇ}

FF Yoga Sans Regular

Overhanging arch with downward-facing terminal, bottom stroke is terminated vertically

Angled terminal. Terminals are taller than caps

Round dot

Moderate x-height, relatively long extenders, moderate width

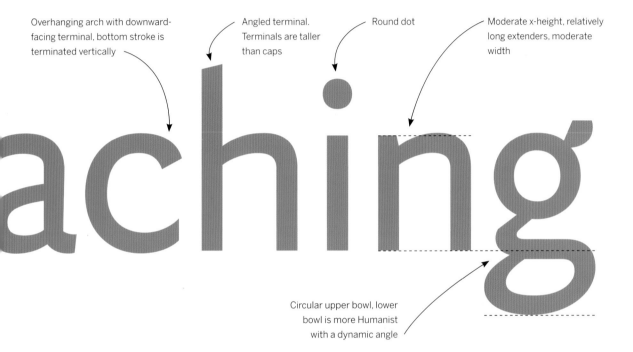

Circular upper bowl, lower bowl is more Humanist with a dynamic angle

FF Yoga Sans could be considered a **Gill Sans** for the 21st century. It speaks the same language as its ancestor, but Xavier Dupré reduces the stroke contrast, regularizes widths, and corrals all Gill's disparate approaches into a more cohesive design. Much of this is encapsulated in the "a," which actually resembles an early Gill Sans sketch that had a tamer character with a smooth, even stroke finishing in a more graceful tail. FF Yoga Sans is part of a double-barreled assault on the traditional classics, with its partner an update of Humanist serifs like Garamond. Not since **FF Scala** has there been such a bold attempt to redefine these models. *Good for:* When Gill Sans is wanted but its idiosyncrasies aren't.

Compare to:

RMagype

Gill Sans

Frutiger

Designer: Adrian Frutiger // **Foundry:** D. Stempel AG, Linotype // **Country of origin:** France, Germany
Release year: 1976 // **Classification:** Humanist Sans

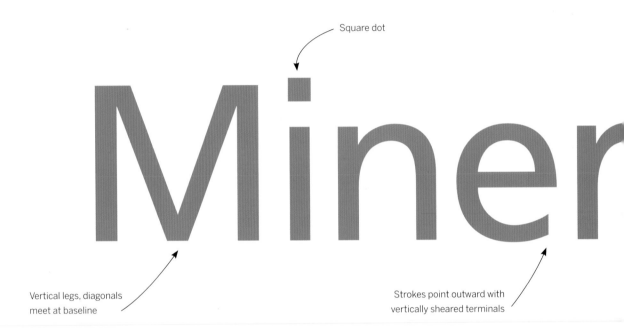

Square dot

Vertical legs, diagonals
meet at baseline

Strokes point outward with
vertically sheared terminals

Fairly small bowl

Arm and leg
meet at stem

Nearly straight leg

Tail curves
slightly upward

ABCDEFGHIJKLMNOPQRSTUVWXYZ

abcdefghijklmnopqrstuvwxyz 1234567890

¼ ½ ¾ [àóüßç](.,:;?!$£&-*){ÀÓÜÇ}

Frutiger 55 Roman

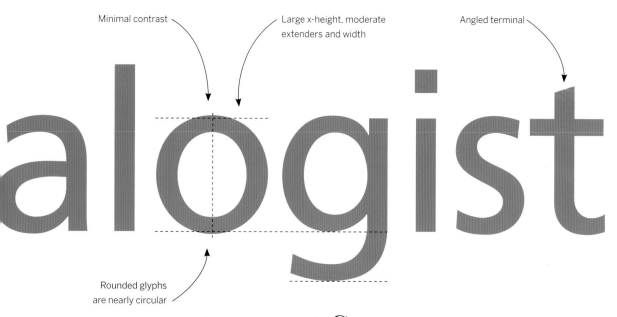

Minimal contrast

Large x-height, moderate extenders and width

Angled terminal

Rounded glyphs are nearly circular

Designed in the mid-1970s for the Charles de Gaulle Airport near Paris, Adrian Frutiger's eponymous typeface has become the wayfinding standard, adopted by airports and other institutions around the world. Frutiger began the commission by adapting his previous design, **Univers**, but favoring a Humanistic approach that aids legibility, obviously a critical factor in airport signage. Thanks to its open apertures, **Frutiger** is famously readable from a wide range of angles and distances. Still, there is a lot of Univers in this typeface, with its very slight stroke contrast and plain forms.
Good for: Simple, unaffected clarity.

Compare to:

MRgeaksyi

Myriad

MRgeaksyi

Verdana

MRgeaksyi

Univers

Myriad

Designer: Carol Twombly, Robert Slimbach // **Foundry:** Adobe // **Country of origin:** United States
Release year: 1992 // **Classification:** Humanist Sans

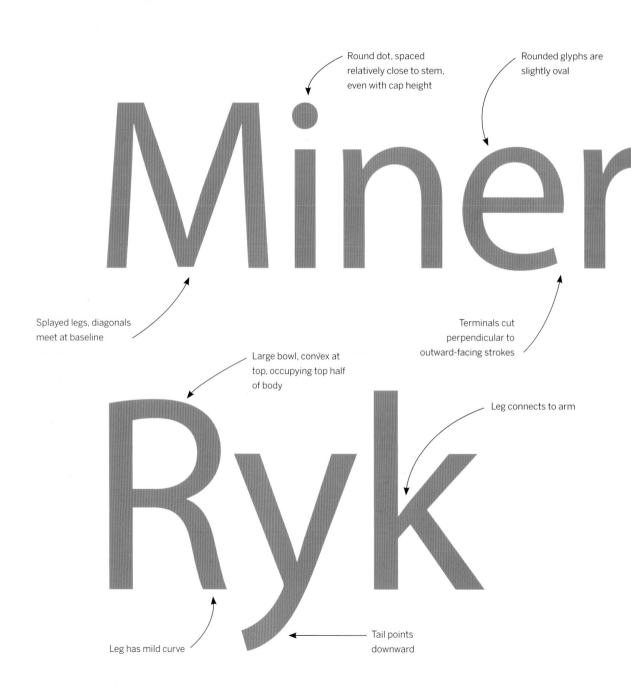

Round dot, spaced relatively close to stem, even with cap height

Rounded glyphs are slightly oval

Splayed legs, diagonals meet at baseline

Terminals cut perpendicular to outward-facing strokes

Large bowl, convex at top, occupying top half of body

Leg connects to arm

Leg has mild curve

Tail points downward

ABCDEFGHIJKLMNOPQRSTUVWXYZ

abcdefghijklmnopqrstuvwxyz 1234567890 163

¼ ½ ¾ [àóüßç](.,:;?!$£&-*){ÀÓÜÇ}

Myriad Regular

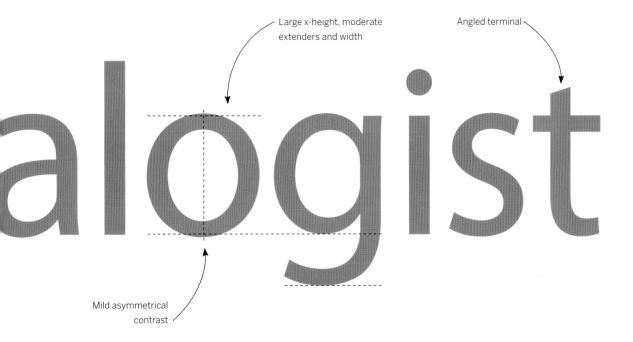

Large x-height, moderate
extenders and width

Angled terminal

Mild asymmetrical
contrast

Compare to:

A skeptic might denigrate this typeface, calling it simply "Adobe's **Frutiger**." **Myriad** does owe a lot to the grandaddy of modern Humanist sans serifs, but it brings its own contributions to the table. Where Frutiger's curved strokes end abruptly with mostly vertical cuts, Myriad has angled terminals that naturally follow the path of the stroke. Letters like the "M" and "R" are more Humanistic as well, and the dots are round, not square. All these make Myriad a slightly warmer, friendlier Frutiger, while retaining its modern simplicity. These attributes make it an ideal identity face for companies like Apple who want to be high-tech but approachable. Functionally, Myriad also offers more as the family is much larger.

MRgeaksyi

Frutiger

Verdana

Designer: Matthew Carter // **Foundry:** Microsoft // **Country of origin:** United States
Release year: 1994 // **Classification:** Humanist Sans

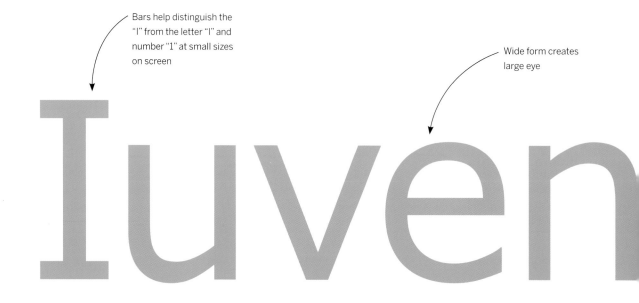

Bars help distinguish the "I" from the letter "l" and number "1" at small sizes on screen

Wide form creates large eye

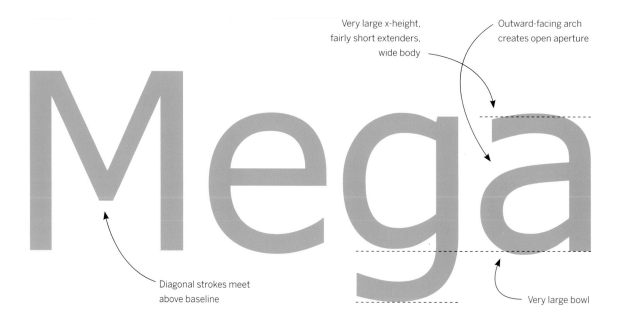

Very large x-height, fairly short extenders, wide body

Outward-facing arch creates open aperture

Diagonal strokes meet above baseline

Very large bowl

ABCDEFGHIJKLMNOPQRSTUVWXYZ
abcdefghijklmnopqrstuvwxyz 1234567890
¼ ½ ⅝ [àóüßç](.,:;?!$£&-*){ÀÓÜÇ}

Verdana Regular

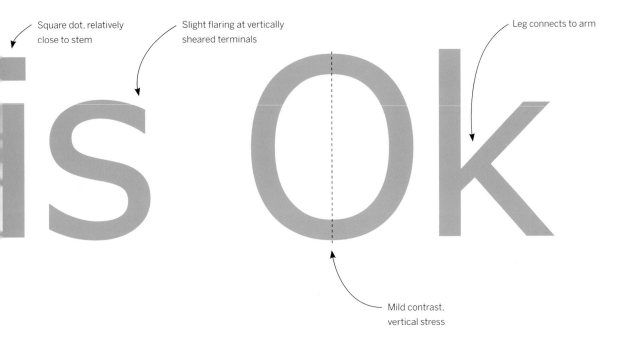

Square dot, relatively
close to stem

Slight flaring at vertically
sheared terminals

Leg connects to arm

Mild contrast,
vertical stress

Matthew Carter is probably one of the most well-known living type designers. He gained that position not by imposing a recognizable personal style but by solving design problems, by creating functional type that serves a specific need. Just like **Bell Centennial**, Verdana is another case in point. Its large, broad lowercase letters with slightly flaring terminals, its seriffed "I," "J," and "j," and its loose spacing can appear almost horsey when viewed large or in print. But this typeface was made for the screen. Every design decision makes Verdana the most legible small Text option for the coarse resolutions of all but the most modern displays. The family, along with Georgia, was recently expanded to 20 styles, including a very welcome condensed width.

Compare to:

IMaesgky

Frutiger

Syntax

Designer: Hans Eduard Meier // **Foundry:** D. Stempel AG, Linotype // **Country of origin:** Switzerland, Germany
Release year: 1968 // **Classification:** Humanist Sans

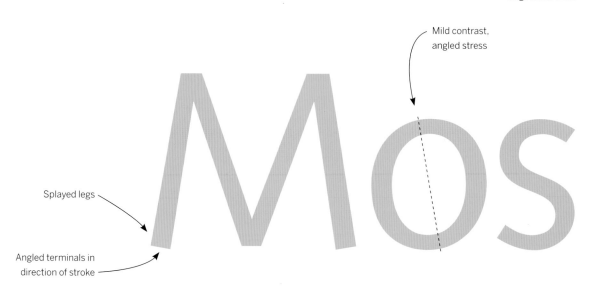

Arm and leg meet at stem, creating a sharp point

All letters lean slightly to right

Binocular form, large lower bowl

Mild contrast, angled stress

Splayed legs

Angled terminals in direction of stroke

ABCDEFGHIJKLMNOPQRSTUVWXYZ

abcdefghijklmnopqrstuvwxyz 1234567890

¼ ½ ¾ [àóüßç](.,:;?!$£&-*){ÀÓÜÇ}

Syntax Roman

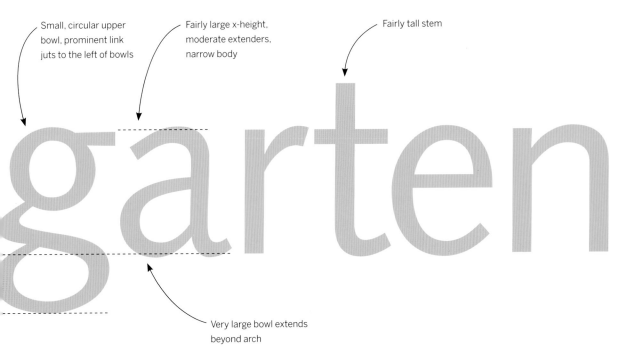

Small, circular upper bowl, prominent link juts to the left of bowls

Fairly large x-height, moderate extenders, narrow body

Fairly tall stem

Very large bowl extends beyond arch

One of the first of its kind, **Syntax** is a sans serif that shows obvious ties to Humanist serif roots. It is based on Stempel Garamond, and while it wouldn't work to simply trim the serifs off an old-style book face, Syntax comes very close. The forms are calligraphic, with a fairly consistent angled axis that gives Syntax a dynamic motion. Every character leans slightly forward, even the stems, adding to this sans serif's unusually forward movement. Angled strokes also terminate at an angle, rather than sitting flat on the baseline. This is an uncommon feature and can be a distraction when large, but at Text sizes it feels like a natural part of Syntax's lively attitude. ***Good for:*** Modernizing and energizing text that would otherwise be set in a serif.

Compare to:

Kaesgt

Today Sans

Kaesgt

Cronos

Cronos

Designer: Robert Slimbach // **Foundry:** Adobe // **Country of origin:** United States
Release year: 1996 // **Classification:** Humanist Sans

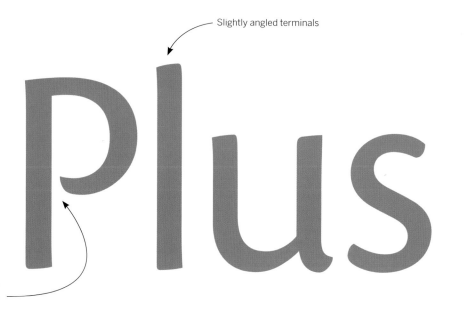

Pen-influenced downstrokes extend beyond upstrokes

Soft, rounded terminal

Moderate x-height and extenders, fairly narrow body

Binocular form

Slightly angled terminals

Open bowl reveals calligraphic stroke

ABCDEFGHIJKLMNOPQRSTUVWXYZ

abcdefghijklmnopqrstuvwxyz ctststþ 1234567890 163

¼ ⅔ ⅝ [àóüßç](.,:;?!$£&-*){ÀÓÜÇ}

Cronos Regular

Moderate contrast, angled stress

Bottom stroke faces outward, creating a very large aperture

Small dent in eye where calligraphic stroke changes direction

opere

Calligraphic pointed terminals

Compare to:

MGpets

Today Sans

MGpets

Syntax

MGpets

Optima

Like **Syntax**, **Cronos** echoes the organic feeling and readability of old-style serif type. But, in contrast to the angular energy of Syntax, Cronos has a soft, calligraphic finish with pointed curves and rounded terminals. These letters genuinely appear to be written by a very steady hand. The overall effect is quite pleasant and comfortable. Adobe gave Cronos its optical sizes treatment, offering low-contrast, large x-height type for small text, and more expressive, higher-contrast type for Display uses, but the adjustments are minimal compared to optical sizes of other families, especially Garamond Premier. See also the older Today Sans by Volker Küster. *Good for:* Organic goods. Contemporary wedding invitations. A subdued alternative to calligraphy.

TheSans

Designer: Luc(as) de Groot // **Foundry:** LucasFonts // **Country of origin:** Germany
Release year: 1994 // **Classification:** Humanist Sans

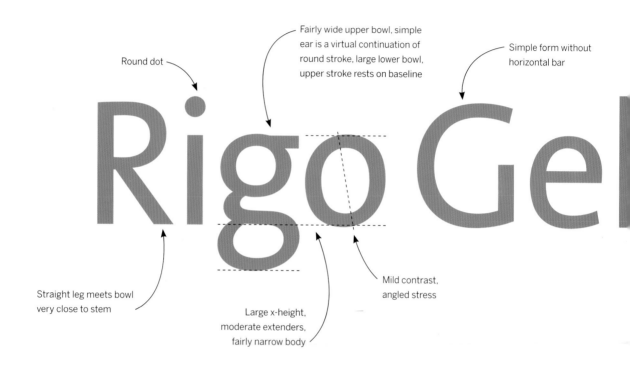

Round dot

Fairly wide upper bowl, simple ear is a virtual continuation of round stroke, large lower bowl, upper stroke rests on baseline

Simple form without horizontal bar

Straight leg meets bowl very close to stem

Large x-height, moderate extenders, fairly narrow body

Mild contrast, angled stress

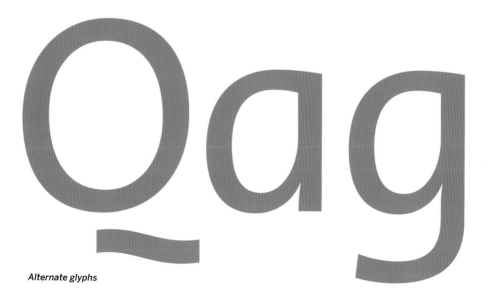

Alternate glyphs

ABCDEFGHIJKLMNOPQRSTUVWXYZ

abcdefghijklmnopqrstuvwxyz ćkćtśtfÿ 1234567890

163 ¼¼ ⅔⅔ ⅝⅝ [àóüßç](.,:;?!$£&-*){ÀÓÜÇ}

TheSans Plain

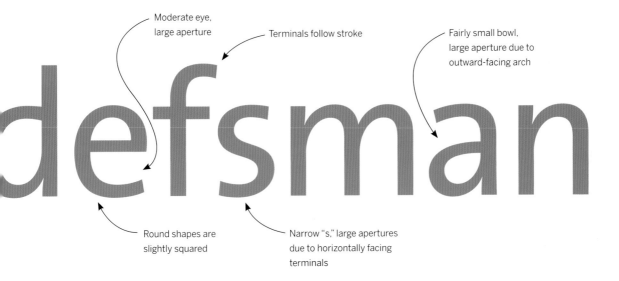

Moderate eye, large aperture

Terminals follow stroke

Fairly small bowl, large aperture due to outward-facing arch

Round shapes are slightly squared

Narrow "s," large apertures due to horizontally facing terminals

TheSans belongs to one of the original *superfamilies*, a collective system of typefaces, called Thesis, that includes a slab (TheSerif), a semi-slab (TheMix), and a serif (TheAntiqua). TheSans has very Humanist bones, but very little of its contrast. Its personality can range from mildly informal to official, but its dynamic foundation ensures that it is never dull. This has made TheSans and its counterparts some of the most popular typefaces for contemporary identities, used by any organization that wants to appear simultaneously modern, approachable, active, and professional. TheSans offers a few alternative characters: single-story forms of "a" and "g" for a more casual demeanor, and its signature oddity that originally came as standard, a "Q" with a disconnected tail.

Compare to:

GRaesgo

Auto 1

GRaesgo

Syntax

GRaesgo

Frutiger

Auto

Designer: Akiem Helmling, Bas Jacobs, Sami Kortemäki // **Foundry:** Underware // **Country of origin:** The Netherlands
Release year: 2005 // **Classification:** Humanist Sans

Vertical stroke
terminal detail

Angled upper terminal

Small bowl,
large aperture

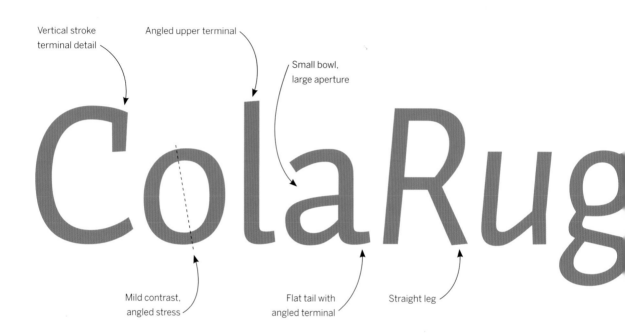

Mild contrast,
angled stress

Flat tail with
angled terminal

Straight leg

Slightly calligraphic structure,
extended stroke and tail

Very calligraphic structure,
almost upright stem, swash
and descending tail

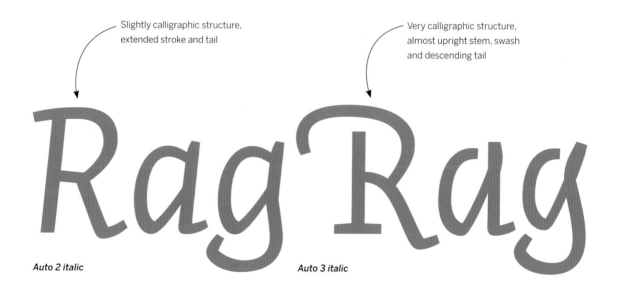

Auto 2 italic

Auto 3 italic

ABCDEFGHIJKLMNOPQRSTUVWXYZ

abcdefghijklmnopqrstuvwxyz 1234567890

¼ ½ ¾ [àóüßç](.,:;?!$£&-*){ÀÓÜÇ}

Auto 1

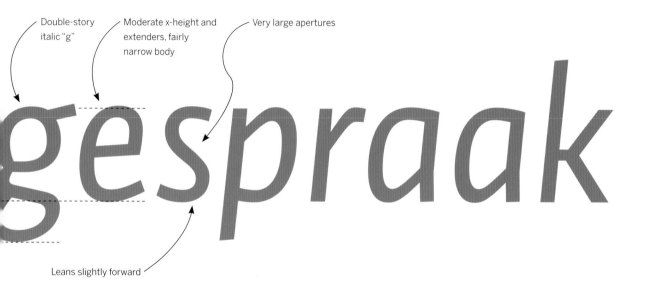

Double-story
italic "g"

Moderate x-height and
extenders, fairly
narrow body

Very large apertures

Leans slightly forward

From an innovative trio of Dutch, Finnish, and German designers comes a unique concept: a typeface with not one, but three italics. First, the roman: a sprightly, monolinear Humanist. Where **Cronos** feels like careful calligraphy, **Auto** is quick writing—the clear but energetic marks of a lively pen. The italics—labeled as Auto 1, 2, and 3—offer increasingly expressive forms. The progression is like the growth of a plant, starting with basic stems that grow from buds into long vines that visibly overlap where they change direction, and that then extend to long swashes. The three options let users choose the level of embellishment while retaining the type's basic weight and constitution. This is the same character playing different roles.

Compare to:

Rageslk

Doko

Optima

Designer: Hermann Zapf // **Foundry:** D. Stempel AG, Linotype // **Country of origin:** Germany
Release year: 1958 // **Classification:** Humanist/Inscriptional Sans

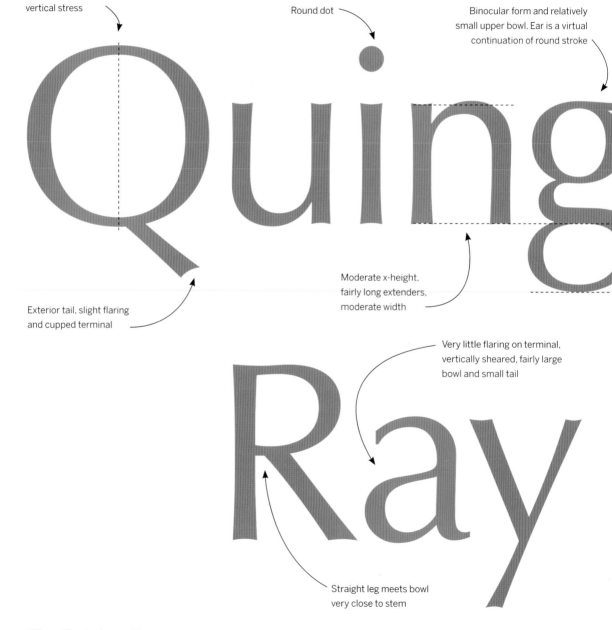

High contrast, nearly vertical stress

Round dot

Binocular form and relatively small upper bowl. Ear is a virtual continuation of round stroke

Exterior tail, slight flaring and cupped terminal

Moderate x-height, fairly long extenders, moderate width

Very little flaring on terminal, vertically sheared, fairly large bowl and small tail

Straight leg meets bowl very close to stem

ABCDEFGHIJKLMNOPQRSTUVWXYZ

abcdefghijklmnopqrstuvwxyz 1234567890

¼ ½ ¾ [àóüßç](.,:;?!$£&-*){ÀÓÜÇ}

Optima Roman

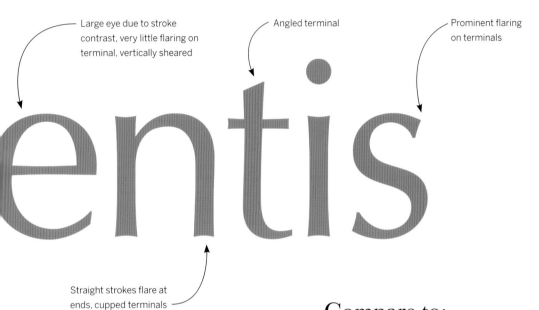

Large eye due to stroke contrast, very little flaring on terminal, vertically sheared

Angled terminal

Prominent flaring on terminals

Straight strokes flare at ends, cupped terminals

Optima is one of those typefaces that defies categorization. In a way, it's a Humanist sans—built like a serif without serifs—but its vertical stress is more Rational than Humanist. Perhaps it's actually Inscriptional, with its concave strokes that follow classical proportions and end in cupped terminals. To some, this split personality is a negative trait, demonstrating an identity crisis—it can't decide what it wants to be and ends up being nothing. But tell that to the cosmetic and pharmaceutical industries who have adopted Optima as their banner, utilizing its elegant serenity to label all manner of creams, ointments, and makeup. *Good for:* The stuff of the establishment. Tranquil beauty. Wellness.

Compare to:

GQagefs

Beorcana

GQagefs

Cronos

GQagefs

SangBleu

Beorcana

Designer: Carl Crossgrove // **Foundry:** Terrestrial Design // **Country of origin:** United States
Release year: 2006 // **Classification:** Humanist Sans

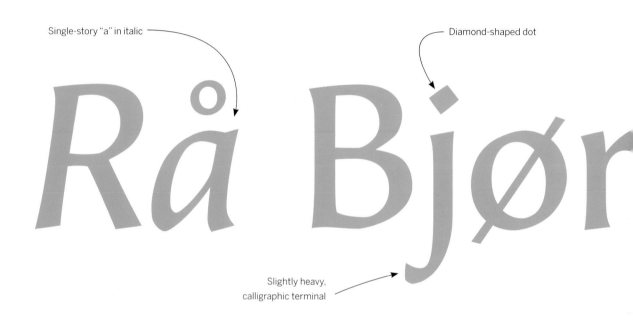

Single-story "a" in italic

Diamond-shaped dot

Slightly heavy, calligraphic terminal

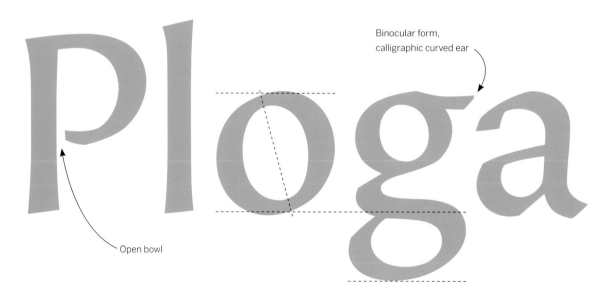

Binocular form, calligraphic curved ear

Open bowl

ABCDEFGHIJKLMNOPQRSTUVWXYZ

abcdefghijklmnopqrstuvwxyz 1234567890

¼ ½ ¾ [åøüßç](.,:;?!$£&-*){ÀÓÜÇ}

Beorcana Regular

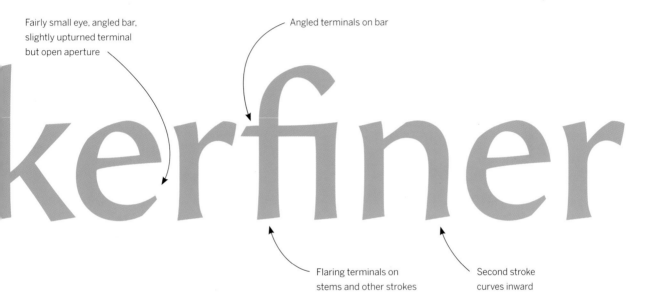

Fairly small eye, angled bar, slightly upturned terminal but open aperture

Angled terminals on bar

Flaring terminals on stems and other strokes

Second stroke curves inward

Beorcana is about as calligraphic as you can get without being a serif or script. Over 14 years in the making, Carl Crossgrove's design represents his long commitment to the skill of making letters with a pen. The tool here is a broad-nib pen held at a relatively consistent angle. The rhythm and contrast are as present as in any Renaissance roman, but there are no serifs; instead there is a subtle flare at the end of strokes created by pressure on (or a turn of) the pen. These gestures are well suited to lovely headlines and ornamental work, and there are plenty of flourishing swashes in the Display italics. But Beorcana is designed to set text, too—books and tiny captions even—using special optical versions that have the strength and proportions required for small type.

Compare to:

GMWeagoy

Optima

GMWeagoy

Cronos

XXXXX

Background typefaces are Amplitude and FF Dax

Neo-Humanist Sans

FF Meta

Designer: Erik Spiekermann // **Foundry:** FontFont // **Country of origin:** Germany
Release year: 1991 // **Classification:** Neo-Humanist Sans

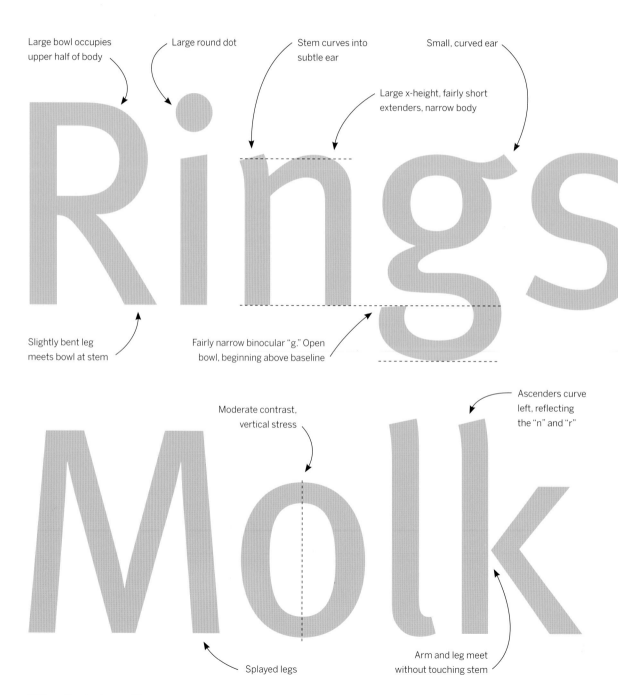

Large bowl occupies upper half of body

Large round dot

Stem curves into subtle ear

Small, curved ear

Large x-height, fairly short extenders, narrow body

Slightly bent leg meets bowl at stem

Fairly narrow binocular "g." Open bowl, beginning above baseline

Ascenders curve left, reflecting the "n" and "r"

Moderate contrast, vertical stress

Splayed legs

Arm and leg meet without touching stem

ABCDEFGHIJKLMNOPQRSTUVWXYZ

abcdefghijklmnopqrstuvwxyz ćkftšbšþ 1234567890

163 ¼ ½ ¾ [àóüßç](.,:;?!$£&-*){ÀÓÜÇ}

FF Meta Book

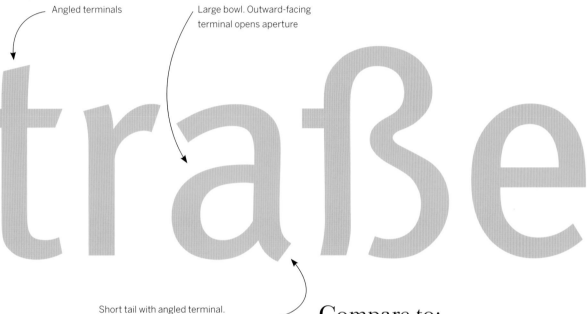

Angled terminals

Large bowl. Outward-facing terminal opens aperture

Short tail with angled terminal. Terminals follow stroke

Compare to:

RMaegils

FF Unit

RMaegils

FF Meta Serif

RMaegils

Farao

The first rendition of Erik Spiekermann's most famous typeface was a commission from the West German Post Office. They never used the design, but the subsequent **FF Meta** became one of the most successful typefaces designed in the digital era. The brief was a spatially economical face for use at small sizes on cheap paper. Spiekermann's solution was a combination of Humanist and Grotesque concepts, a mildly rationalized design with open forms and just enough of the pen in its contrast and forms to maintain readability. The ideas in FF Meta, along with the FontFont label he co-founded, ushered in a new genre of sans serifs that exemplify digital typography. **Good for:** Modern, readable text; 25 years later, it still feels fresh.

Amplitude

Designer: Christian Schwartz // **Foundry:** Font Bureau // **Country of origin:** United States
Release year: 2003 // **Classification:** Neo-Humanist Sans

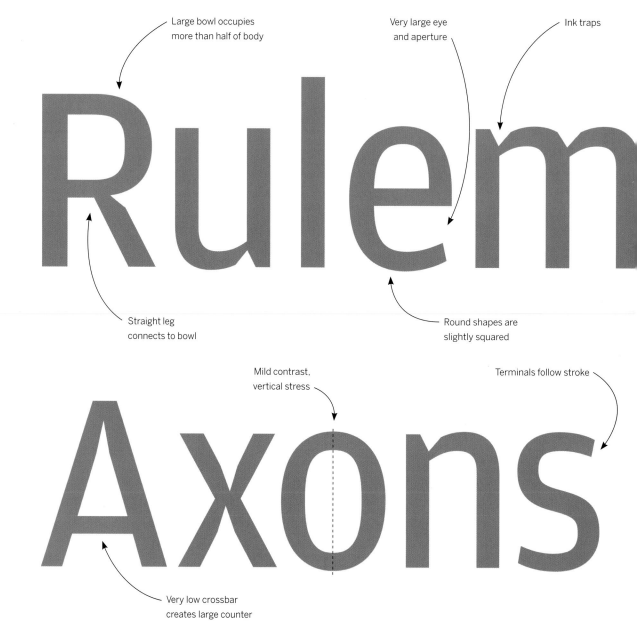

Large bowl occupies
more than half of body

Very large eye
and aperture

Ink traps

Straight leg
connects to bowl

Round shapes are
slightly squared

Mild contrast,
vertical stress

Terminals follow stroke

Very low crossbar
creates large counter

ABCDEFGHIJKLMNOPQRSTUVWXYZ

abcdefghijklmnopqrstuvwxyz 1234567890

¼ ½ ¾ [àóüßç](.,:;?!$£&-*){ÀÓÜÇ}

Amplitude Regular

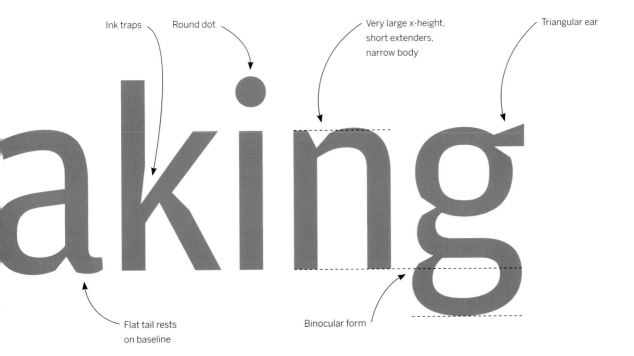

Ink traps

Round dot

Very large x-height, short extenders, narrow body

Triangular ear

Flat tail rests on baseline

Binocular form

At its face, **Amplitude** is in the vein of **FF Meta**: a condensed, upright blend of Humanist and Grotesque. Here, the apertures are even larger, and the x-height is massive. But the shtick that makes Amplitude unique is its prominent triangular nicks that carve out space at stroke junctions. The "ink trap" is normally a functional device, used to compensate for ink gain (see **Bell Centennial**), but Christian Schwartz makes it an aesthetic device, giving a stylish edge to headlines without sacrificing the type's readability in Text. That combination has made Amplitude a 21st-century favorite of publication designers who also appreciate its large family of weights and widths. *Good for:* Straightforward text and expressive headlines using the same typeface.

Compare to:

NMRagek

FF Meta

NMRagek

Bell Centennial

Fedra Sans

Designer: Peter Bilak // **Foundry:** Typotheque // **Country of origin:** The Netherlands
Release years: 2001–2005 // **Classification:** Neo-Humanist Sans

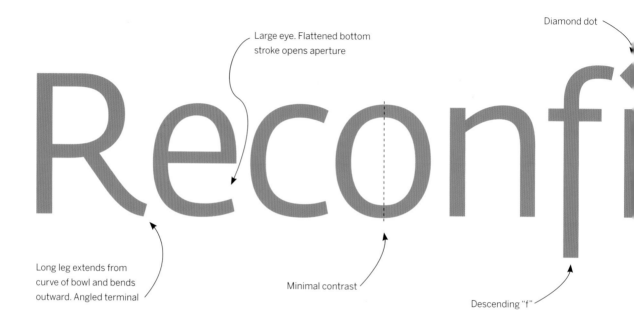

Diamond dot

Large eye. Flattened bottom
stroke opens aperture

Long leg extends from
curve of bowl and bends
outward. Angled terminal

Minimal contrast

Descending "f"

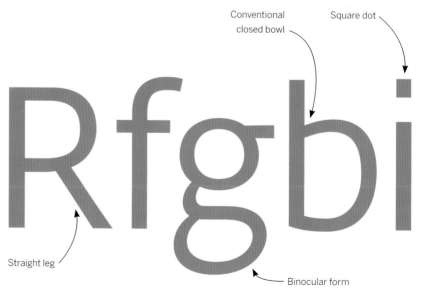

Conventional
closed bowl

Square dot

Straight leg

Binocular form

Fedra Sans Alt Std Book

ABCDEFGHIJKLMNOPQRSTUVWXYZ

abcdefghijklmnopqrstuvwxyz 1234567890 163

¼ ⅔ ⅝ [àóüßç](.,:;?!$£&-*){ÀÓÜÇ}

Fedra Sans Book

Distinctive open bowl

Monocular form, large bowl made fuller by
curving upward from top of stem

Bowl has
horizontal top

gurable

Very large x-height, short
extenders, moderate
width

Compare to:

PRWabfikg
Auto

PRWabfikg
Klavika

PRWabfikg
TheSans

PRWabfikg
Fedra Serif A

This typeface was born from a client request to
"de-protestantize **Univers**." Among the Neo-Humanists,
Fedra Sans is indeed a free spirit, enlivened with various
features inspired by handwriting. In addition to its very
large x-height (with stunted caps and ascenders) are
diamond dots, open bowls, a spurless "g" and "b," a
descending roman "f," and an "R" and "k" with
outward-curving legs. None of these quirks affect
Fedra's readability, which benefits from the large
apertures and sturdiness of a typeface intended for the
computer screen as well as print. But if the situation
calls for more conventional forms, there is Fedra Sans
Alt, a restrained version that retains the original's
intrinsic identity, proving there is more to the face than
its idiosyncrasies.

FF Dax

Designer: Hans Reichel // **Foundry:** FontFont // **Country of origin:** Germany
Release years: 1995–1997 // **Classification:** Neo-Humanist Sans

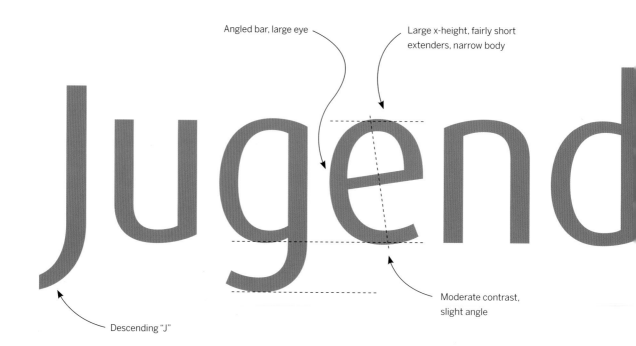

Angled bar, large eye

Large x-height, fairly short extenders, narrow body

Descending "J"

Moderate contrast, slight angle

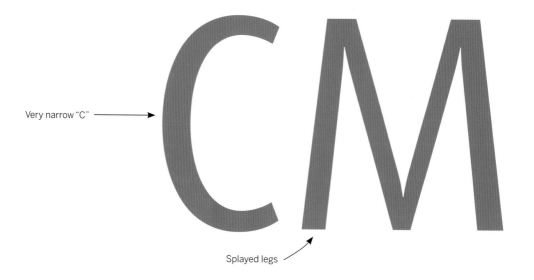

Very narrow "C"

Splayed legs

ABCDEFGHIJKLMNOPQRSTUVWXYZ
abcdefghijklmnopqrstuvwxyz 1234567890 163
¼ ⅔ ⅝ [àóüßç](.,:;?!$£&-*){ÀÓÜÇ}

FF Dax Regular

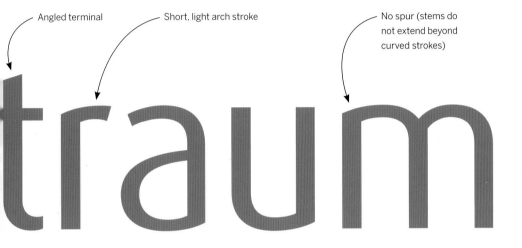

Angled terminal — Short, light arch stroke — No spur (stems do not extend beyond curved strokes)

Hans Reichel's goal was to "combine the clarity of a narrow Futura with a more humanist touch." The result ventures quite far away from sterile geometry, with its high contrast, elliptical rounds, and various letters clearly inspired by handwriting, but remains quite minimal. This simplicity is due in large part to the lack of extending stems (or spurs) on the "d," "g," "m," "n," "p," "q," "r," and "u." It was an idea that Reichel first tried in 1983 with his Barmeno (originally called Barmen), but **FF Dax** popularized the look, influencing the design of countless followers since its 1995 release. The follow-up FF Daxline offers lower contrast, larger caps, and more consistent letter widths. It is better suited for Text and is generally more in line with current typographical tastes.

Compare to:

Caengdruo

FF Daxline

FF Balance

Designer: Evert Bloemsma // **Foundry:** FontFont // **Country of origin:** The Netherlands
Release year: 1993 // **Classification:** Neo-Humanist Sans

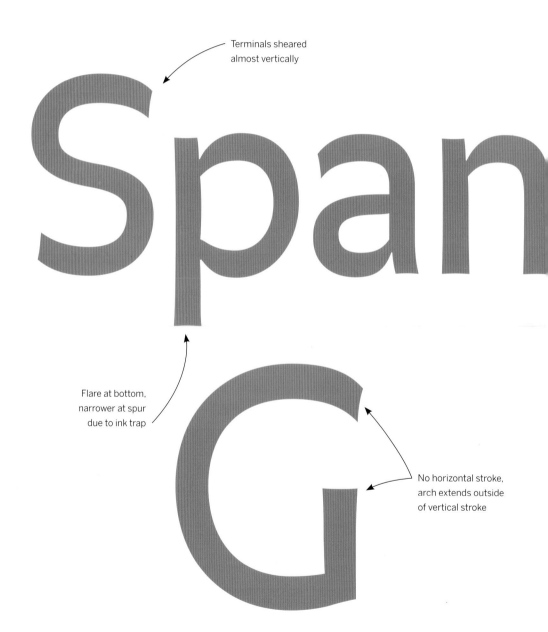

Terminals sheared
almost vertically

Flare at bottom,
narrower at spur
due to ink trap

No horizontal stroke,
arch extends outside
of vertical stroke

ABCDEFGHIJKLMNOPQRSTUVWXYZ

abcdefghijklmnopqrstuvwxyz 1234567890 163

¼ ⅔ ⅝ [àóüßç](.,:;?!$£&-*){ÀÓÜÇ}

FF Balance Regular

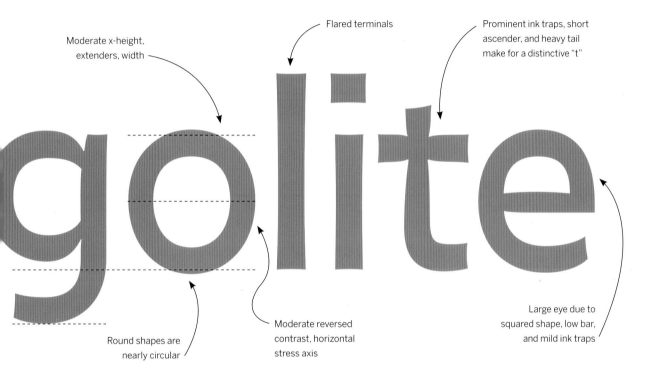

Moderate x-height, extenders, width

Flared terminals

Prominent ink traps, short ascender, and heavy tail make for a distinctive "t"

Round shapes are nearly circular

Moderate reversed contrast, horizontal stress axis

Large eye due to squared shape, low bar, and mild ink traps

Evert Bloemsma was a remarkable innovator, always questioning conventions and experimenting with new ideas in typeface design. We lost him too soon at the young age of 47. Fortunately, he left us with four inventive and useful designs: **FF Balance**, FF Cocon, FF Avance, and FF Legato. Like **Antique Olive**, FF Balance reverses the traditional stress angle, putting weight on the top and bottom of letters instead of the sides. But where Antique Olive forces letters into geometric molds, FF Balance is more Humanist in structure, even to the point of including imperfect terminals reminiscent of pen strokes. Prominent ink traps allow use in small text. The horizontal emphasis created by the reversed contrast facilitates long reading.

Compare to:

Gsegaito

Antique Olive

Gsegaito

Metric

XXXX

Background typefaces are Giza and Farao

Grotesque Slab

Giza

Designer: (Vincent Figgins) David Berlow // **Foundry:** Font Bureau // **Country of origin:** (United Kingdom) United States // **Release year:** (1845) 1994 // **Classification:** Grotesque Slab

Lighter horizontal strokes allow for heavy overall weight

Nearly horizontal terminal, very closed aperture, unusually broad due to prominent tail

Unbracketed slab serifs are technically the same weight as stems but appear even heavier

Spur is angled at interior

Rectangular dot

Double-curved tail, quite light in counter, heavy in exterior

Curved tail, turns upward

ABCDEFGHIJKLMNOPQRSTUVWXYZ
abcdefghijklmnopqrstuvwxyz
1234567890 [àóüßç](.,:;?!$£&-*)}{ÀÓÜÇ}

Giza OneFive

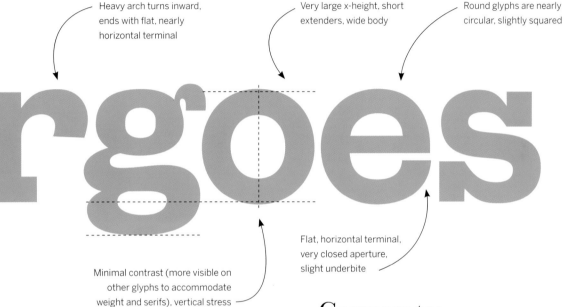

Heavy arch turns inward, ends with flat, nearly horizontal terminal

Very large x-height, short extenders, wide body

Round glyphs are nearly circular, slightly squared

Minimal contrast (more visible on other glyphs to accommodate weight and serifs), vertical stress

Flat, horizontal terminal, very closed aperture, slight underbite

The thunderous, head-turning slab serifs of the Victorian era are the basis for **Giza**. The name comes from what these typefaces were called at the time: "Egyptian." Every style in the Giza family is heavy, in typographic terms, but also in its visual impression. One can imagine the effort required to lift a physical representation of these letters. This isn't a compact headliner by any means. Not only is it quite broad, with massive slabs, but there are also prominent tails that need a lot of space to extend from the body and turn upward. ***Good for:*** Grabbing attention. Occupying a lot of space with a powerful message. Emulating the bolder side of vintage ephemera.

Compare to:

QReagrse

Bureau Grot

QReagrse

Clarendon

QReagrse

Farao

Clarendon

Designer: (Robert Besley) Hermann Eidenbenz // **Foundry:** (Fann Street Foundry) Haas, Linotype, Monotype, Bitstream
Country of origin: (United Kingdom) Switzerland // **Release year:** (1840s) 1953 // **Classification:** Grotesque Slab

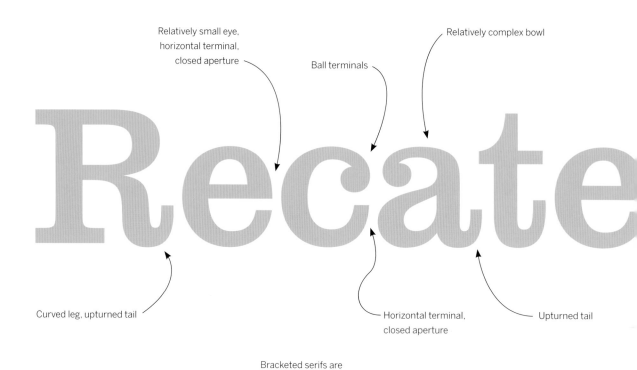

Relatively small eye, horizontal terminal, closed aperture

Ball terminals

Relatively complex bowl

Curved leg, upturned tail

Horizontal terminal, closed aperture

Upturned tail

Bracketed serifs are lighter than stems

ABCDEFGHIJKLMNOPQRSTUVWXYZ
abcdefghijklmnopqrstuvwxyz
1234567890 ¼ ½ ¾ [àóüßç](.,:;?!$£&-*) {ÀÓÜÇ}

Clarendon Roman

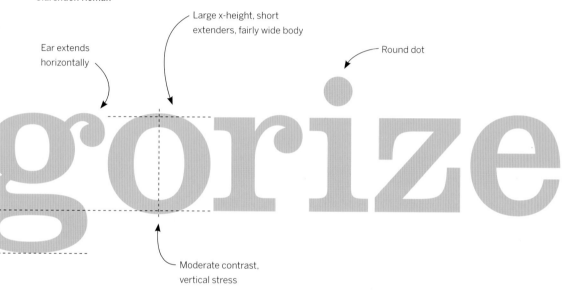

Ear extends horizontally

Large x-height, short extenders, fairly wide body

Round dot

Moderate contrast, vertical stress

When one thinks "slab serif," **Clarendon** is often the first thing that comes to mind. Its sturdy structure, punctuated by ball terminals, has made it one of the most popular faces of the last 50 years. The versions we know today are generally derived from mid-20th-century modernizations of styles from the early 1800s. Unlike the type that inspired **Giza**, Clarendon has an increased contrast that opens up the counters. This lets it be used for short passages of text. Serifs are also lighter and bracketed—still heavier than a book serif, but less imposing than Giza's. There are a variety of Clarendon alternatives that either improve its readability (**Ingeborg**, **Eames Century Modern**) or enhance its expressive qualities (**Farao**).

Compare to:

Raceyrkg
Helvetica

Raceyrkg
Farao

Raceyrkg
Giza

Farao

Designer: František Štorm // **Foundry:** Storm // **Country of origin:** Czech Republic
Release year: 1998 // **Classification:** Grotesque Slab

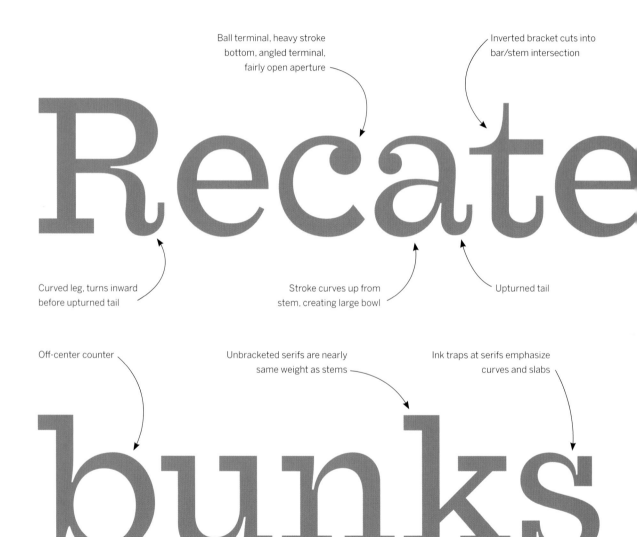

Ball terminal, heavy stroke bottom, angled terminal, fairly open aperture

Inverted bracket cuts into bar/stem intersection

Curved leg, turns inward before upturned tail

Stroke curves up from stem, creating large bowl

Upturned tail

Off-center counter

Unbracketed serifs are nearly same weight as stems

Ink traps at serifs emphasize curves and slabs

Deep cuts where curves meet stems emphasize thin strokes

One-sided serif at foot

ABCDEFGHIJKLMNOPQRSTUVWXYZ
abcdefghijklmnopqrstuvwxyz 1234567890
¼ ½ ¾ [àóüßç](.,:;?!$£&-*){ÀÓÜÇ}

Farao Regular

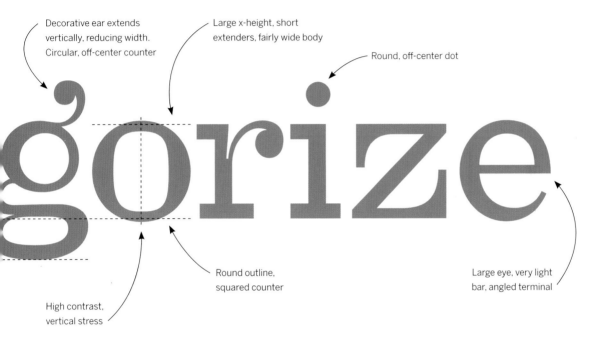

Decorative ear extends vertically, reducing width. Circular, off-center counter

Large x-height, short extenders, fairly wide body

Round, off-center dot

Round outline, squared counter

Large eye, very light bar, angled terminal

High contrast, vertical stress

Czech type designer František Štorm has made a habit of infusing historical styles with his own eccentric brand of expression. His **Farao** is a perfect example. Most modern interpretations of **Clarendon** and other *Egyptians* are somewhat cold and calculated. Štorm went back to their ancestors—the uneven, untamed type of the 19th century—and celebrated its imperfections. Farao has exaggerated ball terminals and serifs, inconsistent contrast, and a potpourri of seemingly incompatible features. Yet it all comes together in a wonderful, sparkling typeface full of humor and life. This is Clarendon let loose. *Good for:* A wink and a smile and a nod to the past.

Compare to:

Raceyrkg

Clarendon

Raceyrkg

Giza OneFive

Heron Serif

Designer: Cyrus Highsmith // **Foundry:** Font Bureau // **Country of origin:** United States
Release year: 2012 // **Classification:** Grotesque Slab

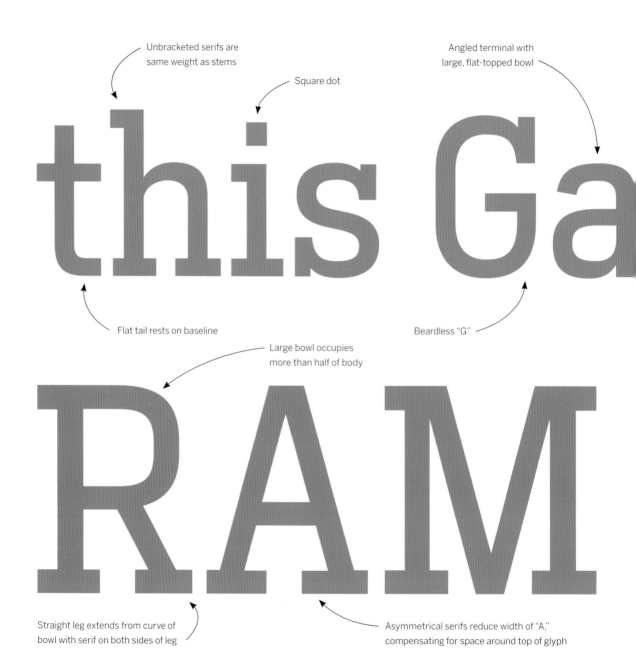

Unbracketed serifs are same weight as stems

Square dot

Angled terminal with large, flat-topped bowl

Flat tail rests on baseline

Beardless "G"

Large bowl occupies more than half of body

Straight leg extends from curve of bowl with serif on both sides of leg

Asymmetrical serifs reduce width of "A," compensating for space around top of glyph

ABCDEFGHIJKLMNOPQRSTUVWXYZ

abcdefghijklmnopqrstuvwxyz 1234567890

¼ ½ ¾ [àóüßç](.,:;?!$£&-*){ÀÓÜÇ}

Heron Serif Regular

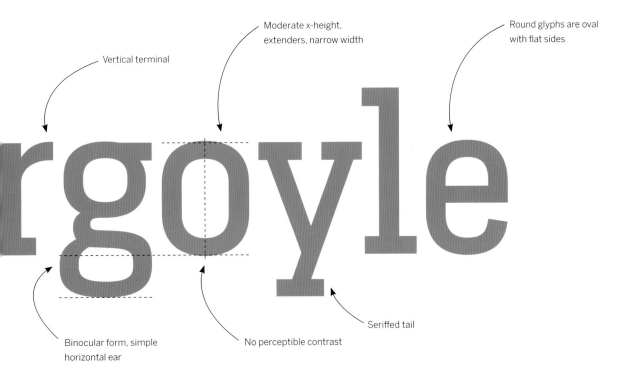

Moderate x-height,
extenders, narrow width

Round glyphs are oval
with flat sides

Vertical terminal

Binocular form, simple
horizontal ear

No perceptible contrast

Seriffed tail

Heron Serif is a strong, no-nonsense, hard-nosed typeface ready to go to work. There is a solid monolinear quality to every weight and style—even the bold keeps this feeling, as it lacks the increased stroke contrast that sometimes makes an otherwise stoic face appear somewhat friendly, even whimsical. Still, Heron is not cold: if DIN is a German number-cruncher—a stickler for rules and regulations while devoid of personality—Heron is an American steelworker, tough as nails and steadfast on the job, but loose enough to get a little dirty and tell a tall tale. Created by Cyrus Highsmith specifically for publications, Heron Serif has 20 styles, various alternative glyphs (like a tailed "l," stemless "u," and single-story "a" and "g"), and a sans companion.

Compare to:

Gesgak

Adelle

Gesgak

FF DIN

XXX

Background typefaces are Archer and Rockwell

Geometric Slab

Archer

Designer: H&FJ staff // **Foundry:** Hoefler & Frere-Jones // **Country of origin:** United States
Release year: 2008 // **Classification:** Geometric Slab

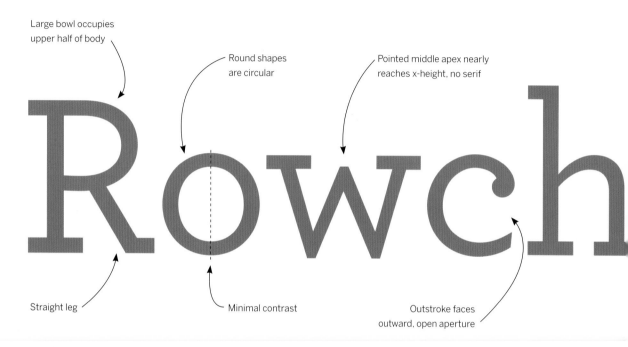

Large bowl occupies upper half of body

Round shapes are circular

Pointed middle apex nearly reaches x-height, no serif

Straight leg

Minimal contrast

Outstroke faces outward, open aperture

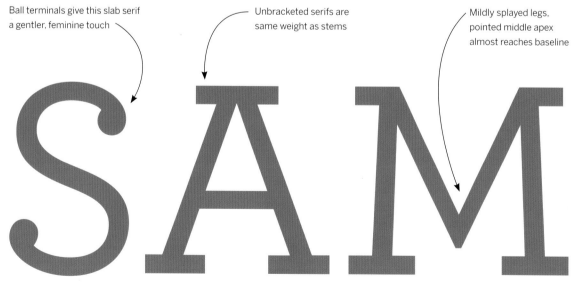

Ball terminals give this slab serif a gentler, feminine touch

Unbracketed serifs are same weight as stems

Mildly splayed legs, pointed middle apex almost reaches baseline

ABCDEFGHIJKLMNOPQRSTUVWXYZ
abcdefghijklmnopqrstuvwxyz 1234567890 163
¼½¾ [àóüßç](.,:;?!$£&-*)}ÀÓÜÇ}

Archer Medium

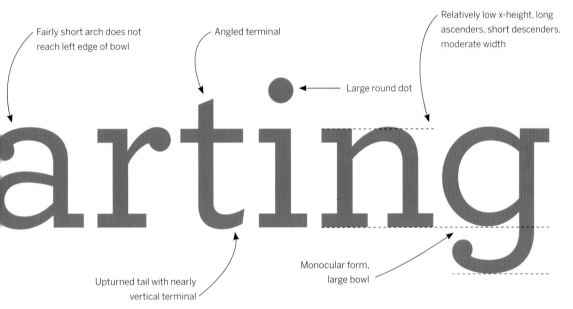

Fairly short arch does not reach left edge of bowl

Angled terminal

Large round dot

Relatively low x-height, long ascenders, short descenders, moderate width

Upturned tail with nearly vertical terminal

Monocular form, large bowl

Most Geometric slabs are cold and rigid, but **Archer** has a sweet, almost dainty nature. The main contributors to its complexion are the small ball terminals that frequently occur, even on the "s," a letter that rarely gets that treatment (see also **Filosofia**). But Archer also feels approachable because it avoids the monotony of other Geometrics. The legs of the "M" are mildly angled rather than rigidly vertical. The "c" and "e" end in an outward stroke rather than closing in a tight circle. The relatively low x-height of Archer also gives it a more gentle, antique touch. Like most H&FJ families, Archer is packed with weights and features for complex typesetting. *Good for:* Informal but proper announcements. Facts and figures with a positive slant. Cookbooks.

Compare to:

Swgfacroi

Neutraface Slab Text

Swgfacroi

Rockwell

Swgfacroi

PNM Caecilia 55

Neutraface Slab

Designer: Kai Bernau, Susana Carvalho, Christian Schwartz, Ken Barber // **Foundry:** House Industries
Country of origin: United States, The Netherlands // **Release year:** 2009 // **Classification:** Geometric Slab

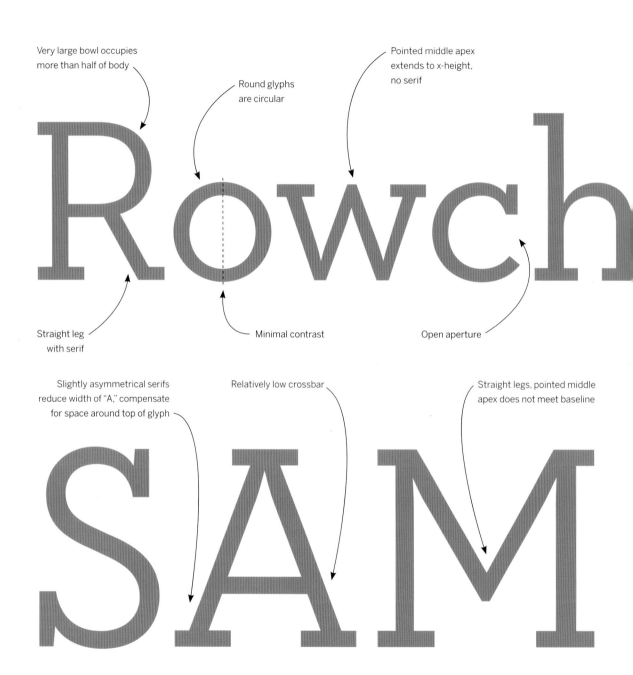

Very large bowl occupies more than half of body

Round glyphs are circular

Pointed middle apex extends to x-height, no serif

Straight leg with serif

Minimal contrast

Open aperture

Slightly asymmetrical serifs reduce width of "A," compensate for space around top of glyph

Relatively low crossbar

Straight legs, pointed middle apex does not meet baseline

ABCDEFGHIJKLMNOPQRSTUVWXYZ
abcdefghijklmnopqrstuvwxyz 1234567890 163
[àóüßç](.,:;?!$£&-*){ÀÓÜÇ}

Neutraface Slab Text Book

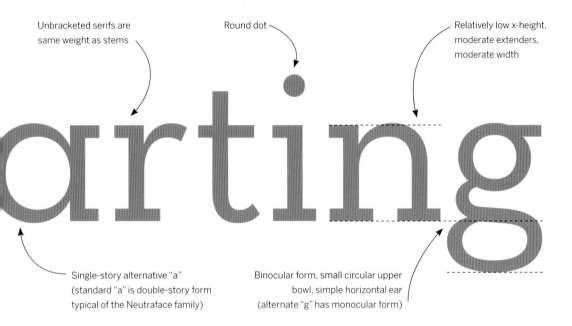

Unbracketed serifs are same weight as stems

Round dot

Relatively low x-height, moderate extenders, moderate width

Single-story alternative "a" (standard "a" is double-story form typical of the Neutraface family)

Binocular form, small circular upper bowl, simple horizontal ear (alternate "g" has monocular form)

In 2002, Christian Schwartz and House Industries released **Neutraface**, a Geometric sans serif inspired by the architectural lettering of celebrated modernist architect Richard Neutra. It is a more nuanced take on **Futura**, along the lines of **Avenir**. It became one of the most successful releases of the decade. It made sense, from both a marketing and design point of view, to give it a seriffed counterpart. Designed by Kai Bernau and Susana Carvalho under Schwartz's direction, Neutraface Slab has a similar build to **Archer**, but is clearly more serious. Still, it avoids the strict geometry of faces like Memphis and Stymie, allowing it to set surprisingly readable text. ***Good for:*** A reference to the crisper, more European side of mid-century modernism.

Compare to:

GMRcaogs

Rockwell

GMRcaogs

Archer

Rockwell

Designer: Monotype staff // **Foundry:** Lanston Monotype Corporation, Monotype Imaging // **Country of origin:** United States
Release years: 1933–1934 // **Classification:** Geometric Slab

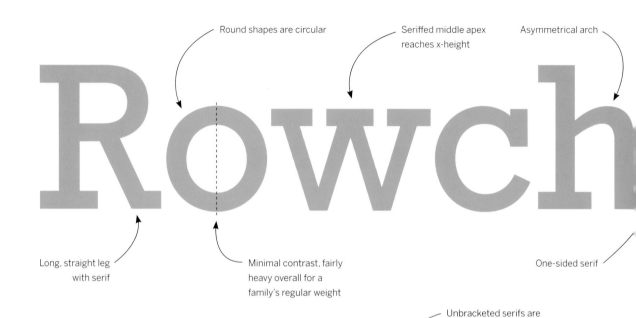

Round shapes are circular

Seriffed middle apex reaches x-height

Asymmetrical arch

Long, straight leg with serif

Minimal contrast, fairly heavy overall for a family's regular weight

One-sided serif

Unbracketed serifs are optically heavier than stems

Straight legs, pointed middle apex overshoots baseline

ABCDEF GHIJKL M NOPQ R STUVWXYZ
abcdefghijklmnopqrstuvwxyz 1234567890
¼ ½ ¾ [àóüßç](.,:;?!$£&-*){ÀÓÜÇ}

Rockwell Regular

Relatively small
round dot

Moderate x-height,
fairly short extenders,
moderate width

Wide arch extends to left
edge of bowl

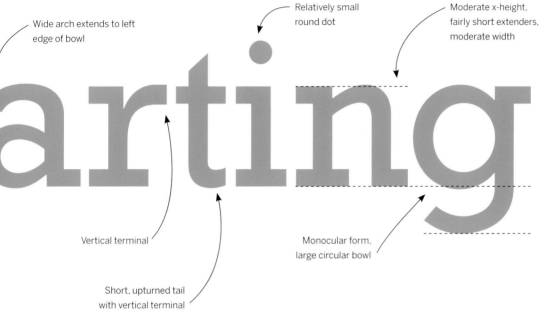

Vertical terminal

Short, upturned tail
with vertical terminal

Monocular form,
large circular bowl

Compare to:

GMRcaogs

Neutraface Slab

GMRcaogs

ITC Lubalin Graph

GMRcaogs

Archer

Rockwell is a 1930s interpretation of what is considered the first Geometric Slab serif, Litho Antique, an American design from 1910. This provenance contributes to Rockwell's older flavor, which is more rugged than the more modernist slabs like Memphis (its main competitor at the time), Lubalin Graph (the seriffed version of **ITC Avant Garde Gothic**), and recent releases **Archer** and **Neutraface Slab**. Rockwell is slightly uneven with bold weights that stray much further from the regular than current users would expect. In certain respects it looks clumsy, but in an earnest way. So, while most Geometric Slabs seem machined, Rockwell feels handmade, and designers often pick it up when they really need something more polished.

XXXX

Background typefaces are Freight Micro and Adelle

Humanist Slab

PMN Caecilia

Designer: Peter Matthias Noordzij // **Foundry:** Linotype // **Country of origin:** The Netherlands, Germany
Release year: 1990 // **Classification:** Humanist Slab

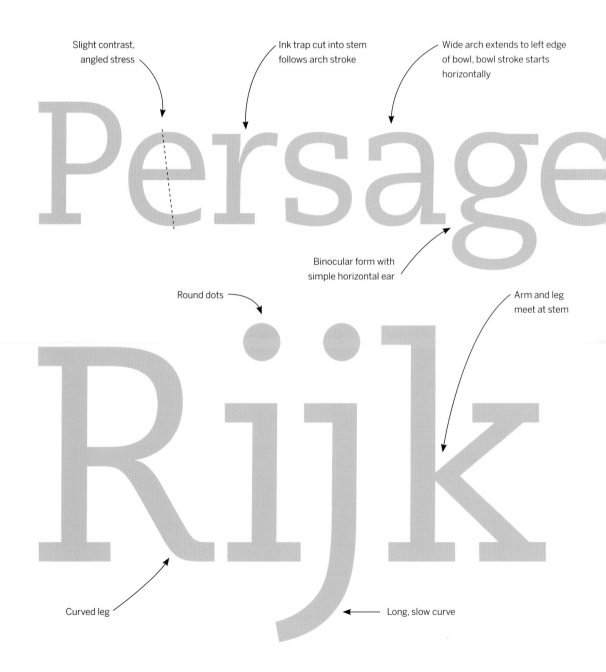

Slight contrast, angled stress

Ink trap cut into stem follows arch stroke

Wide arch extends to left edge of bowl, bowl stroke starts horizontally

Binocular form with simple horizontal ear

Round dots

Arm and leg meet at stem

Curved leg

Long, slow curve

ABCDEFGHIJKLMNOPQRSTUVWXYZ
abcdefghijklmnopqrstuvwxyz 1234567890
¼ ½ ¾ [àóüßç](.,:;?!$£&-*){ÀÓÜÇ}

PMN Caecilia 55 Roman

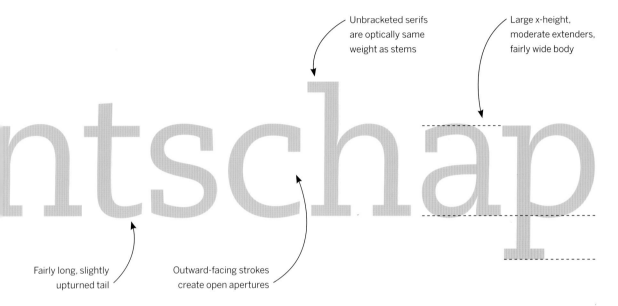

Unbracketed serifs
are optically same
weight as stems

Large x-height,
moderate extenders,
fairly wide body

Fairly long, slightly
upturned tail

Outward-facing strokes
create open apertures

Compare to:

Rgspya

TheSerif

Rgspya

Adelle

Rgspya

Archer

Designed by Peter Matthias Noordzij (and named
after his wife), **PMN Caecilia** is among the most
readable of slab serifs. Its structure is very Humanist,
and as close as a slab comes to an old-style book face.
The difference is very little stroke contrast and
unbracketed, rectangular serifs that nearly match stems
in weight. These characteristics are very well suited for
long texts on coarse resolution displays, and that's
exactly why Amazon chose it as the default face for their
Kindle. PMN Caecilia also has a very pleasant, inviting
quality, delivering text without pretension. ***Good for:***
Books on low-res screens or in poor printing conditions.
Professional but approachable text.

FF Unit Slab

Designer: Christian Schwartz, Erik Spiekermann, Kris Sowersby // **Foundry:** FontFont // **Country of origin:** United States, Germany, New Zealand // **Release year:** 2009 // **Classification:** Humanist/Grotesque Slab

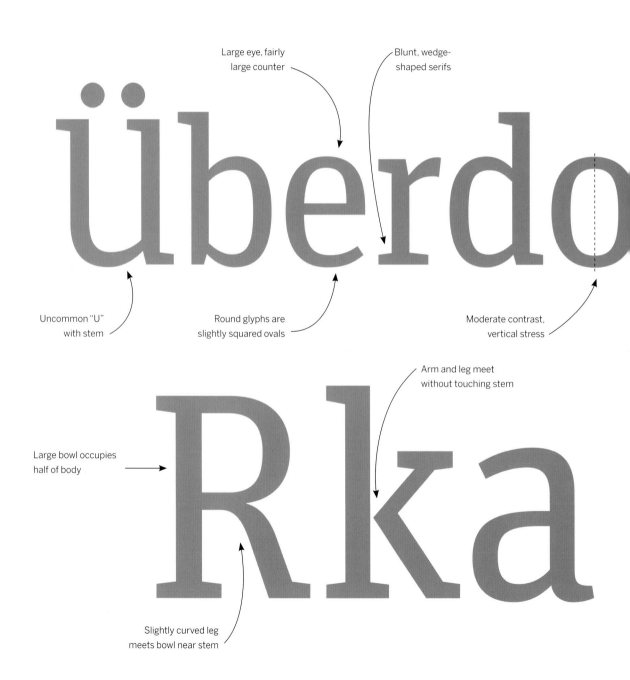

Large eye, fairly large counter

Blunt, wedge-shaped serifs

Uncommon "U" with stem

Round glyphs are slightly squared ovals

Moderate contrast, vertical stress

Arm and leg meet without touching stem

Large bowl occupies half of body

Slightly curved leg meets bowl near stem

ABCDEFGHIJKLMNOPQRSTUVWXYZ

abcdefghijklmnopqrstuvwxyz 1234567890 163

¼ ⅔ ⅝ [àóüßç](.,:;?!$£&-*){ÀÓÜÇ}

FF Unit Slab Regular

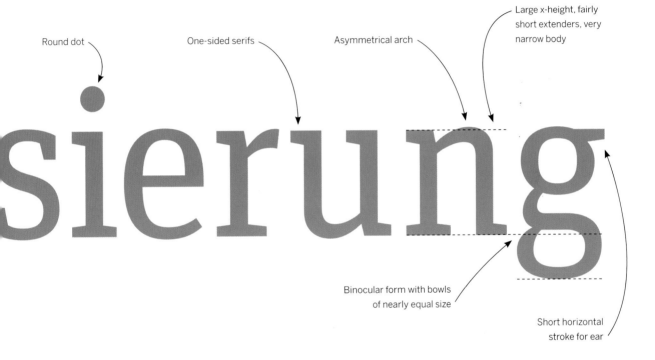

Round dot

One-sided serifs

Asymmetrical arch

Large x-height, fairly short extenders, very narrow body

Binocular form with bowls of nearly equal size

Short horizontal stroke for ear

The compact FF Unit, described by FontFont as "**FF Meta**'s grown-up, no-nonsense sister," was released in 2003 as a regimented alternative to Erik Spiekermann's famous typeface. Later, as Spiekermann and Christian Schwartz were working on **FF Meta Serif**, they also developed **FF Unit Slab**. It's a fitting companion to FF Unit, with thick, wedge-shaped slabs that maintain FF Unit's businesslike demeanor without making it too stiff or mechanical. Thanks to their concurrent development, the two serifs can work together, along with either of their sans serif counterparts. *Good for:* Saving space without losing legibility. An unconventional typographic hierarchy combining serif and slab, in lieu of serif and sans. Twenty-first-century business.

Compare to:

UKRbagomk

Adelle

UKRbagomk

Heron Serif

Adelle

Designer: Veronika Burian, José Scaglione // **Foundry:** TypeTogether // **Country of origin:** Czech Republic, Argentina
Release year: 2009 // **Classification:** Humanist/Grotesque Slab

Serifless middle apex does not reach cap height. Asymmetrical serifs reduce width

Terminal serif

Wisecr

Large bowl

Slightly squared, nearly circular

Prominent downturned arch stroke

Rolf

Nearly straight leg with two-sided serif

Minimal contrast

Extended bar and serif balance arch stroke

ABCDEFGHIJKLMNOPQRSTUVWXYZ
abcdefghijklmnopqrstuvwxyz Thctchckst
1234567890 163 ¼ ⅔ ⅝ [àóüßç](.,:;?!$£&-*){ÀÓÜÇ}

Adelle Regular

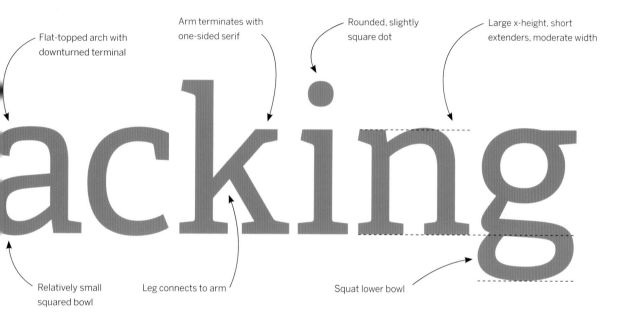

Flat-topped arch with downturned terminal

Arm terminates with one-sided serif

Rounded, slightly square dot

Large x-height, short extenders, moderate width

Relatively small squared bowl

Leg connects to arm

Squat lower bowl

Released in late 2009, **Adelle** is one of the newest entries in the Humanist Slab category. In some ways, though, Adelle is as much a Grotesque, with bones that echo the early sans serifs, especially visible in the squarish "a," "o," and "f," and the leg of the "R." But this is a contemporary design in nearly every other respect, from its lack of contrast to its wide-open apertures and wedge serifs. A sans serif companion was recently added, increasing Adelle's versatility. ***Good for:*** Informal publications, particularly those published on unforgiving paper or the internet.

Compare to:

MREacgrks

PMN Caecelia

MREacgrks

TheSerif

MREacgrks

FF Unit Slab

Freight Micro

Designer: Joshua Darden // **Foundry:** GarageFonts // **Country of origin:** United States
Release year: 2004 // **Classification:** Humanist Slab/Serif

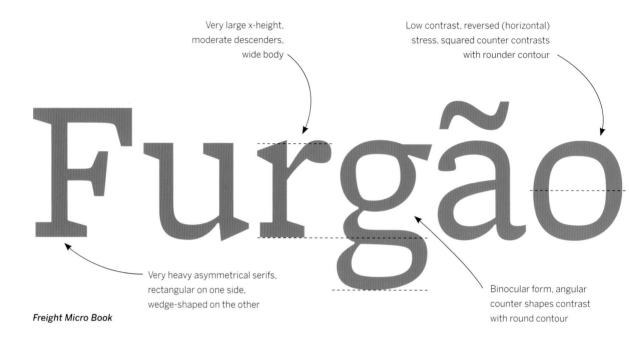

Very large x-height, moderate descenders, wide body

Low contrast, reversed (horizontal) stress, squared counter contrasts with rounder contour

Very heavy asymmetrical serifs, rectangular on one side, wedge-shaped on the other

Binocular form, angular counter shapes contrast with round contour

Freight Micro Book

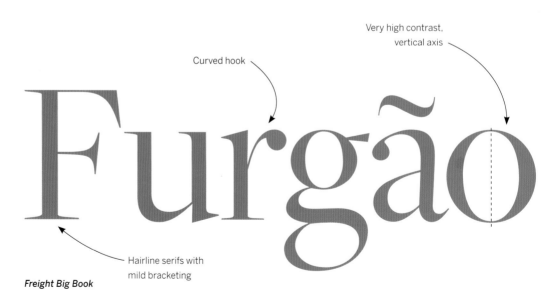

Curved hook

Very high contrast, vertical axis

Hairline serifs with mild bracketing

Freight Big Book

ABCDEFGHIJKLMNOPQRSTUVWXYZ

abcdefghijklmnopqrstuvwxyz 1234567890 163

¼ ½ ¾ [ãóüßç](.,:;?!$£&-*){ÀÓÜÇ}

Freight Micro Book

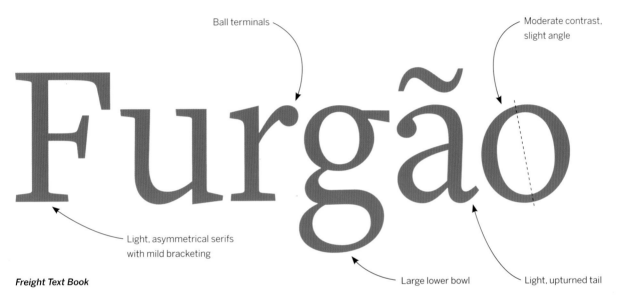

Ball terminals

Moderate contrast, slight angle

Light, asymmetrical serifs with mild bracketing

Freight Text Book

Large lower bowl

Light, upturned tail

With Freight, Joshua Darden follows in the footsteps of Adobe and others who are championing a return to the size-specific designs that were a given in metal typefounding. Freight Text, Display, and Big are typical optical size masters, adjusting contrast and proportion to fit the needs of various settings, whether small text or large titling. But **Freight Micro** is in a very different boat. Rather than relying merely on ink traps (see **Bell Centennial**), Darden solved the problems of tiny type by modulating entire strokes and contours, opening counters while making serifs more robust. The result is a very unusual design that really works (even on screen), but also makes for intriguing Display type of its own. *Good for:* Legible text. Eye-catching headlines.

Compare to:

GRFgraoes

Adelle

GRFgraoes

Fedra Serif A

GRFgraoes

FF Clifford Six

Background typefaces are Radio and Studio Slant

Script

Kinescope

Designer: Mark Simonson // **Foundry:** Mark Simonson // **Country of origin:** United States
Release year: 2007 // **Classification:** Casual Script

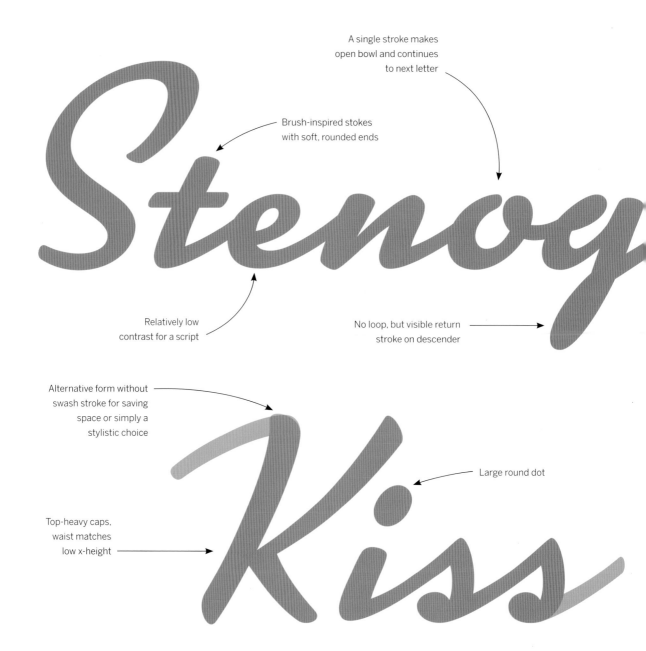

A single stroke makes open bowl and continues to next letter

Brush-inspired stokes with soft, rounded ends

Relatively low contrast for a script

No loop, but visible return stroke on descender

Alternative form without swash stroke for saving space or simply a stylistic choice

Large round dot

Top-heavy caps, waist matches low x-height

ABCDEFGHIJKLMNOPQRSTUVWXYZ

abcdefghijklmnopqrstuvwxyz 1234567890

*¼ ½ ¾ [àóüßç] (.,:;?!$£€- *){ÀÓÜÇ}*

Kinescope Regular

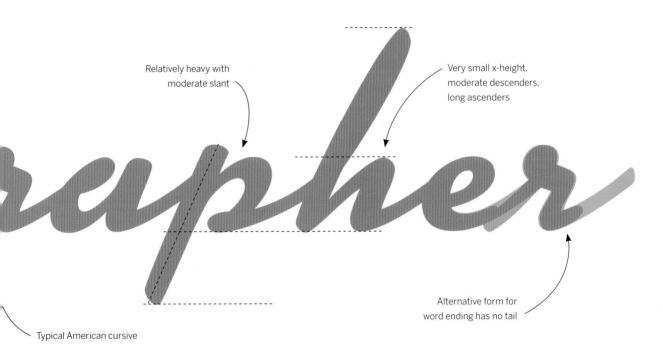

Relatively heavy with moderate slant

Very small x-height, moderate descenders, long ascenders

Alternative form for word ending has no tail

Typical American cursive form

Hand-lettered scripts were once a mainstay of advertising, signage, packaging, and chrome emblems. Writing with a brush or pen was simply the best way to make connected letters. Then came phototypesetting in the 1960s–70s, and digital publishing in the 1980s. Over time, most of that custom lettering was replaced with script typefaces—and, unfortunately, most of them are a poor substitute. That's why well-crafted fonts like **Kinescope** are welcome relief. Inspired by a title card from a 1940s-era cartoon, Mark Simonson engages the power of OpenType substitution to successfully emulate a lettering artist's strokes. ***Good for:*** Retro logos and signage. Take caution: the heavy weight and low x-height doesn't allow for anything too small.

Compare to:

Segrsep

Brush Script

Segrsep

Kaufmann

Studio Slant

Designer: Ken Barber, Tal Leming // **Foundry:** House Industries // **Country of origin:** United States
Release year: 2008 // **Classification:** Casual Script

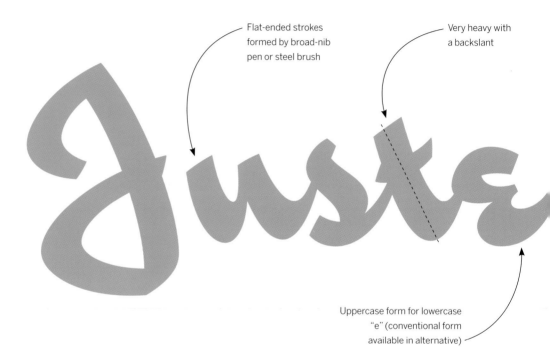

Flat-ended strokes formed by broad-nib pen or steel brush

Very heavy with a backslant

Uppercase form for lowercase "e" (conventional form available in alternative)

Alternative caps are taller

Not an umlaut, but a "courtesy mark" that indicates this is a "u" not an "n." This distinguishing bar was common in German handwriting and is a part of the special cultural-specific features in Studio Slant.

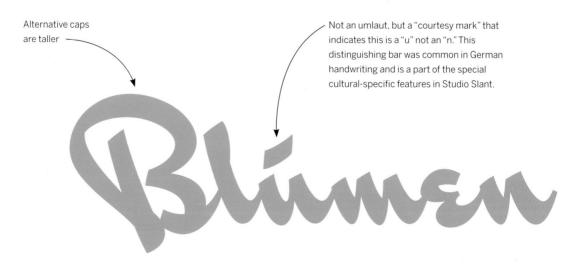

ABCDEFGHIJKLMNOPQRSTUVWXYZ
abcdefghijklmnopqrstuvwxyz 1234567890 163
¼ ½ ¾ [àôéßç] (.,:;?!§£€-*){ÀÔÜÇ}

Studio Slant

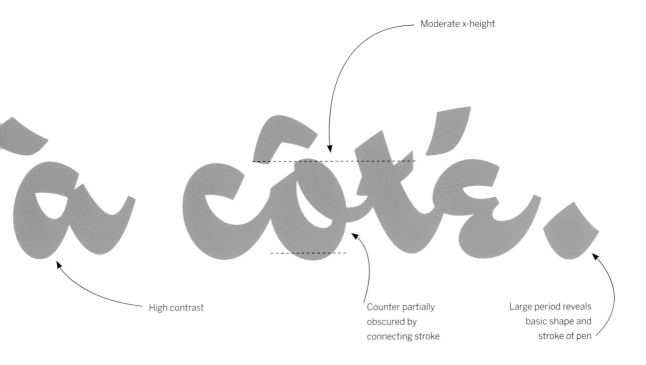

Moderate x-height

High contrast

Counter partially
obscured by
connecting stroke

Large period reveals
basic shape and
stroke of pen

Most scripts lean forward, a few are upright, but those that slant backward are quite rare. They were actually not so unusual in the 1930s–60s, a period that is a constant muse for House Industries type designer Ken Barber. His **Studio Slant** is a hefty thing, "written" with a steel "brush" pen or chisel brush, but quite nimble and vigorous despite its weight. The script is part of a 3-font package that celebrates the golden age of hand lettering. Each has the requisite ligatures and alternates for authentic simulation, but also includes "culture-specific character sets that reflect stylistic preferences of native users." This is more than a cute gimmick—it addresses the problem that some forms of handwritten letters can be illegible to foreign readers.

Compare to:

Juste à côté

Brush Script

Radio

Designer: Magnus Rakeng // **Foundry:** Village Constellation // **Country of origin:** Norway, United States
Release year: 1998 // **Classification:** Formal Script

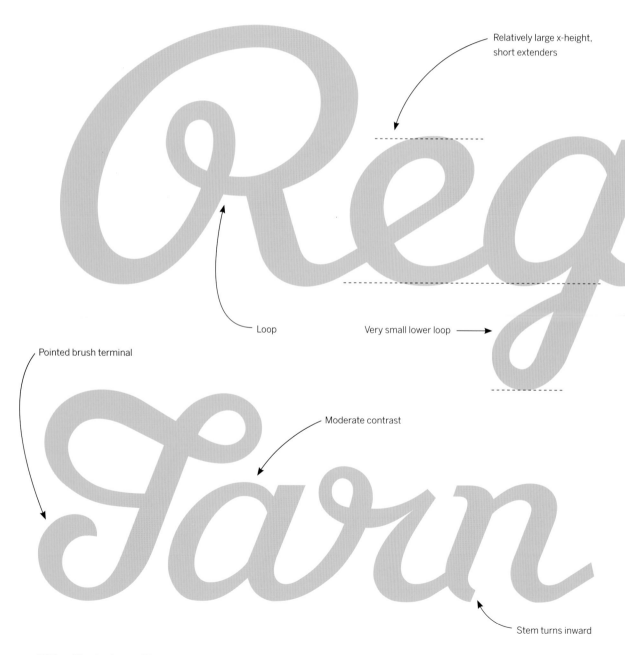

Relatively large x-height, short extenders

Loop

Very small lower loop

Pointed brush terminal

Moderate contrast

Stem turns inward

ABCDEFGHIJKLMNOPQRSTUVWXYZ
abcdefghijklmnopqrstuvwxyz 1234567890
¼ ½ ¾ [àóüßç] (.,:;?!$ £&-*)(ÀÓÜÇ)

Radio AM

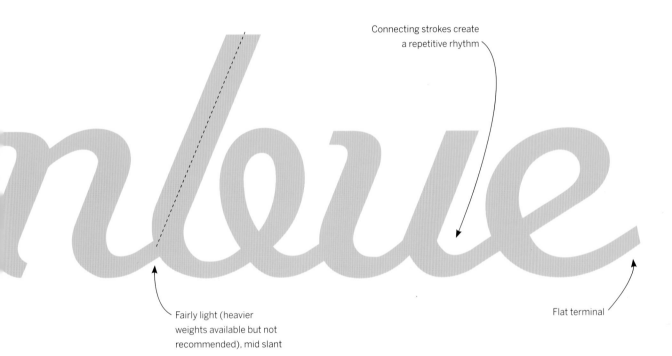

Connecting strokes create
a repetitive rhythm

Fairly light (heavier
weights available but not
recommended), mid slant

Flat terminal

Magnus Rakeng's **Radio** is one of the first digital fonts
to hearken back to the hand-drawn scripts of yester-
year, and it's still one of the most unique and (poorly)
imitated. Perhaps its originality comes from its mix
of sources. As Rakeng puts it, "Radio has its roots in
American commerce, old Norwegian design, rosemaling
(decorative folk painting), and a dash of Viking art." The
drawback to Radio's early arrival on the scene was that
it missed out on technological advancements, such as
OpenType's contextual substitution, that improve a
script's natural flow. Users will inevitably hit letter
combinations in Radio that simply don't work. Still,
there are such beautiful shapes here that we hope
readers will join the chorus in demanding an update.

Compare to:

Regnbue

Studio Slant

Bickham Script

Designer: Richard Lipton // **Foundry:** Adobe // **Country of origin:** United States
Release year: 2000 // **Classification:** Formal Script

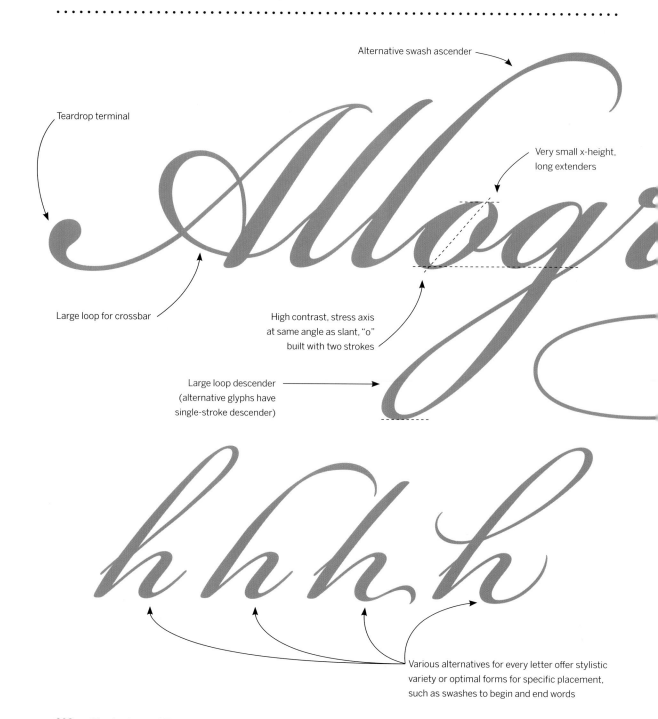

Alternative swash ascender

Teardrop terminal

Very small x-height, long extenders

Large loop for crossbar

High contrast, stress axis at same angle as slant, "o" built with two strokes

Large loop descender (alternative glyphs have single-stroke descender)

Various alternatives for every letter offer stylistic variety or optimal forms for specific placement, such as swashes to begin and end words

A B C D E F G H I J K L M N O P 2 R S T U V W X Y Z

abcdefghijklmnopqrstuvwxyz 1234567890

¼ ½ ¾ [àöüßç](.,;?!$£&-"){ÀÓÜÇ}*

Bickham Script Regular

Large loop ascender (alternative glyphs offer various ascender types, including exuberant swashes)

Descender is down- and return-stroke (alternative glyphs have single stroke)

aphs.

One of the earliest fonts to fully take advantage of automatic alternative-glyph and ligature substitution, **Bickham Script** is the formal script that other digital attempts are inevitably compared to. Richard Lipton, a fine calligrapher in his own right, based the typeface on the engravings of its 18th-century namesake, George Bickham. As a typical "copperplate script," Bickham has grand, sweeping strokes with very fine hairlines. This is a typeface that needs lots of space to work its magic (for more a more compact option, see **Tangier**). Extra glyphs, with entry or exit swashes and alternative descenders, let the user customize Bickham's level of expression. A big bundle of underline and separator flourishes are useful for extra embellishment.

Compare to:

Allographs

Tangier

Allographs

Zapfino

Tangier

Designer: Richard Lipton // **Foundry:** Font Bureau // **Country of origin:** United States
Release year: 2010 // **Classification:** Formal Script

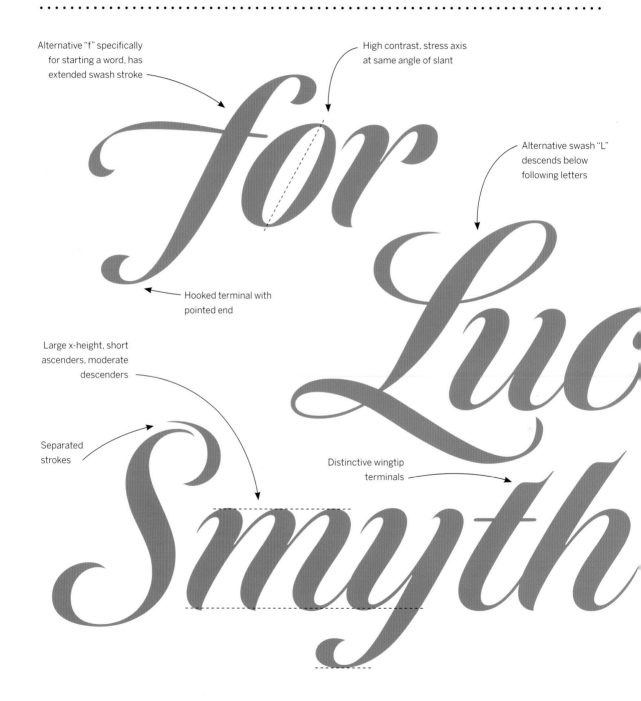

Alternative "f" specifically for starting a word, has extended swash stroke

High contrast, stress axis at same angle of slant

Alternative swash "L" descends below following letters

Hooked terminal with pointed end

Large x-height, short ascenders, moderate descenders

Separated strokes

Distinctive wingtip terminals

ABCDEFGHIJKLMNOPQRSTUVWXYZ

abcdefghijklmnopqrstuvwxyz 1234567890

¼ ½ ¾ [àóüßç](.,:;?!$£&~*)¿ÀÓÜÇ¿

Tangier Bold

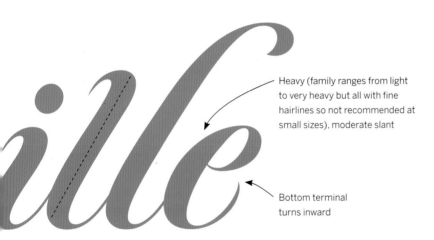

Heavy (family ranges from light
to very heavy but all with fine
hairlines so not recommended at
small sizes), moderate slant

Bottom terminal
turns inward

A decade after his **Bickham Script**, Richard Lipton
followed up with **Tangier**. The new design continues
to explore the possibilities of formal calligraphy, but its
much larger x-height offers more versatility in where the
type can be used. Prior to its public release, it was used
by *Glamour* magazine, who surely appreciated the
spatial efficiency for its covers and section titles. Like
Bickham, Tangier offers a variety of swashes, alternative
letterforms, and extender variants. There are also
four weights, including a very dark Black. ***Good for:***
Occasions that require elegance, but don't leave
much space for it.

Compare to:

Lucille Sm

Bickham Script

Suomi Hand Script

Designer: Tomi Haaparanta // **Foundry:** Suomi // **Country of origin:** Finland
Release year: 2008 // **Classification:** Casual Script

Stroke weight varies, but contrast is usually low

Heavy when stroke begins, light as it lifts off paper

Kynä, se on fontti—mutta

There is a general alignment, but letters bounce along baseline as in natural handwriting

Connections emulate quick writing in which pen occasionally stays on paper between letters

ss oo ee

A variety of shapes for each letter reduces the chances of mechanical repetition

ABCDEFGHIJKLMNOPQRSTUVWXYZ

abcdefghijklmnopqrstuvwxyz 1234567890

¼ ½ ¾ [äöüßç](.,:;?!$£&-*){ÀÖÜÇ}

Suomi Hand Script

Large x-height,
varying extenders

enenkään ei tarvitse tietää

Slant varies, simulating
an informal writer

Designers often need a handwriting font to humanize a product, simulate notes, or simply communicate in a more personable tone. There are dozens that attempt to do this but fail for a variety of reasons: they are too perfect, too illegible, or have unnatural connections between letters. But most importantly, there are usually plenty of repeating lettershapes, exposing the fact that the text was not really handwritten. Now take a look at the sample above. There are some identical forms, but it takes a while to find them. **Suomi Hand Script** achieves this through hundreds of ligatures, connecting pairs, and trios of letters in the way most of us do when we write. The strokes themselves are quite convincing, too, with the natural rhythm of a person using a regular pen.

Compare to:

Kyllätarvitse

Comic Sans

xXXxX

Background typefaces are Sang Bleu and Bree

Display

XXXX

Nitti

Designer: Pieter van Rosmalen // **Foundry:** Bold Monday // **Country of origin:** The Netherlands
Release year: 2008 // **Classification:** Monospaced Sans

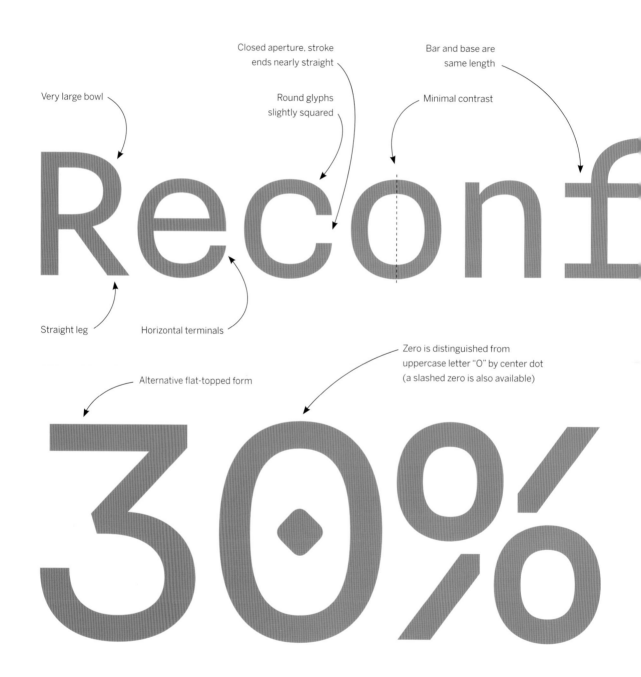

Very large bowl

Closed aperture, stroke ends nearly straight

Round glyphs slightly squared

Bar and base are same length

Minimal contrast

Straight leg

Horizontal terminals

Alternative flat-topped form

Zero is distinguished from uppercase letter "O" by center dot (a slashed zero is also available)

ABCDEFGHIJKLMNOPQRSTUVWXYZ

abcdefghijklmnopqrstuvwxyz

1233456789O ¼ ½ ¾

[àóüßç](.,:;?!$£&-*){ÀÓÜÇ}

Nitti Basic Normal

Large square dot

Large x-height, fairly short extenders, wide body

Wide horizontal stroke at baseline extends width of otherwise narrow characters

Designing a monospaced typeface (in which each character is the same width) is a tricky task. Creating one that contributes something new to the typographic canon is even more difficult. Most attempts come off looking like the hundreds of antique typewriter simulations or the awkward, strained artifacts of the computer age. Somehow, **Nitti** avoids both of these fates. Pieter van Rosmalen's typeface has a comfortable disposition that is rare in monospaced faces. It resolves the usual trouble spots (narrow "M" and "W," wide "f," "i," "j," and "t") without making compromises to readability. In fact, Nitti has recently proven its effectiveness as the default font in iA Writer, the most popular word processor for the iPad.

Compare to:

MRSascrfge

Courier

MRSascrfge

Monaco

Ed Interlock

Designer: Ed Benguiat, Ken Barber, Tal Leming // **Foundry:** House Industries // **Country of origin:** United States
Release year: 2004 // **Classification:** Display

Unaligned counters defy the idea of a main stem. This design feels more like it was molded from clay than built with conventional strokes

Large x-height, moderate extenders, narrow width, and even more condensed with ligatures

Flared stroke, huge rounded square dot

Strong horizontal contrast

Spiral form occupies as much negative space as possible

ABCDEFGHIJKLMNoPQRStuVWXYZ

abcdefghijklmnopqrstuvwxyz 1234567890

¼ ½ ¾ [àóüßç](.,:;?!$£&-*){ÀÓÜÇ}

Ed Interlock

Prominent horizontal stroke
fills in negative space

Ligatures automatically applied for
maximum variety and best fit

Asymmetrical verticals

Ed Interlock is a highly successful collaboration between type legend Ed Benguiat and the popular foundry House Industries. It relives the whimsical lettering that appeared on cereal boxes and magazine ads of the 1950s and 60s—a lot of which was drawn by Ed himself. But the team didn't settle for a simple alphabet with an animated appearance; they practically animated the font. Using over 1,400 ligatures, Ed Interlock's uppercase letters duck and stretch to create a variety of compact word marks as you type. There is a delightful lowercase, too—it just doesn't have the same interlocking magic.

Compare to:

Benguiat

Antique Olive

Bree

Designer: Veronika Burian, José Scaglione // **Foundry:** TypeTogether // **Country of origin:** Czech Republic, Argentina
Release year: 2008 // **Classification:** Display/Humanist Sans

Mild contrast, slight angle

Italic style, looped "k"

Italic style, single-stroke "e"

Descender

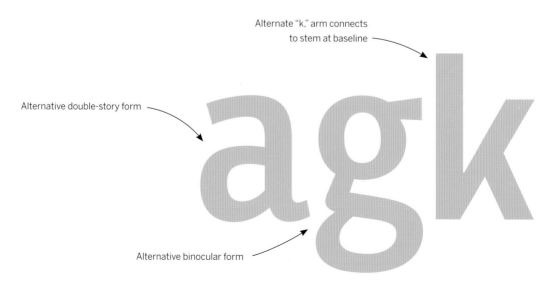

Alternate "k," arm connects to stem at baseline

Alternative double-story form

Alternative binocular form

ABCDEFGHIJKLMNOPQRSTUVWXYZ
abcdefghijklmnopqrstuvwxyz 1234567890 163
¼ ⅔ ⅝ [àóüßç](.,:;?!$£&-*){ÀÓÜÇ}

Bree Regular

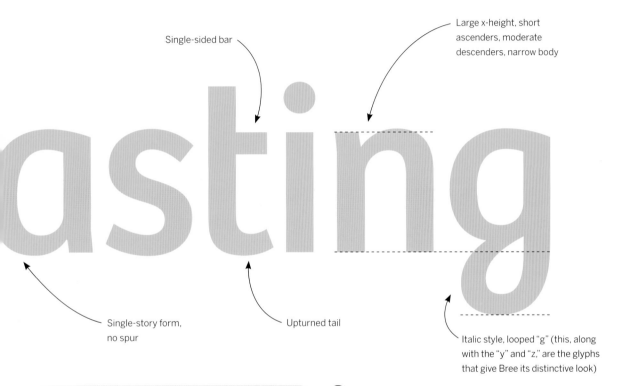

Single-sided bar

Large x-height, short ascenders, moderate descenders, narrow body

Single-story form, no spur

Upturned tail

Italic style, looped "g" (this, along with the "y" and "z," are the glyphs that give Bree its distinctive look)

Bree is based on the logotype of TypeTogether, a collaboration between José Scaglione and Veronika Burian. The concept seems simple: take cursive forms ("a," "e," "f," "v," "w") that are normally leaning forward and push them upright. In less capable hands the result would be a disaster. Instead, Bree has won multiple design awards and the hearts of countless internet fans. The success is partly due to keeping quirks to a minimum and pairing the lowercase with a basic set of caps. But it also comes from a couple of very contagious characters: the closed-loop "g" and "y." Handy bonus: there is a set of alternative forms that can fill in when a more conventional sans serif is desired. ***Good for:*** Cheerful headlines and branding.

Compare to:
Baetfkgl

FF Dax

Rumba

Designer: Laura Meseguer // **Foundry:** Type-Ø-Tones // **Country of origin:** Spain
Release year: 2005 // **Classification:** Display/Humanist Serif

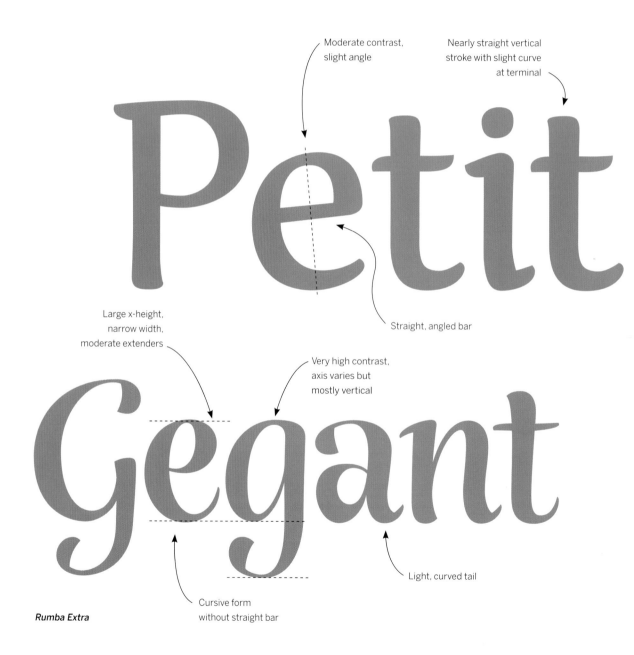

Moderate contrast, slight angle

Nearly straight vertical stroke with slight curve at terminal

Straight, angled bar

Large x-height, narrow width, moderate extenders

Very high contrast, axis varies but mostly vertical

Light, curved tail

Cursive form without straight bar

Rumba Extra

ABCDEFGHIJKLMNOPQRSTUVWXYZ
abcdefghijklmnopqrstuvwxyz 1234567890 163
¼ ½ ¾ [àóüßç](.,:;?!$£&-*){ÀÓÜÇ}

Rumba Small

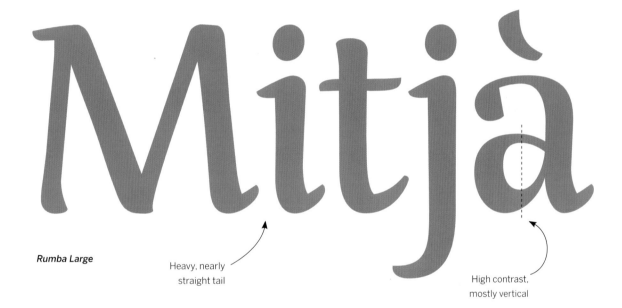

Rumba Large

Heavy, nearly
straight tail

High contrast,
mostly vertical

Laura Meseguer, a lettering artist and typeface designer from Barcelona, already had commercially successful fonts in her portfolio when she joined the Type and Media program at the Royal Academy of Art (KABK) in The Hague. But the product of her studies demonstrates that she took her skills to a new level. **Rumba** is a three-font family that explores the idea of typeface variations optimized for a specific range of sizes, but also degrees of expressiveness. Rumba Small is an organic Text face with a strong calligraphic influence; Rumba Large is much looser, with contrast only suitable for headlines; Rumba Extra is the most active and irregular, a celebration of vibrant hand lettering. *Good for:* Publications and packaging with a Latin or ebullient vibe.

Compare to:

GRaegkls

Doko

GRaegkls

Cronos

Trade Gothic Bold Condensed No.20

Designer: Jackson Burke // **Foundry:** Linotype // **Country of origin:** United States
Release years: 1948–1960 // **Classification:** Display/Gothic Sans

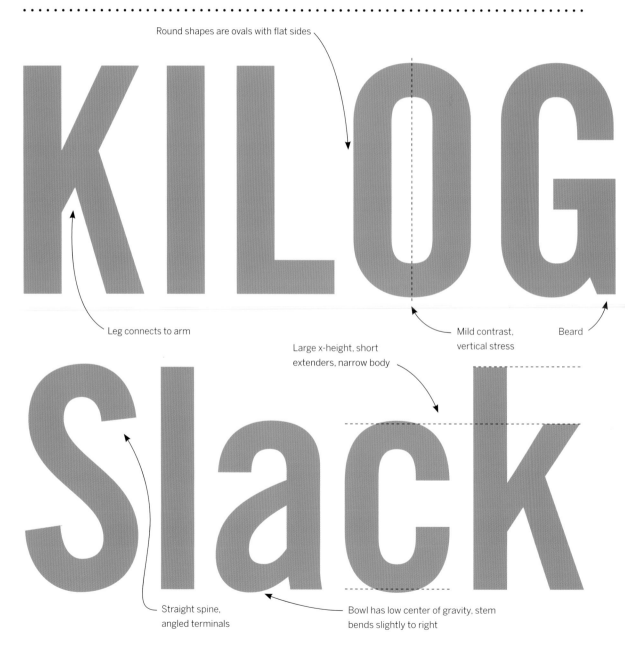

Round shapes are ovals with flat sides

Leg connects to arm

Mild contrast, vertical stress

Beard

Large x-height, short extenders, narrow body

Straight spine, angled terminals

Bowl has low center of gravity, stem bends slightly to right

ABCDEFGHIJKLMNOPQRSTUVWXYZ

abcdefghijklmnopqrstuvwxyz 1234567890

¼ ½ ¾ [àóüßç](.,:;?!$£&-*){ÀÓÜÇ}

Trade Gothic Bold Condensed No.20

RAM

Straight leg extends slightly
beyond width of bowl

Middle apex rests on baseline—
this, combined with narrow width,
requires very light diagonal strokes

Designed in the mid-20th century, **Trade Gothic** is Linotype's response to ATF's **News Gothic** that came about 50 years earlier. Like its forebear, Trade Gothic had a range of styles and weights that were quite inconsistent, including a Bold and Bold Condensed (No.20) that had flat sides, unlike the rest of the family. These two styles have become increasingly popular for setting tightly packed headlines—made possible by the design's verticality—or emphasizing words in strong contrast to other text. Alternate Gothic, a relative of the Franklin Gothic family, offers three widths but Trade Gothic Bold Condensed No.20 packs the most punch. ***Good for:*** A sturdy, down-to-earth appeal—robust, but economical.

Compare to:

RGOMA lance

FF DIN Condensed

RGOMA lance

Heroic Condensed

Heroic Condensed

Designer: Silas Dilworth // **Foundry:** TypeTrust // **Country of origin:** United States
Release year: 2008 // **Classification:** Display/Neo-Grotesque/Geometric Sans

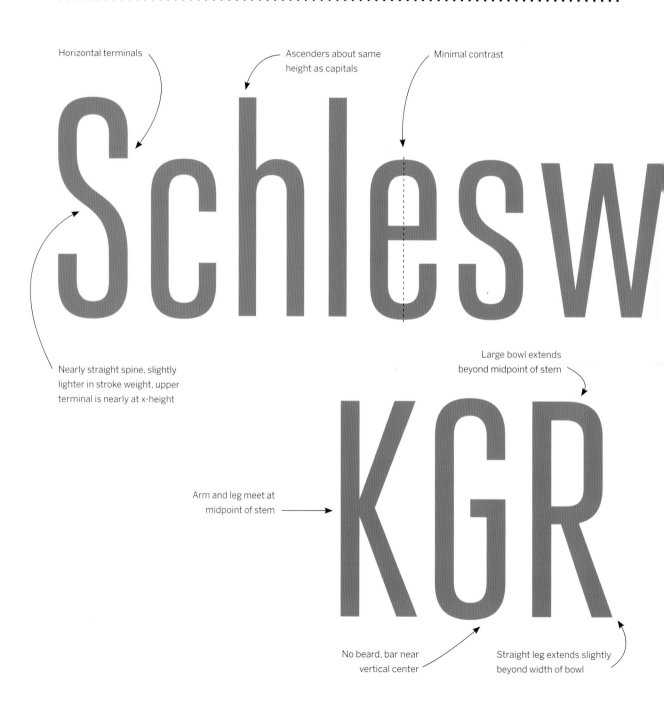

Horizontal terminals

Ascenders about same height as capitals

Minimal contrast

Nearly straight spine, slightly lighter in stroke weight, upper terminal is nearly at x-height

Large bowl extends beyond midpoint of stem

Arm and leg meet at midpoint of stem

No beard, bar near vertical center

Straight leg extends slightly beyond width of bowl

ABCDEFGHIJKLMNOPQRSTUVWXYZ

abcdefghijklmnopqrstuvwxyz 1234567890

¼ ⅔ ⅝ [àöüßç](.,:;?!$£&-*){ÀÓÜÇ}

Heroic Condensed Regular

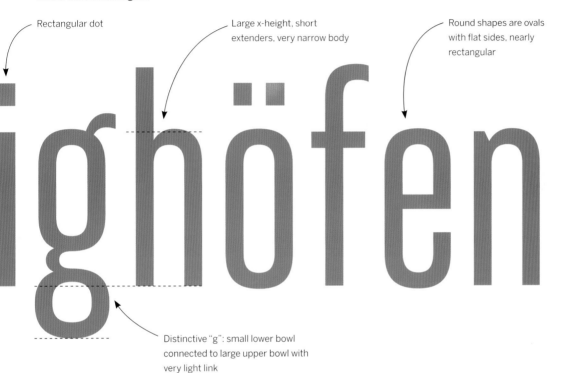

Rectangular dot

Large x-height, short extenders, very narrow body

Round shapes are ovals with flat sides, nearly rectangular

Distinctive "g": small lower bowl connected to large upper bowl with very light link

Heroic Condensed saves space. Despite its name, it does so in a very straightforward, unassuming way, making it a very versatile typeface for any kind of content. While there are many Grotesque or Geometric megafamilies (such as **Univers**, Helvetica, or **Futura**) that include a token compressed style or two, Heroic was conceived from the beginning as a narrow typeface. In this way it avoids any of the design compromises often made to unify a large family. With eight weights and the newly added compressed width, it's a handy toolset for all those projects with a vertical orientation: publications, advertising, packaging, or even the standard credit lines at the bottom of movie posters.

Compare to:

GRKaegst

Trade Gothic Bold Condensed No.20

GRKaegst

FF DIN Condensed

Cabazon

Designer: Jim Parkinson // **Foundry:** Parkinson Type Design // **Country of origin:** United States
Release year: 2005 // **Classification:** Blackletter/Textura

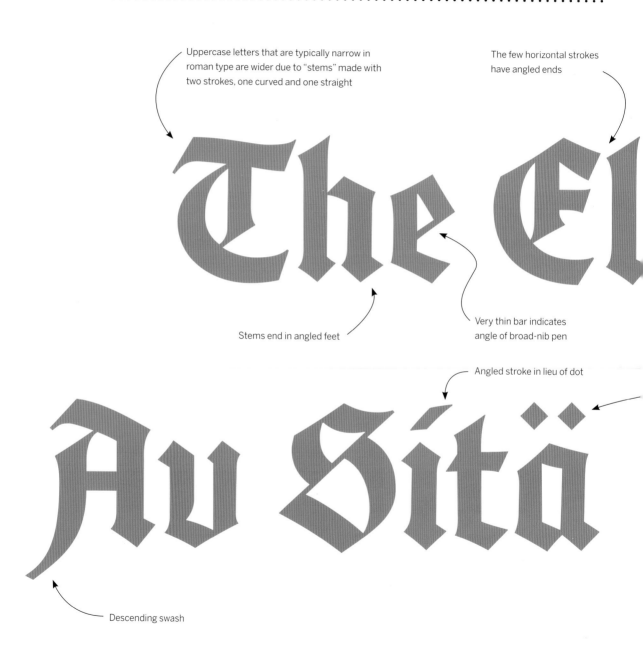

Uppercase letters that are typically narrow in roman type are wider due to "stems" made with two strokes, one curved and one straight

The few horizontal strokes have angled ends

Stems end in angled feet

Very thin bar indicates angle of broad-nib pen

Angled stroke in lieu of dot

Descending swash

ABCDEFGHIJKLMNOPQRSTUVWXYZ

abcdefghijklmnopqrstuvwxyz 1234567890

[àöüßç](.,:;?!$£&-*){ÀÖÜÇ}

Cabazon Regular

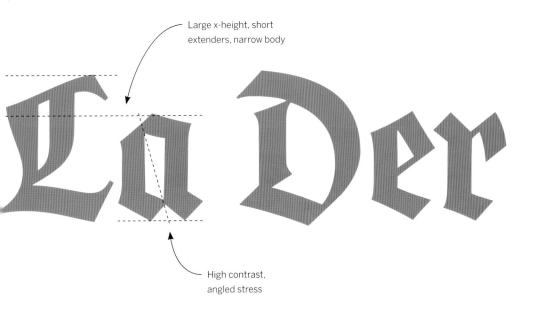

Large x-height, short extenders, narrow body

High contrast, angled stress

Diamond strokes for umlauts and punctuation

Perhaps because of its age, perhaps due to its association with Gutenberg, or maybe simply because it's not used anymore except for certificates, official proclamations, and newspaper logos, blackletter has come to represent a certain reverence and antiquity. There are various forms, such as the French/Flemish Bâtarde, or the German Schwabacher and Fraktur, but the style familiar to most modern-day readers is Textura (colloquially—and inaccurately—called Old English). Yet most Textura typefaces still aren't very legible to a public accustomed to roman letterforms. **Cabazon** alleviates that issue by keeping things fairly informal and free of ornamentation. It has a subtle hand-lettering quality, like much of Jim Parkinson's work.

Compare to:

Fette Fraktur

Old English

SangBleu

Designer: Ian Party // **Foundry:** B+P Swiss Typefaces // **Country of origin:** Switzerland
Release year: 2008 // **Classification:** Display/Humanist Sans

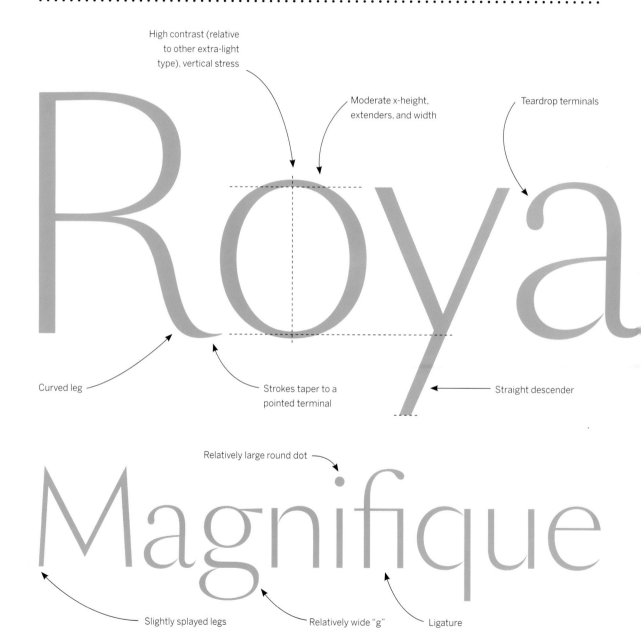

High contrast (relative to other extra-light type), vertical stress

Moderate x-height, extenders, and width

Teardrop terminals

Curved leg

Strokes taper to a pointed terminal

Straight descender

Relatively large round dot

Slightly splayed legs

Relatively wide "g" with large bowls

Ligature

ABCDEFGHIJKLMNOPQRSTUVWXYZ
abcdefghijklmnopqrstuvwxyz 1234567890
[àóüßç](.,:;?!$£&-*){ÀÓÜÇ}

SangBleu Sans Light

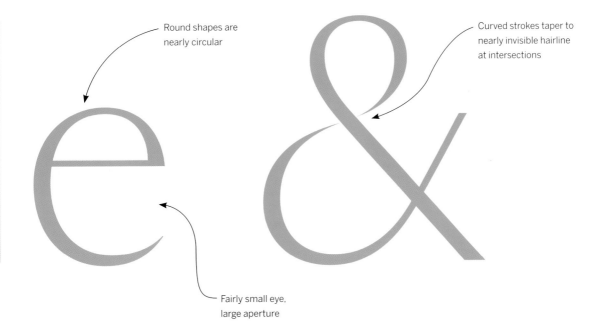

Round shapes are
nearly circular

Curved strokes taper to
nearly invisible hairline
at intersections

Fairly small eye,
large aperture

If there's one thing we've learned from the label on a perfume bottle or the glossy pages of a fashion magazine, it's that very thin type is stylish and sophisticated. Somehow, once you move a couple levels lighter than a standard "light" weight, everything on the page becomes chic and refined. The Swiss foundry B+P takes that principle to even more elegant extremes with their **SangBleu** family, a sans and serif based on a 17th- and 18th-century French type called Romain du Roi. SangBleu is just heavy enough, with just enough contrast to expose some delicately undulating curves. It's a very sexy type and a worthy replacement for the dated **Optima**.

Compare to:

GMRaegs

Optima

Marian

Designer: Paul Barnes // **Foundry:** Commercial Type // **Country of origin:** United Kingdom, United States
Release year: 2012 // **Classification:** Display/Humanist Sans

Very narrow "s"

Slant angle varies

Return stroke
departs from stem
to form arm

Alternative swash

Leg connects to loop

Marian 1554 Italic

ABCDEFGHIJKLMNOPQRSTUVWXYZ

abcdefghijklmnopqrstuvwxyz &st 1234567890 163

$\frac{1}{4}$ $\frac{2}{3}$ $\frac{5}{8}$ [àóüßç](.,:;?!$£&-*){ÀÓÜÇ}

Marian 1554 Roman

Discretionary ligature

Long, upturned tail

Moderate x-height,
extenders, narrow width,
no contrast

Stroke turns inward

Paul Barnes's concept for **Marian** is a fascinating study of history and typeface design. Always interested in the possibilities of thin, monolinear strokes, he used them to explore several classics, including the works of Fleischmann, Fournier, **Baskerville**, and Bodoni. The experiments peel away the skin and muscle of the letters to reveal their bones, reintroducing us to the underlying structure that helps define each style but that is often hidden by weight and contrast. Marian 1554 is the classic combination of Garamond's roman and Granjon's italic, coupled with a batch of swashes in a mode like you've never seen swashes before. If only every research project could produce such beautiful and useful results.

Compare to:

Makefr

Garamond Premier

Makefr

Cronos

Index

Credits and Acknowledgments

. .

Thank You

The extent to which this book is useful, insightful, or accurate is largely due to the generous input of Paul Shaw, Dan Reynolds, Florian Hardwig, Sébastien Morlighem, Laura Meseguer, Tânia Raposo, Ivo Gabrowitsch, and Nina Stössinger.

Erik Spiekermann not only offered the book's foreword but the content was surely indirectly influenced by his many years as my employer and mentor. The book's approach to classification was informed by the wise and pragmatic ideas of Indra Kupferschmid.

The anatomical diagrams were made possible by the type foundries who provided fonts and historical information; the book's designer, Tony Seddon who endured my myriad changes and visual nitpicking as he crafted the pages; and Laura Serra, Miguel Sousa, Frank Grießhammer, and Marina Chaccur who assisted in the formidable task of finding appropriate sample words in various languages.

I am also grateful to James Evans of Quid Publishing for dreaming up the concept in the first place and offering me the opportunity to tackle it. Finally, my deepest gratitude to Matthew Coles and Laura Serra for proofing my copy and lifting my spirits.

Stephen Coles

Quid Publishing would like to thank the following for kindly supplying typefaces for use in this book:

Adobe / Font Bureau / FontShop / GarageFonts / Hoefler & Frere-Jones / Hoftype / Laura Meseguer / Lineto GmbH / LucasFonts GmbH / Magnus Rakeng / Mark Simonson / Monotype / MVB Fonts / Neufville Digital / OurType / Parkinson Type Design / Process Type Foundry / Storm Type Foundry / The Enschedé Font Foundry / Typejockeys / TypeTogether / TypeTrust / Typofonderie / Typotheque / Underware / Urtd

Further Reading

Beier, Sofie. *Reading Letters: Designing for Legibility*. Amsterdam: BIS, 2012
An overview of the decisions a typeface designer can make, and how those decisions affect the performance of their designs in different settings.

FontShop USA. FontShop.com Glossary
http://www.fontshop.com/glossary/
A thorough glossary of typographic terminology.

Kupferschmid, Indra.
http://kupferschrift.de/cms/2012/03/on-classifications/
"Type Classifications Are Useful, but the Common Ones Are Not." Weblog post. Kupferschrift. 31 Mar. 2012.
An excellent essay on the pros and cons of historical typeface classification systems, along with some practical solutions for organizing and labeling type today.

Noordzij, Gerrit. *The Stroke: Theory of Writing*.
Trans. Peter Enneson. London: Hyphen, 2005.
The construction of letters explained through their origins in writing. For many, Noordzij's theory is the basis of typeface design.

Spiekermann, Erik and Ginger, E. M. *Stop Stealing Sheep & Find out How Type Works*. Berkeley, CA: Adobe, 2003.
Now that you know your typefaces, this is one of the best books for learning how to use them.

Van Blokland, Erik.
http://typecooker.com/parameters.html
"TypeMedia TypeCooker: Parameters."
TypeCooker is a drawing exercise for type design students at the Royal Academy of Arts in The Hague. Its list of parameters offers a good summary of the variety of visual traits found in typefaces.

Updated information and online resources will be posted periodically at: http://typographica.org/anatomy